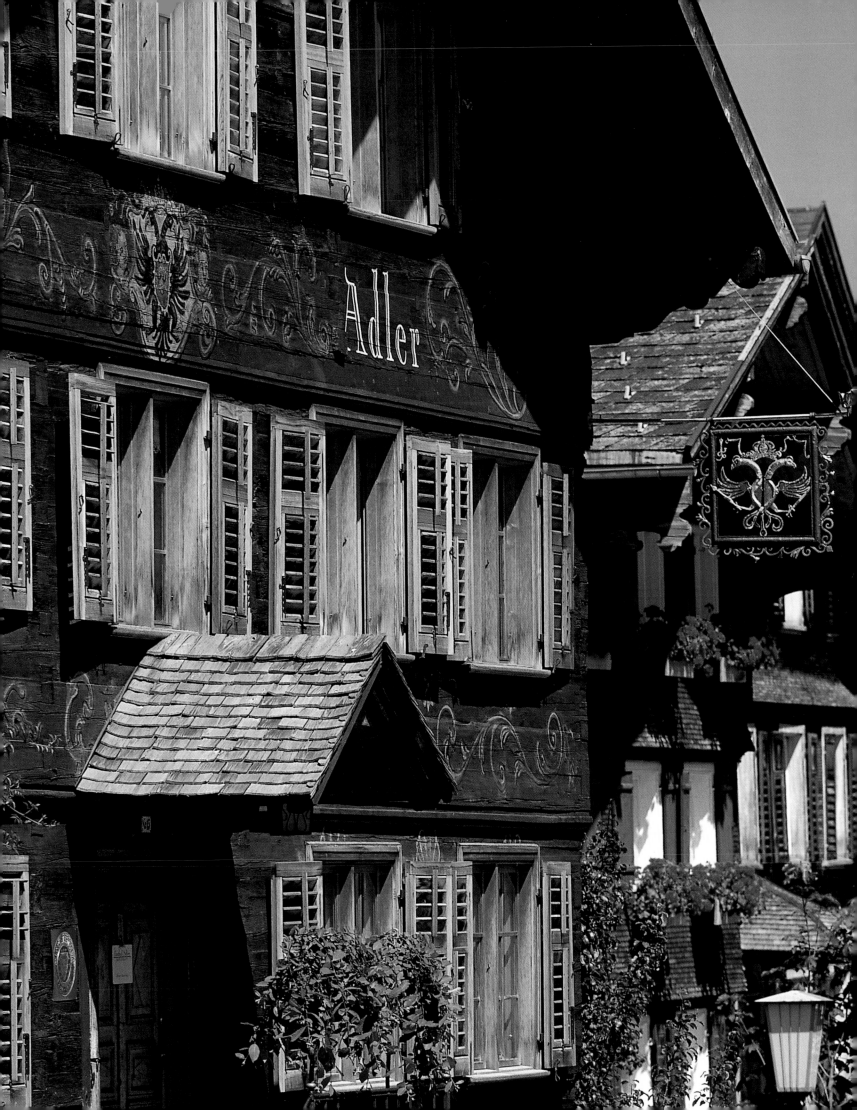

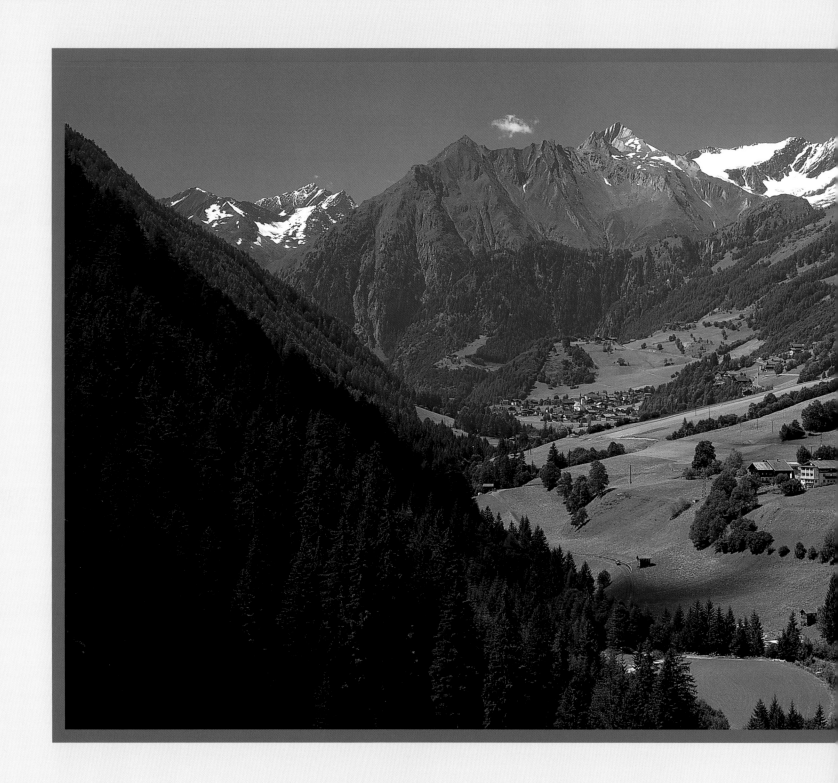

AUSTRIA

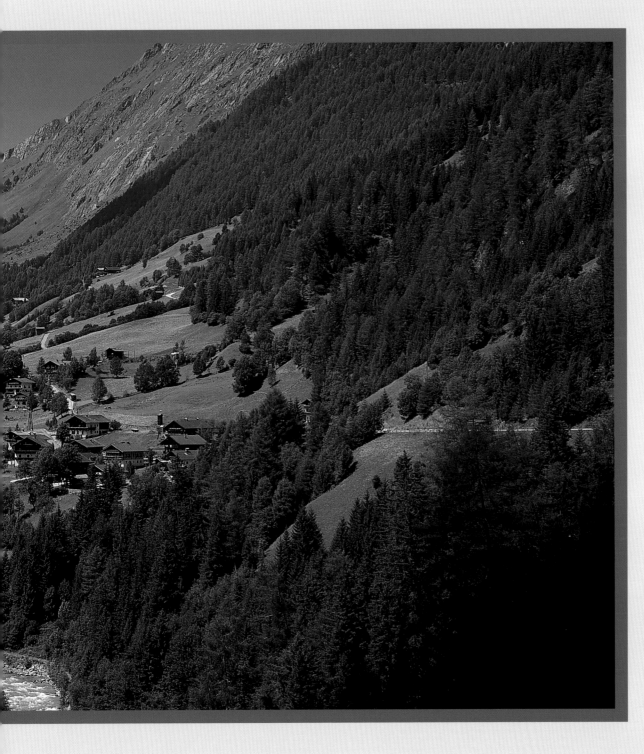

Prägraten near the Großvenediger is the last village in the remote and idyllic Virgental in East Tyrol. It's an ideal starting point for mountaineering tours of the Hohe Tauern; it was from here that Großvenediger Mountain was first vanquished in 1845.

WITH PHOTOS BY MARTIN SIEPMANN AND TEXT BY MARION VOIGT

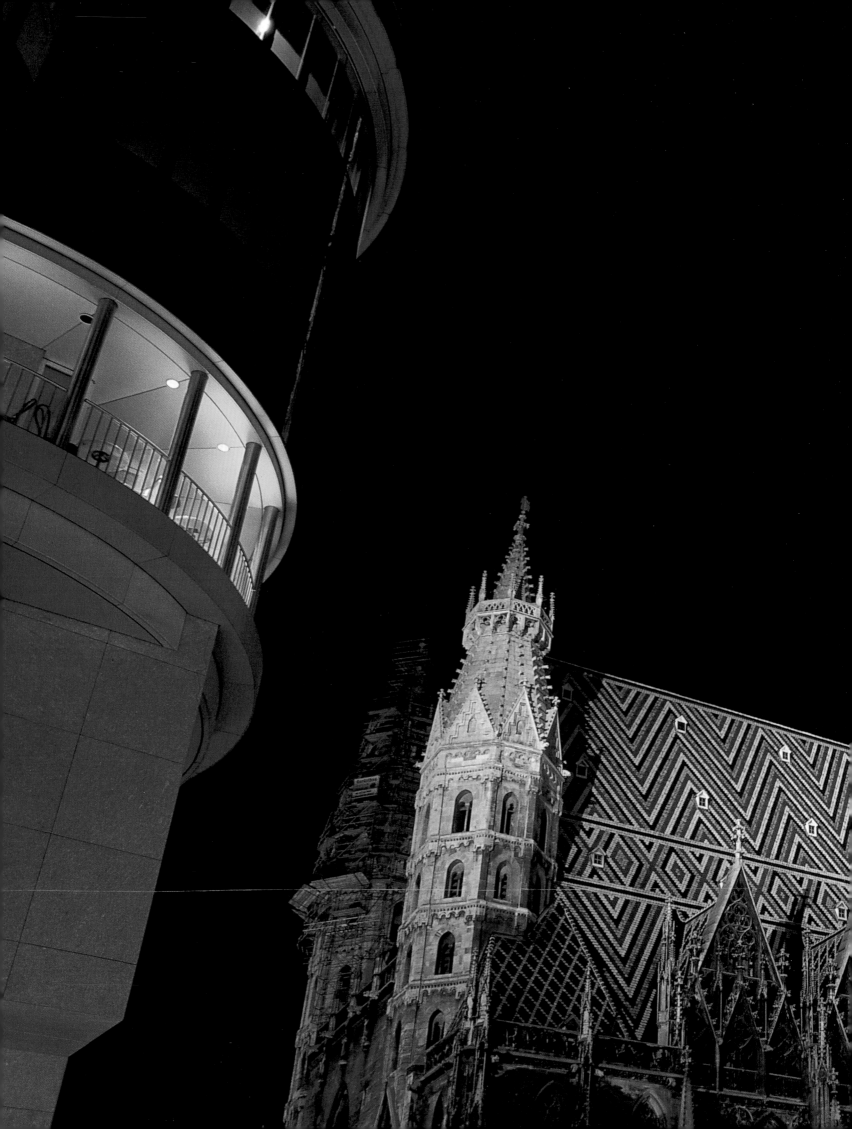

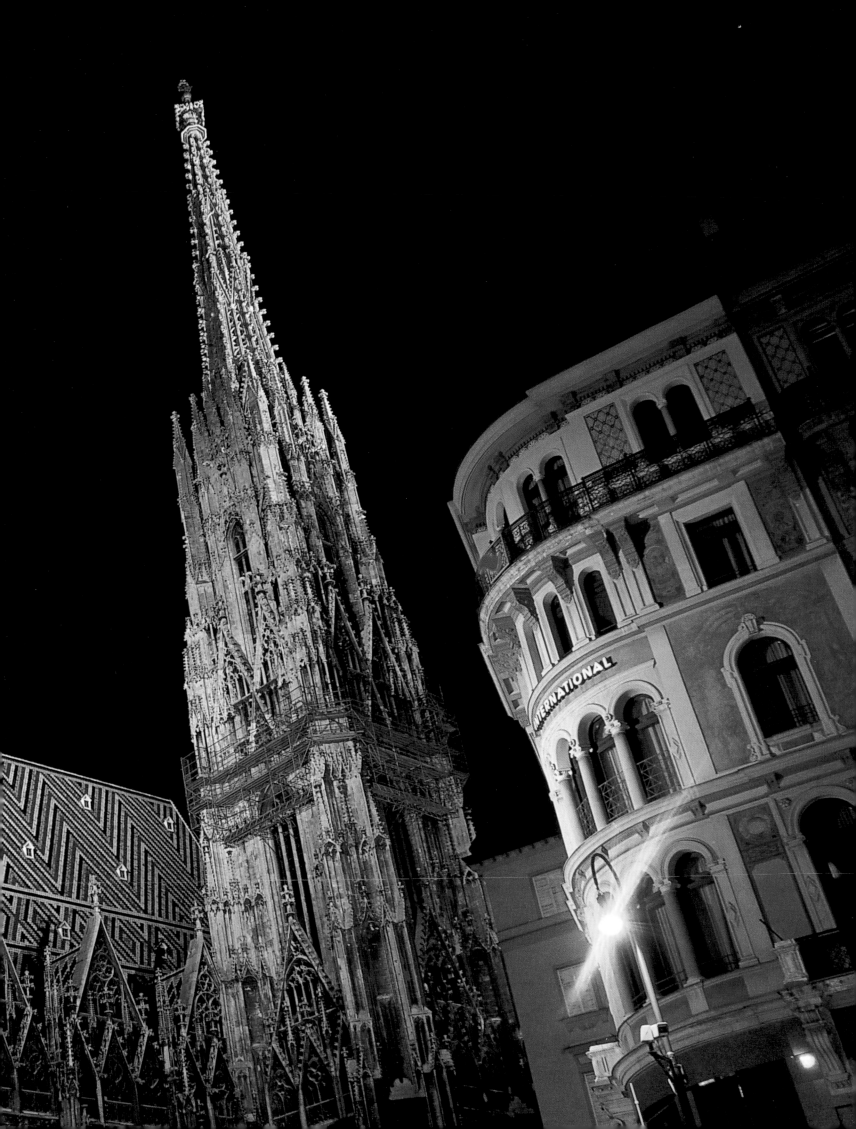

CONTENTS AUSTRIA

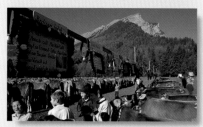
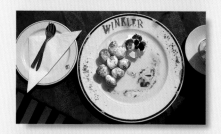

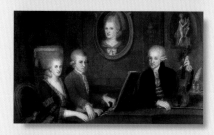
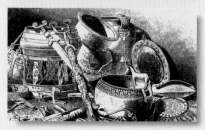

Page 5:
The village of Schwarzenberg lies east of Dornbirn in the heart of the Bregenz Forest where many ancient traditions have been upheld. The timbering of the Gasthof Adler, built in 1757, is typical of the region's traditional architecture.

Page 8/9:
St Stephen's Cathedral in Vienna is the most momentous sacred building from the Gothic period in Austria, its famous square, octagonal and triangular tower majestic in the glow of the evening lamplight.

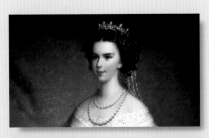

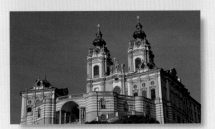
Page 12/13:
The Corpus Christi procession in Oberndorf takes place each year against the spectacular backdrop of the Wilder Kaiser. Ancient traditions are very much part of life in Tyrol, with the entire village often joining in the celebrations.

Page 14/15:
Styria is home to the Benedictine monastery of Admont, founded in 1074 on the River Enns. Its valuable library, stored in an opulent and spacious baroque setting, miraculously survived the terrible fire of 1867 and boasts more volumes even than its famous counterpart at Melk Monastery.

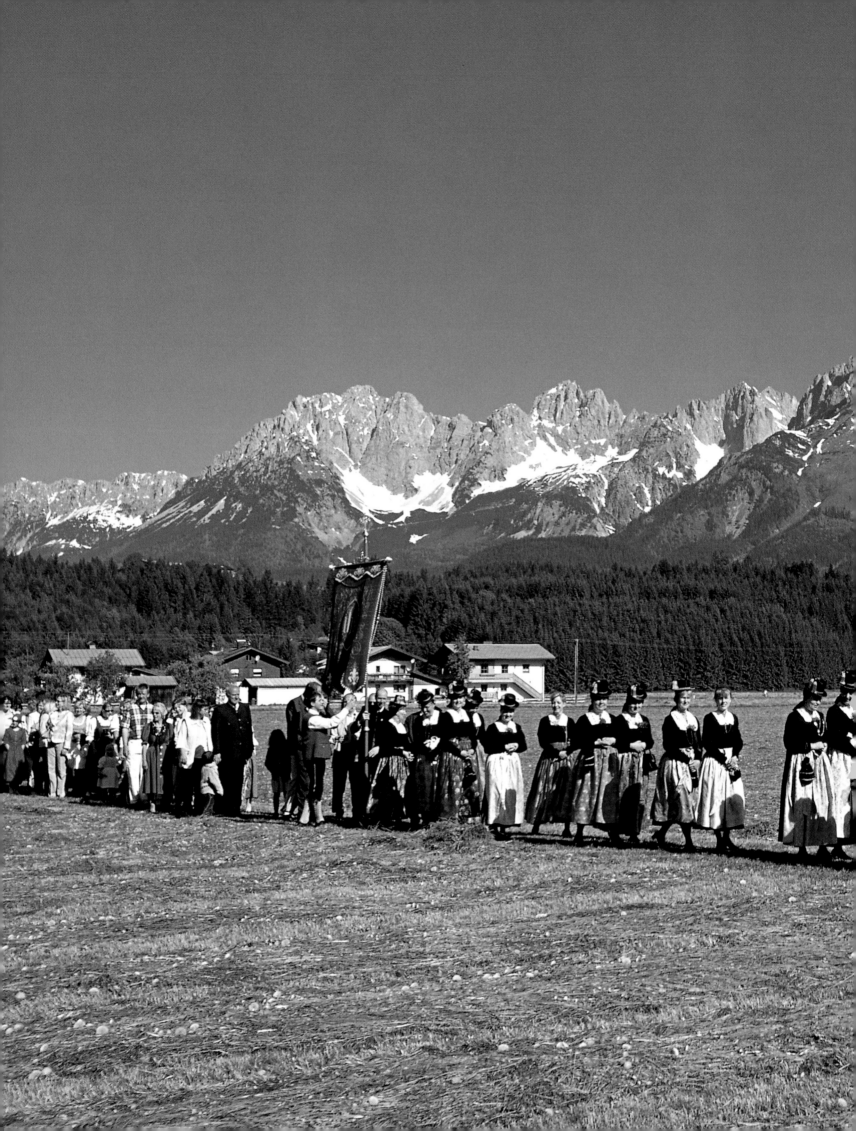

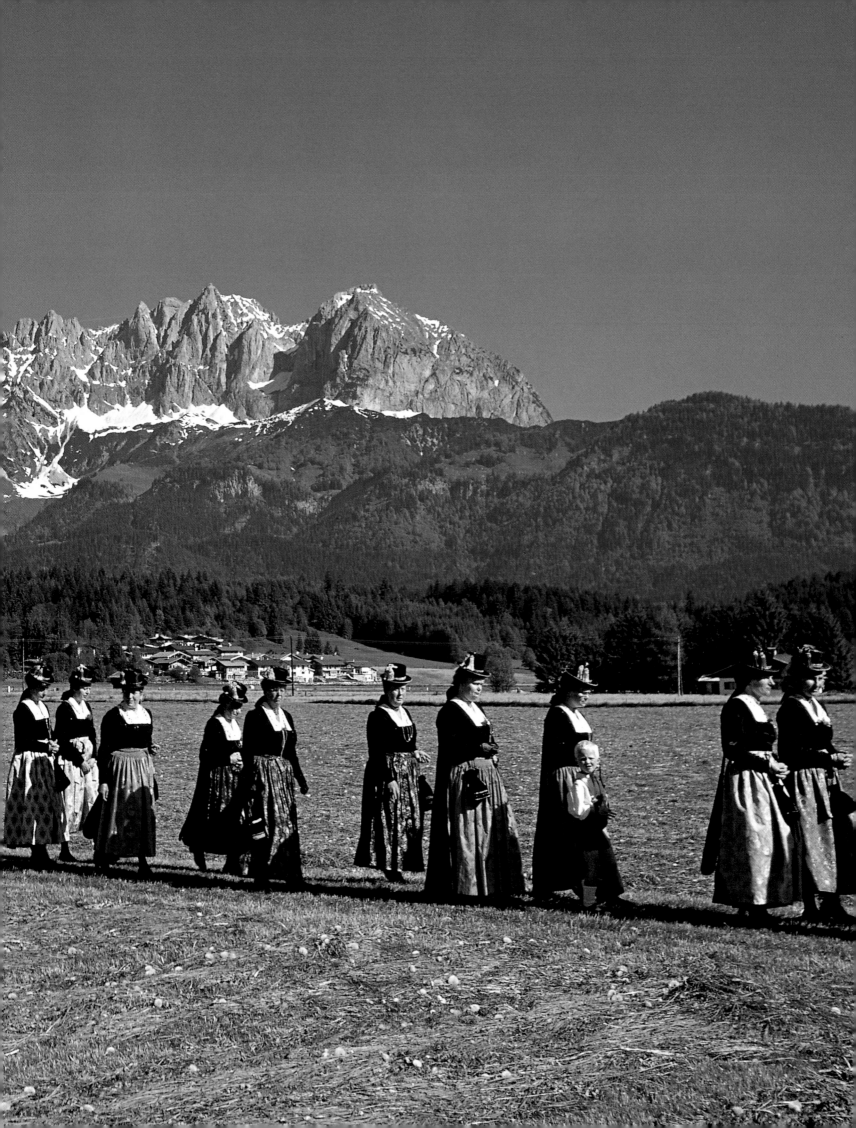

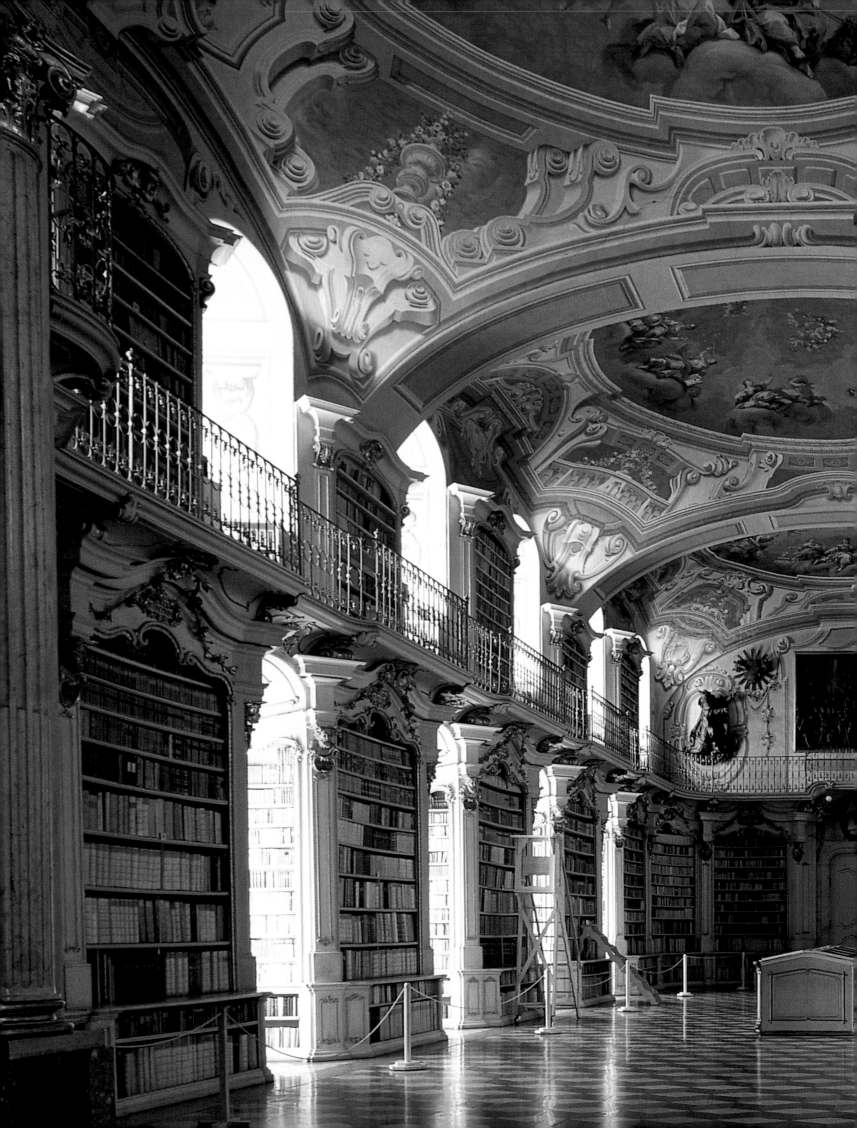

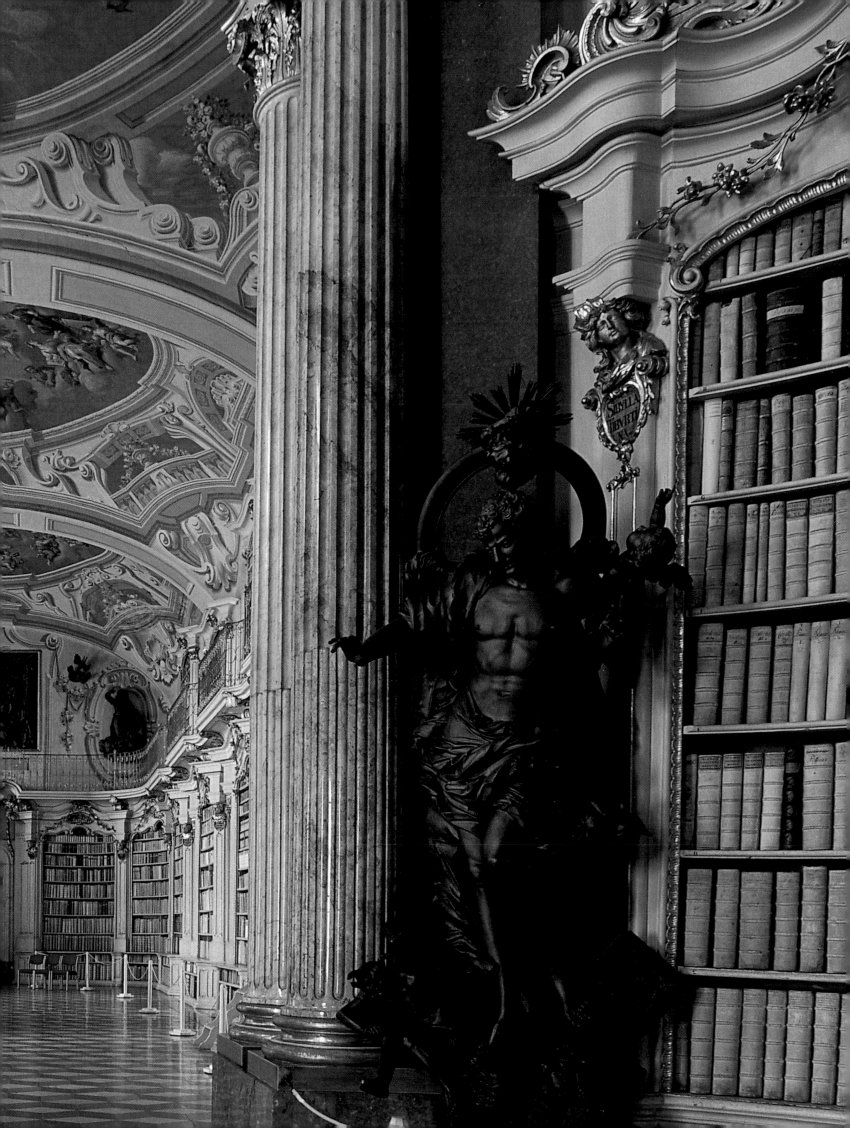

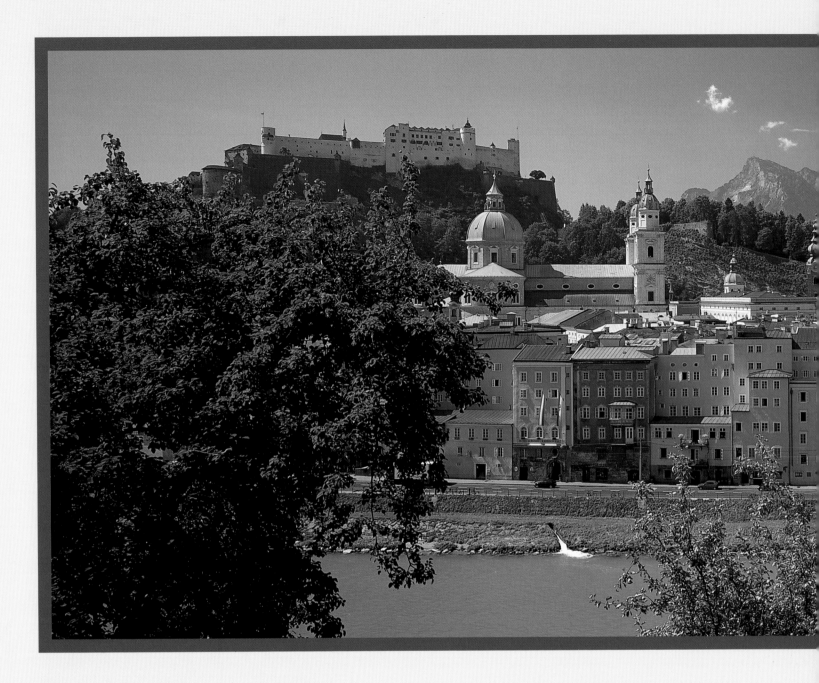

A TURBULENT HISTORY – FROM OSTARRÎCHI TO HABSBURG EMPIRE TO ALPINE REPUBLIC

Between Lake Constance and Lake Neusiedler is an area of great beauty stretching right across the heart of Europe which acts both as a natural boundary and geographical bridge.

Since the end of the Cold War Austria's function as a pathway to the east and southeast of Europe has become more accentuated; its exposed position on the edge of western Europe has, however, also done much to shape its turbulent history. How has this region changed over the course of time? Which essential features have characterised the country's past from the eastern marches of the Franks to the fall of the Danube monarchy?

From the Kapuzinerberg in Salzburg there are fantastic views out across the Salzach River and up to the giddy heights of Hohensalzburg Fortress from 1077, rising proud above the old town and cathedral. To the south lie the mountains encircling Berchtesgaden in Bavaria, Germany.

First and foremost, here a few facts and figures on the Austria of the present. At its widest it measures 753 kilometres (468 miles) east to west; from north to south the country is 45 kilometres (28 miles) at its narrowest and 294 kilometres (183 miles) at its widest point. With its nine provinces the Alpine republic covers a surface area of ca. 84,000 square kilometres (ca. 32,430 square miles) and has a population of approximately 8.1 million. Putting numbers aside, geographically Austria is an amalgamation of five different European topographies, with the eastern Alps alone taking up almost two thirds of the country. The rest is divided up between granite and gneiss highlands (north of the Danube to the Carpathian foothills), the foothills of the Alps and the Carpathian Mountains (south of the Danube to the Vienna Basin), the Vienna Basin (in the northeast) and the lowlands of the east (in the southeast). These varied and starkly characteristic landscapes are served by ancient waterways, such as the Danube and the Inn, Alpine passes and major European roads.

GATEWAY TO PANNONIA

Millions of years ago the two mountain ranges of the Alps and the Carpathians were one, forming a natural boundary to the southeast. The subsi-

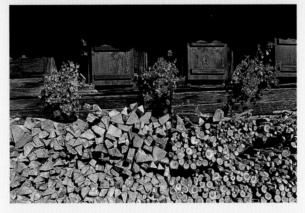

dence of a large section of the range near the Vienna Basin created further access to the lowlands of Pannonia, a geographical loophole which was to play a key strategic role from the Middle Ages to the modern day.

EARLY SETTLERS

Numerous finds from the late Palaeolithic Age have been excavated from the loess of Lower Austria between the Danube, Kamp and March rivers, such as the 30,000-year-old Venus of Willendorf (just 11 centimetres/4 $^1/_2$ inches tall), now in the natural history museum in Vienna and almost undoubtedly Austria's most significant contribution to our study of prehistory. During the Neolithic Age (5000–2200 BC) it is thought that there was heavy settlement in extensive areas of the Alpine and Carpathian foothills, the Vienna Basin and the eastern lowlands, with early tribes also migrating towards the Alps which provided essential raw materials and protection against attack.

During the Celtic period (from c. 200 BC onwards) the kingdom of Noricum was established south of the Danube and occupied by the Romans in 15 BC. Together with Rhaetia to the west and Pannonia to the east, for centuries the province formed the outermost boundary of the Roman Empire. The largely Celtic population was gradually Romanised and also mingled with the Germanic peoples who increasingly harried Latin borders. In the 5th century AD the Huns invaded from the east, later usurped by the Goths. They were followed by Langobardi, Slavic Moravians and Slovenes, with the Alemanni and from the 7th century onwards the Bavarians settling from the west on what is now Austrian terrain.

A NEW STRUCTURE OF POWER

Following centuries of territorial wrangling and political discontinuity the Carolingians created a

new structure of power in c. 800. Charlemagne annexed the duchy of Bavaria – among others – to his Frankish Empire, setting up a buffer zone of marches to secure his extensive boundaries. One of these was the eastern march stretching between the Enns, Gyor and the Drava, later to become the nucleus of Austria.

Throughout and beyond the 9th century the Hungarians in the area continued to pose a threat to Carolingian territorial order. Only following their defeat at the Battle of Lechfeld in 955 could a certain consolidation of land be instigated, leading in 976 to the founding of the duchy of Carinthia. Margrave Leopold I was entrusted with reorganising the eastern marches, heralding the beginning of the rule of the Babenbergs. By the end of the dynasty's supremacy in 1246 the region had been greatly expanded and strengthened. It is believed that this family was not descended from Adalbert von Bamberg but from the Bavarian high nobility. Where the Benedictine monastery of Melk now stands Leopold took up residence in 984. And just a few years later in 966 a document was drawn up which still exists today and in which we find the first mention of the word "Ostarrîchi" for Austria.

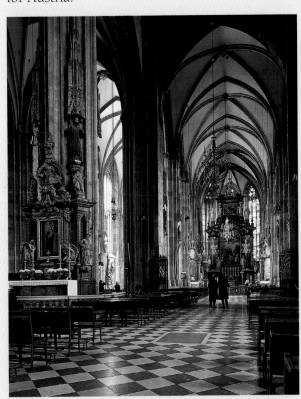

PRIVILEGIUM MINUS

Margrave Leopold and his descendants were fiercely loyal to the emperor whereas the dukes in neighbouring Bavaria crossed swords time and again with the central administration. One such rebel was Henry the Proud of Bavaria, who in the 12th century was deposed and outlawed in the emperor's name. Margrave Leopold IV was promptly made duke of Bavaria in 1139 thanks to his neighbourly proximity and good relations with the imperial Staufen dynasty. His brother, Henry Jasomirgott II, took over in 1143 after marrying Henry the Proud's widow. The Babenberg duke was obliged to forfeit this honour just over a decade later in 1156 but was generously compensated for his loss by the raising of Austria to a duchy. Indemnification also included the granting of the now famous Privilegium Minus which included both males and females in the line of succession, an ancient right which later permitted Maria Theresa to succeed to the throne.

The Babenbergs exercised great skill in their politics of marriage in an attempt to expand their domain. In 1192, for example, they inherited Styria which had been a duchy since 1180. During the 13th century further land was acquired in the same manner, providing the dukes of Austria, now resident in Vienna, with a broad

Left:
Inside St Stephen's Cathedral in Vienna compound piers prop up the net and star vaulting 28 m (92 ft) up above the nave. The aisled Gothic hall is an impressive 92 m (302 ft) long and 39 m (128 ft) wide.

Below:
Emperor Maximilian I lies buried in Innsbruck's Hof-kirche. His tomb is watched over by 28 bronze statues, among them King Arthur and Theoderic the Great. Many of these "black giants" were produced in Nuremberg at the workshop of Peter Vischer the Elder; some of the sketches were made by none other than Albrecht Dürer.

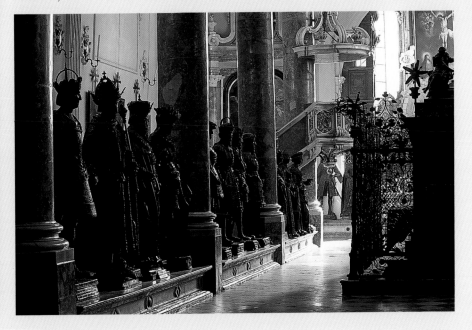

An ancient pass road winds up from the Ötz Valley between the peaks of the Zuckerhütl (3,507 m/ 11,506 ft) and Schalfkogel (3,536 m/11,601 ft) across the Timmelsjoch, now the border between Austria and South Tyrol in Italy. Due to prolonged winter conditions the pass is usually only open from mid-June to mid-October.

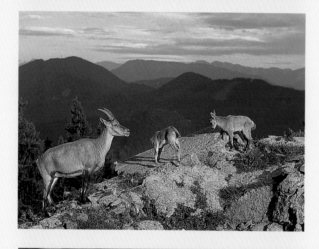

At the Hochkreuth reserve not far from Altmünster in the Salzkammergut nature-lovers can observe Alpine ibex – who incidentally are now also again found in the wild above 2,000 m (6,560 ft). The stately horns of the bocks grow to up to 1 m (3 ft) in length; those of the does to just 30 cm.

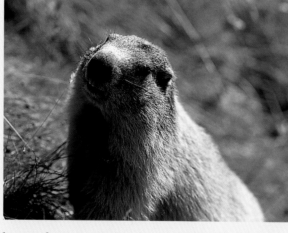

In high-lying regions between 1,400 m (4,590 ft) and 2,700 m (8,850 ft) you may be lucky enough to spot marmots feeding on the sweet Alpine grasses. The animals warn each other of intruders and other possible dangers with a sharp whistling call before scurrying away into their burrows.

Otakar II of Bohemia eventually succeeding. He married Margaret but was forced to wait for possession of Styria, part of Gertrude's inheritance. After he had settled the dispute in his favour in 1260, Ottokar had his marriage to Margaret annulled and married the granddaughter of the king of Hungary. Further territorial acquisitions followed.

A DOUBLE WEDDING AS ATONEMENT

With the election of Rudolf of Habsburg as king in 1273 the interregnum of the Holy Roman Empire came to a close and Otakar's expansive designs were finally curbed. In 1278 Rudolf emerged victorious from his battle with the king of Bohemia at Marchfeld and confiscated almost all of Otakar's territorial gains. In a gesture of atonement the king arranged a double wedding between his children and those of his adversary; King Wenceslas of Bohemia married Guta of Habsburg and Rudolf II the Bohemian princess Agnes. Rudolf enfeoffed the Babenberg lands he had reclaimed to his sons Albrecht I and Rudolf II in 1282. This resulted in heavy conflict and the division of property among the various branches of the family over the next few centuries which only ceased with the ascension of Maximilian I in 1493.

FREDERICK II's PRIVILEGIUM MAJUS

After securing a number of further territories through inheritance, purchase and skilled tactics – Carinthia and Carniola (1335), Tyrol and parts of Vorarlberg (1363), Inner Istria (1374) and Trieste (1382) – by 1395 there were three regions under Habsburg control: the Austrian Danube territories (roughly Vienna and Upper and Lower Austria), Inner Austria, including Styria, Carinthia and Carniola, and Tyrol and the Vorlande foothills (terrain in southern Germany). Frederick II, who was also made emperor of the Holy Roman Empire in 1452, was successful in reuniting the Austrian Danube territories and Inner Austria. He also managed to secure the status

basis of power. Duke Frederick II died in 1246 without leaving a male heir. His sister Margaret and niece Gertrude succeeded him. The latter had been promised to the Staufen emperor Frederick II who intended to make Austria a kingdom in return for her hand. The wedding never took place, however, with Gertrude instead marrying a relative of the king of Hungary. In the wake of the difficult political situation following the death of Emperor Frederick II in 1250 the neighbouring rulers of Bohemia and Hungary tried to seize control over Austria, with

of his family for centuries to come, legalising a number of demands made in the historical Privilegium Majus in 1453 and again in 1473. The document was actually a famous forgery which was only discovered to be such in the 19th century. The author was Duke Rudolf IV who felt he had been neglected by the Golden Bull of 1356 in which he was not named as one of the seven members of the electoral college. He thus invented the title of archduke for himself and his successors, among other privileges.

EXPANSIVE POLITICS OF MARRIAGE

Under Maximilian I, who was elected king in 1486 and reigned as emperor from 1508 to 1519, the local power of the Habsburgs continued to grow, particularly around the areas of East Tyrol, Kufstein and what had previously been land - belonging to the Venetians. Maximilian was not only able to procure the wealthy inheritance of his wife Mary of Burgundy; he also married his son, Phillip I the Handsome, off to Joan of Castile and

Aragon and her brother Juán to his daughter Margaret. Heir to the throne Juán died young and the crown of Castile went to Phillip. A third marriage arranged by Maximilian took place in 1521 when Ferdinand I, one of Phillip the Handsome's two sons, was wed to Anna of Bohemia and Hungary, the daughter of Vladislav Jagiellon. Her brother, Ludwig II, took Maximilian's granddaughter Maria of Habsburg's hand in marriage yet died in 1526 in the Battle of Mohacs against the Turks, enabling Ferdinand I to scoop up the Jagiellon inheritance. Within a short space of time the Habsburgs had managed to vastly extend their lands into west, southwest and eastern Europe. Hungary remained a bone of contention, with Ottomans from the southeast threatening occupation, yet the house of Habsburg still managed to lay claim to at least part of the country.

Maximilian's grandson Charles V ascended to the throne in 1519 and was also made Holy Roman Emperor. His brother Ferdinand I was promised the Austrian territories and took over as emperor after Charles V, in whose empire "the sun never

At Vent in the glacial Ötztal Alps the valley of the same name splits into two into the Niedertal and Rofental. Between them rises a mountain ridge from the Talleitspitze to the Hauslabjoch, the highest point being the Kreuzspitze at 3,457 m (11,342 ft).

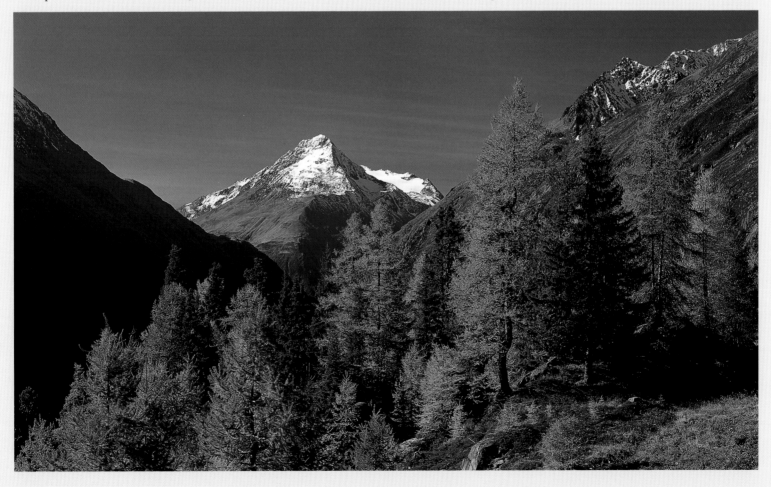

set", abdicated in 1556. Ferdinand I decreed that on his death Austria should be divided between his three sons. In 1564 Styria, Carinthia, Carniola Gorizia and Inner Istria thus went to Charles, Tyrol and the Vorlande to Ferdinand and Lower and Upper Austria, Bohemia and Hungary to the oldest son who was later to become Holy Roman Emperor Maximilian II. He was followed in 1576 by Rudolf II, who never married and was gradually undermined by his brother and rival Matthias until the latter succeeded him in 1612.

A NEW GREAT POWER EVOLVES

In 1619 the imperial crown went to Ferdinand II, son of Archduke Charles of Inner Austria and nephew of Maximilian II, an act which reunited the Inner Austrian and Danube lines of the family. The newly elected emperor installed his younger brother Leopold V as ruler of Tyrol, where the previous archduke had died leaving no heirs. Leopold was largely responsible for the cultural blossoming of the court in Innsbruck. In 1665 possession of Tyrol and the Vorlande reverted to the main branch of the Habsburg dynasty, once again rejoining the parts of Austria divided in 1564. After Ferdinand III (1637–1657) Austria and the Holy Roman Empire

The baroque Benedictine monastery of Melk in the Wachau perches atop a rocky precipice high up above the River Danube. From the south you can marvel at the edifice in its full glory. The main entrance is to the east.

were ruled by Leopold I (1658–1705). During his reign the conflict with the Ottomans again flared up; with their siege of Vienna unsuccessful in 1529, in 1683 they again marched on the city. Once the would-be attackers had been thwarted Austrian troops seized almost the whole of Hungary – including Budapest – from the Ottomans, being granted Hungary and Transylvania at the Treaty of Carlowitz signed in 1699. Under Charles VI (1711–1740) Prince Eugene of Savoy helped the Habsburgs extend their territories yet further, this time on the Balkan peninsula. As Charles VI was also king of Spain the other powers in Europe felt goaded into war by the threat of Habsburg hegemony. The War of the Spanish Succession ended in 1713 with the division of Spain. Charles VI was given parts of Spain with the Spanish Netherlands and parts of Italy. In 1718, following war with Turkey, Austria gained northern Serbia, northern Bosnia, Walachia Minor and the Banat. A new central power had evolved which was to determine the history of Europe for over 200 years.

REFORMS UNDER MARIA THERESA

With the Pragmatic Sanction of 1713 Charles VI again reasserted the right of women to ascend

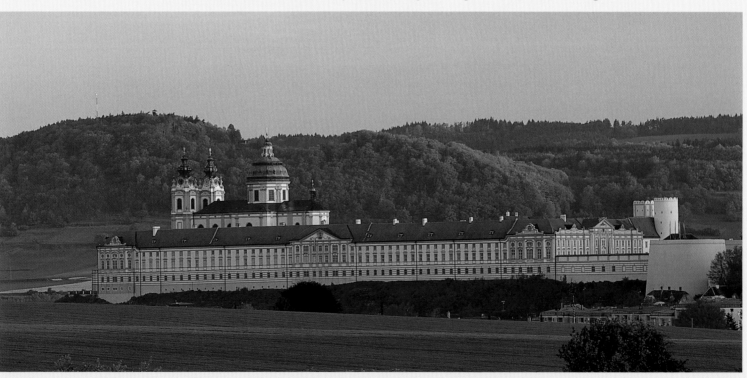

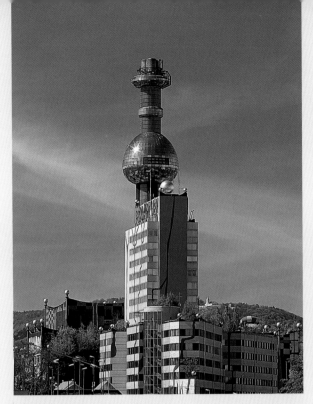

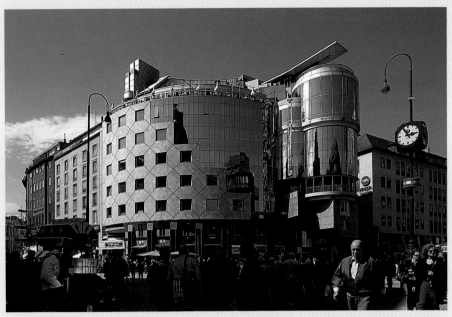

to the throne as stipulated in the earlier Privilegium Minus. His oldest daughter Maria Theresa was thus crowned in 1740 although she first had to assert her claim to the throne in the War of the Austrian Succession during which Silesia was seized by Prussia. During the 18th century Austria gained yet further territories: Galicia, Lodomeria, Bukovina and the Inn region. The long reign of Maria Theresa and her son Joseph II (1780–1790) was also a period of internal reform in which enlightened absolutism slowly triumphed.

With Prussia gradually emerging as a competitive major power and "German dualism" slowly materialising, clashes with revolutionary France and later with Napoleon sparked off a spate of bond-forming and coalition-building among the remaining nations of Europe. In reaction to the crowning of Napoleon as emperor in 1804 Francis II, Holy Roman Emperor since 1792, bestowed upon himself the hereditary title of emperor of Austria; the Holy Roman Empire itself was formally disbanded just two years later in 1806.

THE CONGRESS OF VIENNA

The political reorganisation of Europe as stipulated at the Congress of Vienna in 1815 had largely positive consequences for Austria under

Francis II, thanks to Count von Metternich. As borders were redrawn according to territories held before the rise of Napoleon, Austria again gained ground. It did lose the Austrian Netherlands and its pockets of land in southern Germany, yet the acquisition of Venice and its estates, of Outer Istria and Dalmatia permitted Austria to enlarge its terrain right down to the Adriatic. Tyrol and Bressanone, Vorarlberg and Salzburg all fell to Austria. Those present at the Congress elected the newly founded German Confederation, consisting of 35 sovereign states and four free cities – among them the Habsburg territories – successor to the Holy Roman Empire. Austria assumed the presidency of the Frankfurt Federal Convention and formed the Holy Alliance with Prussia and Russia which in the decades that followed made its mark as the guardian of a conservative order in Europe and a stronghold of reactionary power.

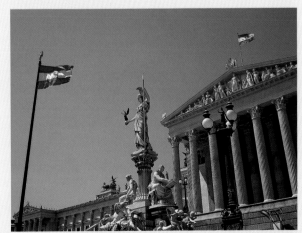

Above left:
Friedensreich Hundertwasser has bequeathed many an architectural gem to his native town of Vienna. Even the facade of the Spittelau incinerator bears his mark, enticing thousands of visitors each year to the district heating plant.

Above:
Architect Hans Hollein, born in Vienna like Hundertwasser, erected his avantgarde Haas Haus on Stock-im-Eisen-Platz opposite St Stephen's Cathedral which initially caused great controversy amongst the local population. Time, however, is a great healer; today the glass, metal and marble construction has pride of place among the sights of Vienna.

Vienna's government buildings were erected in the style of a Greek temple between 1874 and 1883 on Dr-Karl-Renner-Ring opposite the Volksgarten. In front of them stands the 'virgin warrior' Athena, the goddess of wisdom.

REVOLUTIONARY TURMOIL

Back home Biedermeier Austria between 1815 and 1848 also opted for a policy of oppression of movements towards both liberalism and nationalism whose gathering momentum threatened to get out of hand. In the March Revolution of 1848 Metternich was deposed. Revolutionary unrest rapidly spread from Vienna to Italy, Bohemia and Hungary but was successfully quelled by those in command. Emperor Ferdinand I, who had succeeded Francis I in 1835, was unfit to rule and forced to abdicate, enabling 18-year-old Francis Joseph I to ascend to the throne in December 1848. In October of the following year the revolution was finally crushed in Hungary. The army, administration and the Catholic church found themselves strengthened by the uprisings and went on to become the future pillars of the monarchy. The bureaucratic forces of the Habsburgs in particular kept a tight rein on the centrifugal powers of the multiracial state.

In the years following 1848 a number of imprudent military operations regarding foreign policy greatly damaged Austria's reputation. Francis Joseph I first lost Lombardy, then Venetia and finally found himself in prolonged opposition to Russia through his stance on the Crimean War. Following the Austro-Prussian War of 1866 the German Confederation was dissolved and the North German Confederation formed. One further development thrown up by Austria's various crises abroad was the "Ausgleich" or Compromise of Hungary which was made in 1867 and brought what was tantamount to a military dictatorship to an end. The Dual Monarchy of Austria-Hungary followed in its wake, with Francis Joseph now both emperor of Austria and king of Hungary. In the Habsburg half of the empire, which included crownlands such as Bohemia, Dalmatia and Galicia, imperial royal institutions decided on purely Austrian matters, with royal Hungarian concerns a separate entity. The central imperial and royal authorities, on the other hand, were responsible for affairs which affected both parts of the state, such as foreign policy.

DISSOLUTION OF A MULTINATIONAL EMPIRE

The "Ausgleich" the Hungarians had achieved with Austria was long denied the Czechs. In the end the dominance of Germans and Hungarians within the Dual Monarchy prevented a solution being found to the question of nationality long-term. The Hungarians suppressed the Slovaks who in turn expressed solidarity with

the Czechs and later established Czechoslovakia. Slovenes, Croatians and Serbs joined forces in the southern Slavonic movement to found a Yugoslavian state. The Poles in Galicia and Lodomeria enjoyed something of a special status, having been affiliated with the Habsburg empire through the division of Poland in 1772. They were able to make good most of their claims on Austria – to the detriment of the Ukrainians. The Italian section of the population under Habsburg rule also played its part in the general move towards dissolution of a multinational empire which had also governed the Turkish province of Bosnia-Herzegovina since 1878, annexing it in 1908. This tense, potentially explosive cocktail of nationalities, combined with the increasing rejection of society in the wake of the industrial age, was to hound Austria right up to the First World War, culminating in the collapse of no less than three empires: Austria, the Germany of Emperor William II and Tsarist Russia.

FRONTIER POST AND MEDIATOR IN THE HEART OF EUROPE

The first Austrian republic was founded on the basis of the Treaty of Saint-Germain-en-Laye signed in 1919. It covered just one eighth of Austria-Hungary's former territories and faced immense problems – and not just of an economic nature – at its outset, with the former centres of its agriculture and industry, for example, now way beyond its national boundaries. Following the Anschluß with Nazi Germany (1938–1945) and the fall of the Third Reich the second Republic of Austria was set up, gaining independence with the state treaty of 1955. Austria pledged to remain neutral in the conflict between East and West and for decades was something of a Central European outpost cowering in the shadow of the Iron Curtain. In 1995 Austria became a full member of the European Union which with its plans for expansion might restore some sense of normality to the heart of Europe – also for Austria in its "double role as frontier post and mediator" (Felix Jülg).

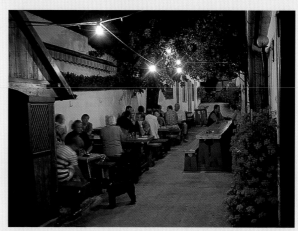

Page 26/27:
The famous winter sports resort of Sölden in the Ötz Valley is also a popular starting point for trips up into the surrounding mountains. A number of lifts transport skiers and hikers up into the higher regions of the area, Hochsölden and Geislacher Kogel among them.

Left:
Genuine Burgenland hospitality can be savoured at this "Buschenschank" in Mörbisch, where homemade specialities and local vintages are served. Wine taverns such as this are only open at certain times in the year.

Below:
On the western shores of Lake Neusiedler, close to the Hungarian border at Sopron, is Mörbisch, surrounded by vineyards bathed in early morning sunshine.

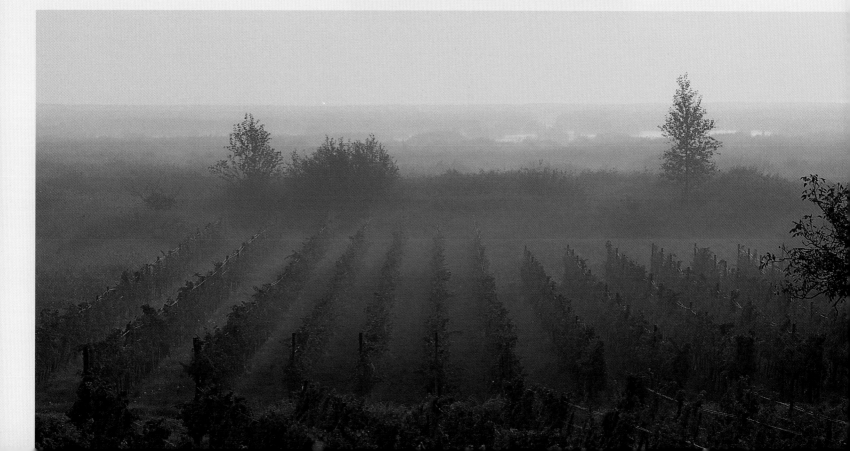

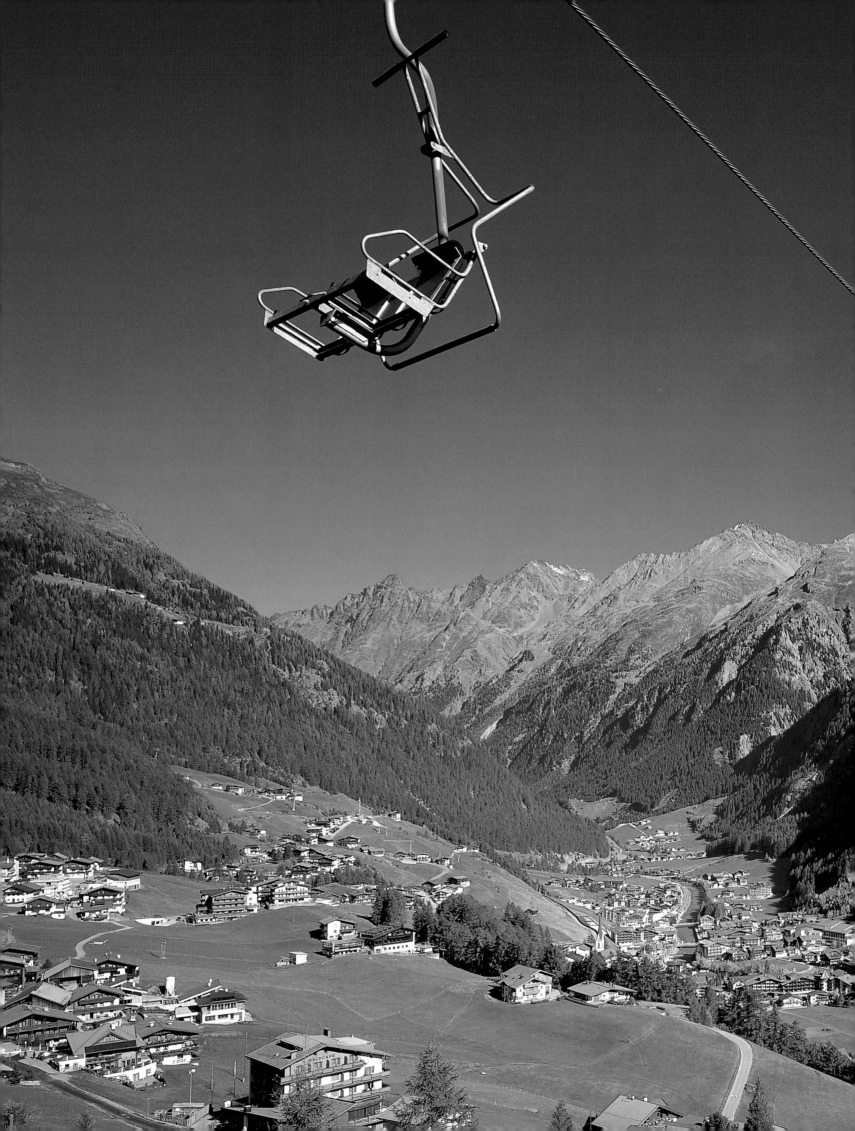

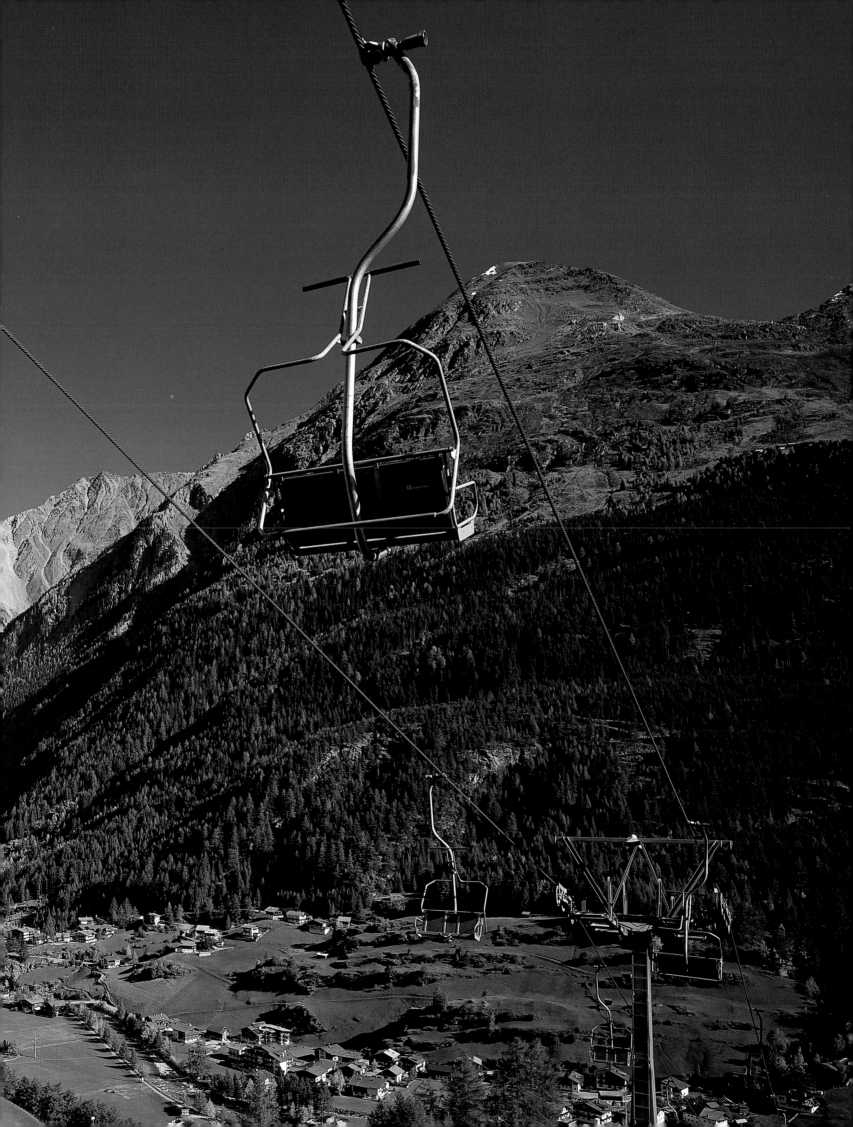

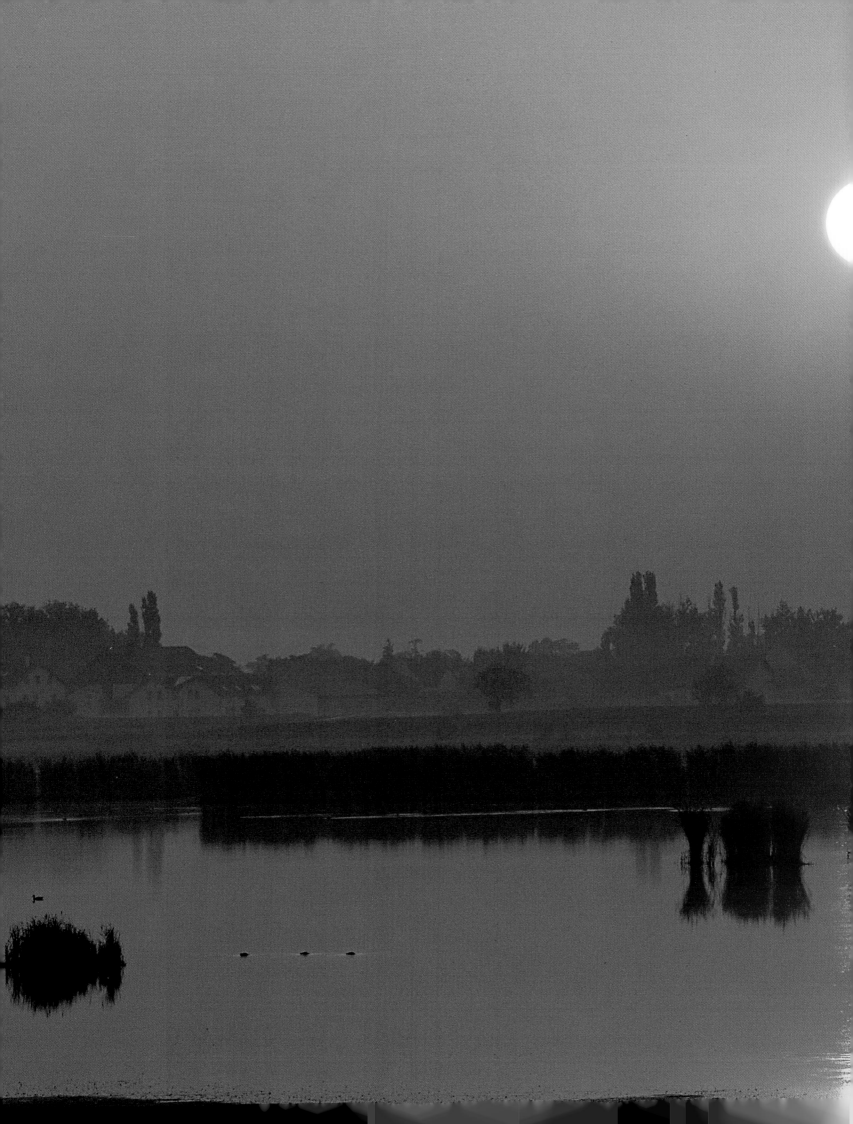

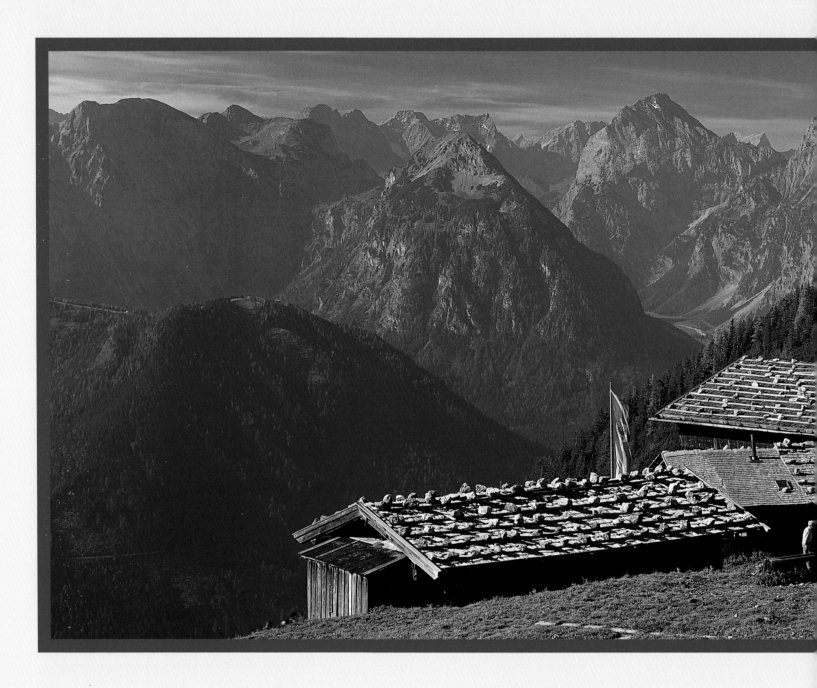

TYROL AND VORARLBERG — THE WEST

North Tyrol between Salzburg and Vorarlberg and East Tyrol between Carinthia and the Italian border make up the second-largest Austrian province of Tyrol, named after a small castle near Merano in South Tyrol, Italy. It was here that in 1120 the counts of Vinschgau erected their ancestral seat, henceforth calling themselves the counts of Tyrol. With the extinction of the dynasty in 1253 the Tyrol estates fell to the counts of Gorizia. The wealthy and strategically placed province was long fought over by the houses of Luxembourg, Habsburg and Wittelsbach. Countess Margaret Maultasch – Lion Feuchtwanger's "ugly duchess", who in reality must have been a confident and clever woman –

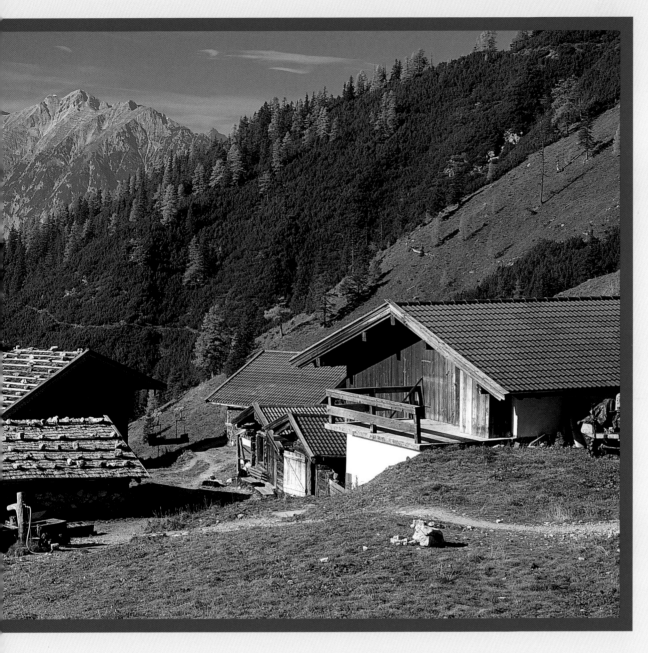

Page 28/29:
The unusually named Zick-lacke is one of the many lakes in the Seewinkel area between the eastern shores of Lake Neusiedler and the Hungarian border. The unique biotope of the saline steppe is home to many species of animals and plants and is also a stop-off point for migratory birds from Siberia.

From the top of the Dalfaz-alm in the Rofan Alps you can gaze out over the peaks of the Karwendel to the west. Between the summits a road carves its way down from the Achen Pass to the Inn Valley.

managed to thwart all designs to divide the county and through the deploying of careful tactics secured its political unity after the untimely death of her heir; in 1363 Margaret abdicated in favour of her cousin Duke Rudolf IV of Habsburg and went into self-imposed exile at the court of Vienna, where she died at the age of 51 in 1369.

A TYROLEAN HERO – ANDREAS HOFER

Another major figure to loom large in Tyrol's history is Andreas Hofer, something of a national hero, who was born in the Passiria Valley north of Merano in 1767. After Napoleon's victory at the Battle of Austerlitz Austria lost Tyrol, Vorarlberg and Lindau to France's ally Bavaria in the 1805 Treaty of Pressburg. Under Wittelsbach rule the Tyroleans found themselves deprived of certain rights and subjected to a number of reforms. Resistance soon formed, with Hofer placing himself at the helm in 1809, confident of the support of the Austrian army. Following several initial successes and victory over a contingent of French troops at the Battle of Berg Isel in the same year Hofer took command in Innsbruck for two months. Yet without the assistance of an Austria weakened by its clashes with Napoleon Hofer was unable to persist for longer

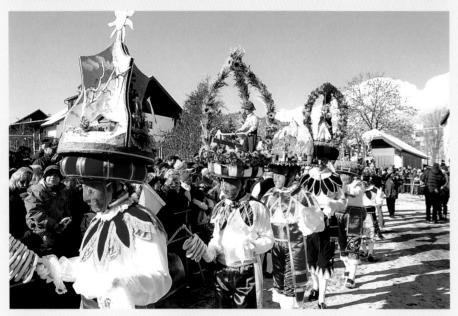

tal and Zillertal, traverse Alpine passes to the south, the Brenner Pass being the most important. At 1,371 metres (4,498 feet) at its highest point it is also the lowest pass cutting down towards Italy, lower even than the Resia Pass at 1,504 metres (4,934 feet).

A RHAETO-ROMAN HISTORY: VORARLBERG

The westernmost region of Austria, Vorarlberg is a narrow strip of land tucked in between the Rhine Valley and the high Alps, between Germany, Switzerland, Liechtenstein and Italy. From Lake Constance in the northwest to Lake Silvretta in the southeast the countryside of the second-smallest of Austria's provinces (after Vienna) ranges from the rolling hills of the Bregenz Forest to the giddy Alpine heights of the Rhätikon Mountains. The River Ill gushes through the Montafon Valley to Bludenz before later flowing into the Rhine, cutting off the Fervall Group north of the Silvretta in its upper reaches.

LINGUISTIC BOUNDARY

Historically speaking, Vorarlberg has close ties with the Lake Constance area and western Switzerland. Under Roman rule the region was made part of the province of Rhaetia and its Rhaeto-Roman inhabitants converted to Christianity, with snippets of their ancient dialect still audible today in Graubünden (the Grisons) in Switzerland and South Tyrol in Italy. Names of some towns and villages in Vorarlberg, such as Tschagguns and Gaschurn, are also remnants of a Rhaeto-Roman past. Vandans, for example, is derived from the word "fantauns" which means "a stretch of water".

Towards the end of the Roman period Alemannic tribes settled in the area, also characterising the local lingua franca with their own form of patois. Arlberg Mountain thus formed a linguistic boundary to the areas further east. From 1363 onwards the region gradually fell under the auspices of the Habsburgs.

and by the end of November was more or less isolated. Following his escape and betrayal to the French he was shot in Mantua in 1810. With the end of the Napoleonic era and the Congress of Vienna Tyrol was once again reunited under Austrian rule. Over a century later, in the wake of the First World War, South Tyrol up to the Brenner Pass was ceded to Italy.

BRENNER, INN AND CENTRAL ALPS

The impressive scenery of Tyrol is dominated by the Central Alps and the region's chief thoroughfare, the Inn Valley. Upstream the river runs in a southwesterly direction from Kufstein via the provincial capital of Innsbruck and Landeck down to the Swiss border and into the Engadin Valley where the Inn rises. Numerous major and minor side valleys, such as the Ötztal, Wipp-

In 1919 Vorarlberg was made a province of the Republic of Austria with Bregenz as its regional capital, although 80 % of the population had voted to become part of Switzerland. Despite this strong economic bonds were formed with its westerly neighbour and with Germany, particularly after the Second World War. Profuse industrialisation and productivity in the area ensure that average earnings are higher here than in Vienna, with a flourishing tourist trade providing locals with a steady source of income.

Entrepreneurial spirit even goes so far as to have initiated the export of cable cars from Vorarlberg to Japan, Canada and China. It's thus hardly surprising that the "land beneath the Arlberg" is also known as the Swabia of Austria. Small wonder, then, that the people of Vorarlberg are renowned throughout Austria for their diligence and sound sense of business.

Left:
The largest glacial stream south of the Hohe Tauern is the Isel which squeezes its way through a high narrow valley before tumbling down the Umbal Waterfalls into the Virgen Valley in East Tyrol. Over thousands of years the water has hewn strange formations out of the rock which are quite spectacular.

Below:
Lake Achen mountain railway began operation in 1889. From April to October the metre-gauge, steam rack railway takes just 45 minutes to travel from Jenbach to Maurach-Eben – covering a distance of 6.8 km (4 miles), a change in altitude of 440 m (1,444 ft) and a gradient of 1 in 6.

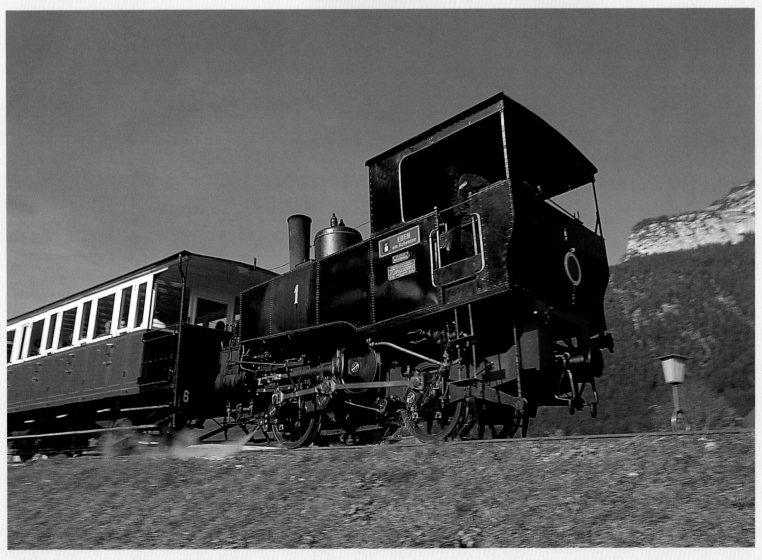

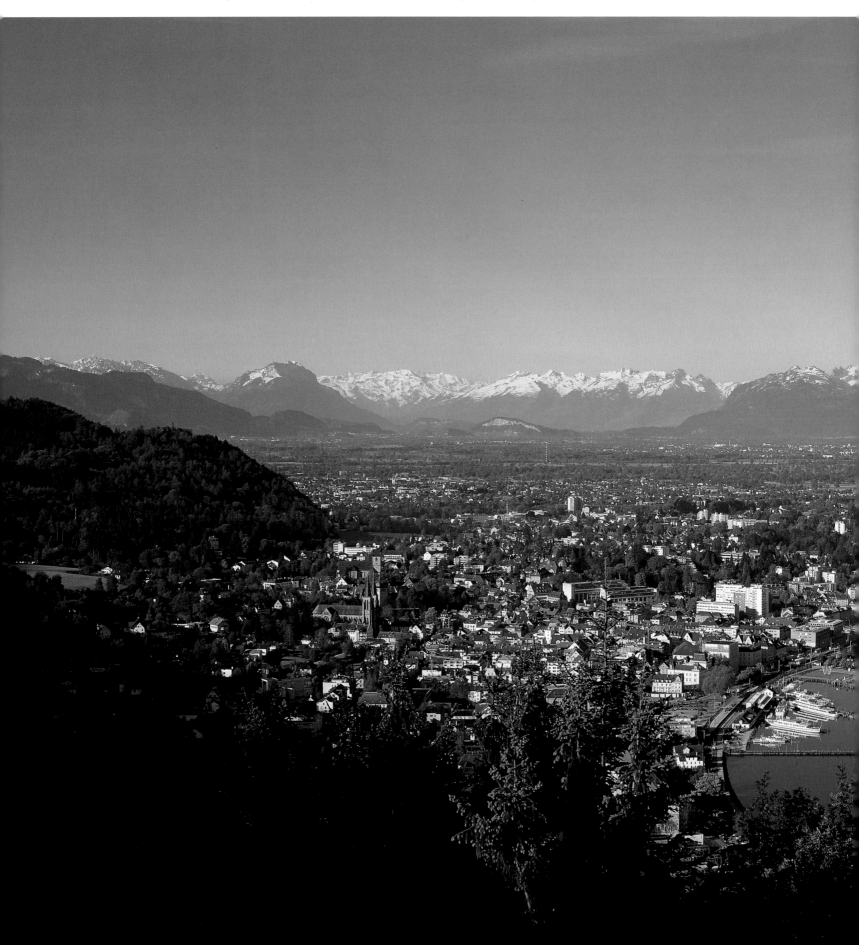

Below:
The name Bregenz stems from the Celtic Brigantier tribe who settled on the southeast shores of Lake Constance, which with its mild climate and favourable location was the ideal place to establish a flourishing port of trade.

Top right:
The Cistercian monastery of Mehrerau west of Bregenz was founded at the end of the 11th century and destroyed several times throughout its history. The present complex dates back to the years 1779 to 1781.

Centre right:
The Seebühne on Lake Constance provides a fantastic backdrop for the performances of the yearly Bregenz Festspiele. The theatre can seat audiences of up to 6,800.

Bottom right:
Swiss architect Peter Zumthor is the mastermind behind the Kunsthaus Bregenz, made of reinforced concrete and panes of etched glass which "absorb the changing light of the sky, the hazy light of the lake like a luminous screen radiating light and colour".

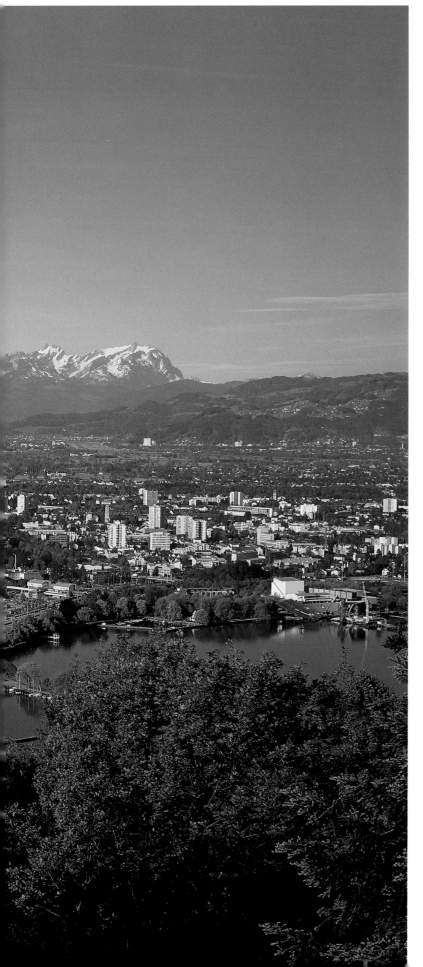

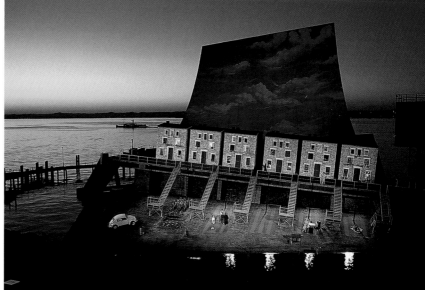

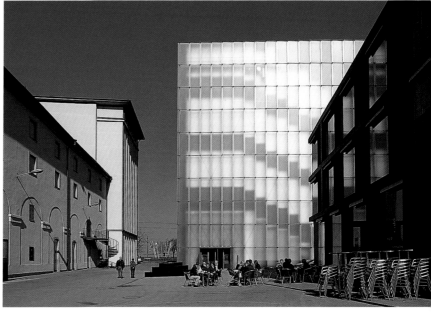

Below:
Dornbirn market place is dominated by its parish church from 1840 with its pillared neoclassical entrance and steeple dating back to 1493. Next to it is the Rotes Haus erected by the Rhomberg family in 1639 and painted red in the style of the half-timbered brick houses of Strasbourg.

Below:
The late Gothic parish church of St Lawrence from the 16th and 17th centuries adorns the heart of Bludenz, an ancient crossroads in Vorarlberg at the entrance to five valleys: the Montafon, Brandner Tal, Klostertal, Walgau and Großes Walsertal.

Right:
On the border to Liechtenstein is Feldkirch, the westernmost city in Austria. The market place is lined with arcades and patrician town houses with the church of St John behind them, founded in 1218 by Count Hugo of Montfort and dedicated to the Order of St John of Jerusalem.

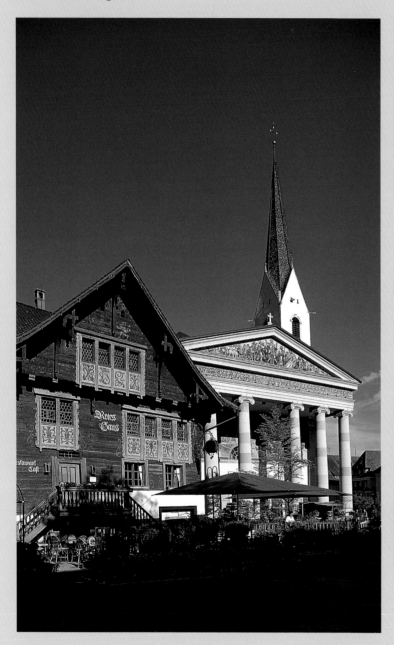

Right:
Count Hugo of Montfort had his family seat of Schattenburg Castle built in c. 1190, with the town of Feldkirch gradually evolving over the years beneath the ramparts.

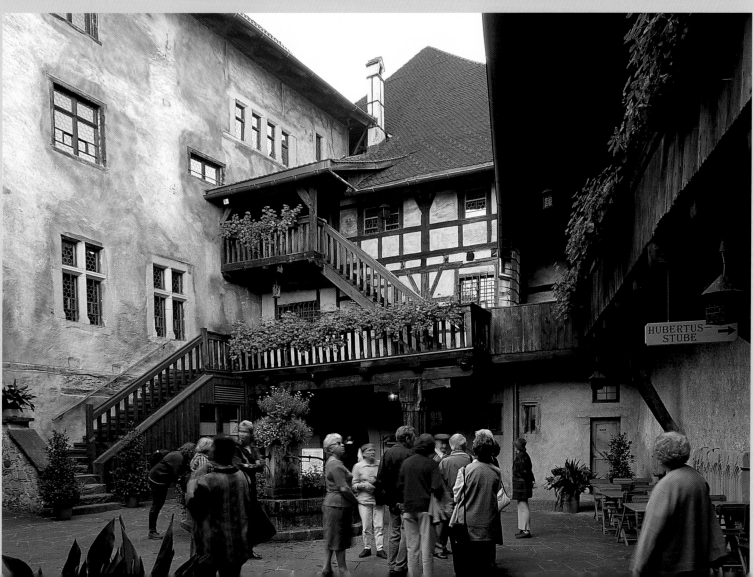

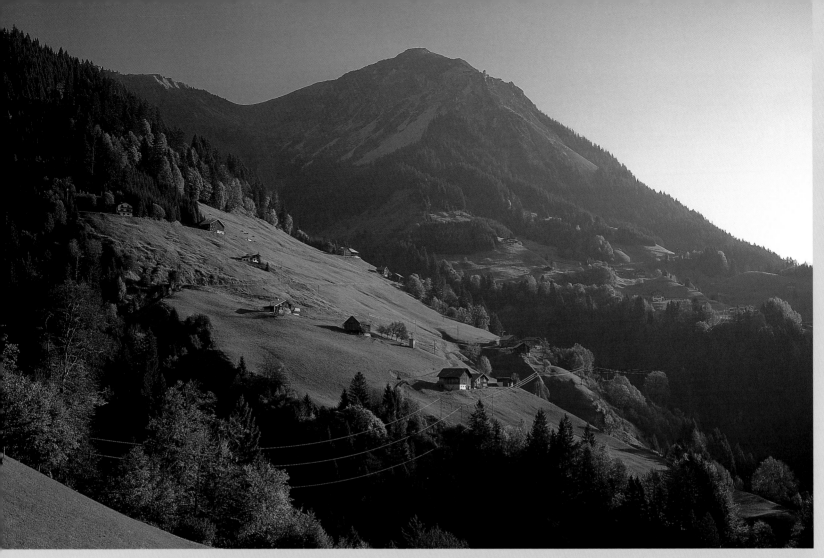

Above:
From the village of Fontanella ("little source") in the Großes Walsertal at 1,145 m (3,757 ft) there are grand views of the rolling northern slopes of the Balsenka. The ravine valley is named after Alpine farmers from Valais in Switzerland who settled here in the 13th and 14th centuries.

Right:
From the Totalphütte at 2,385 m (7,825 ft) above sea level it's a one-and-a-half hour hike to the Schesaplana, the highest summit in the Rhätikon which forms the boundary to Switzerland.

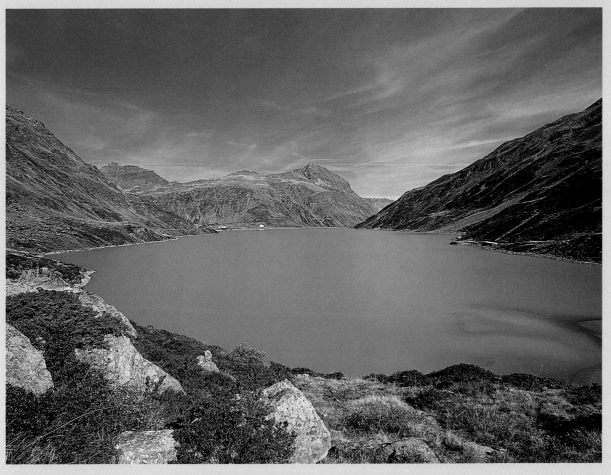

Left:
Montafon and the Paznaun Valley are linked by the Silvretta-Hochalpenstraße, completed in 1953. At its highest point, Bielerhöhe, sparkle the icy waters of the huge Silvretta reservoir.

Below:
The Hoher Ifen, 2,232 metres (7,323 feet) above sea level, is one of the most distinctive peaks in the Allgäu Alps. From the top of its steep-sided, limestone plateau there are marvellous views of the Allgäu. The Hoher Ifen can be easily reached from the Kleinwalsertal and the village of Riezlern.

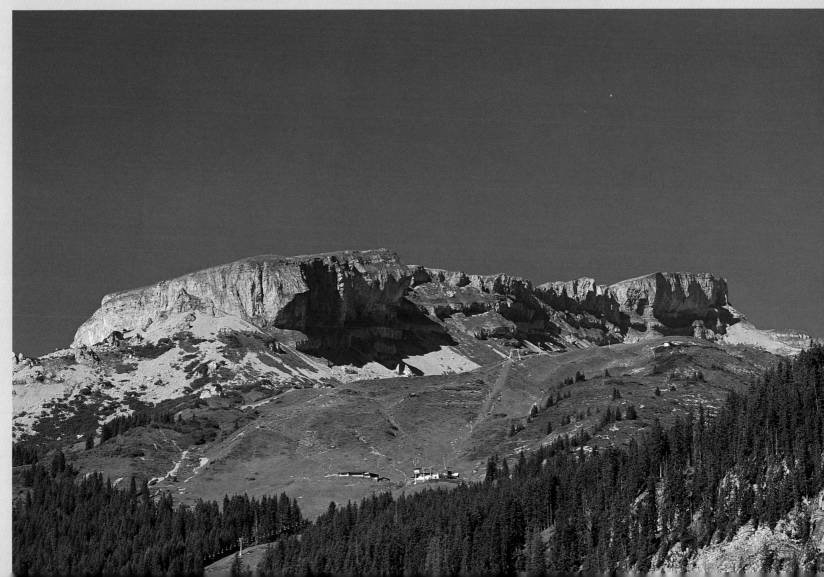

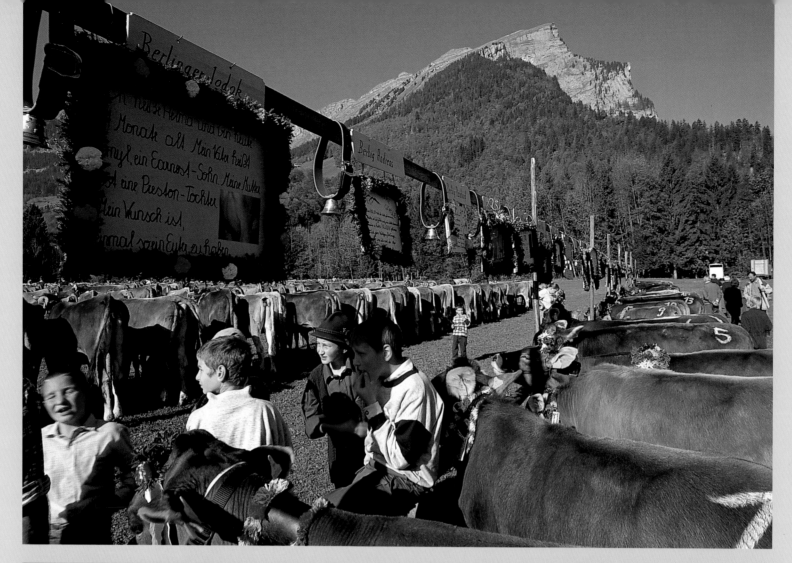
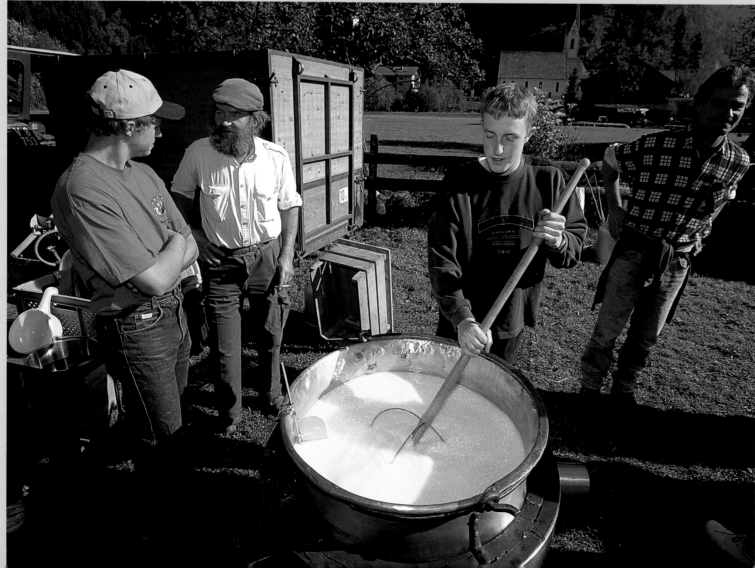

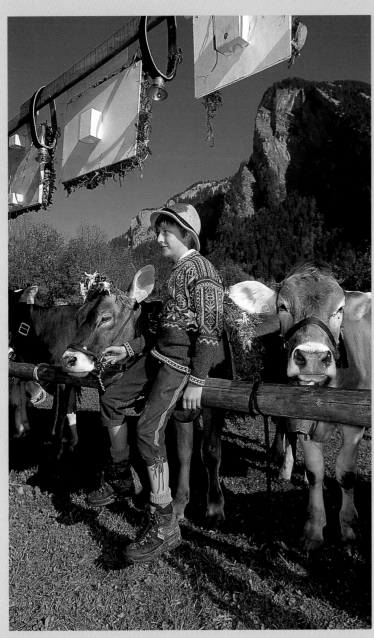

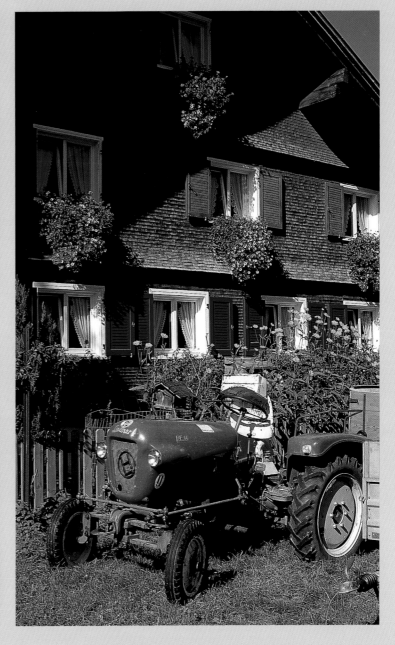

41

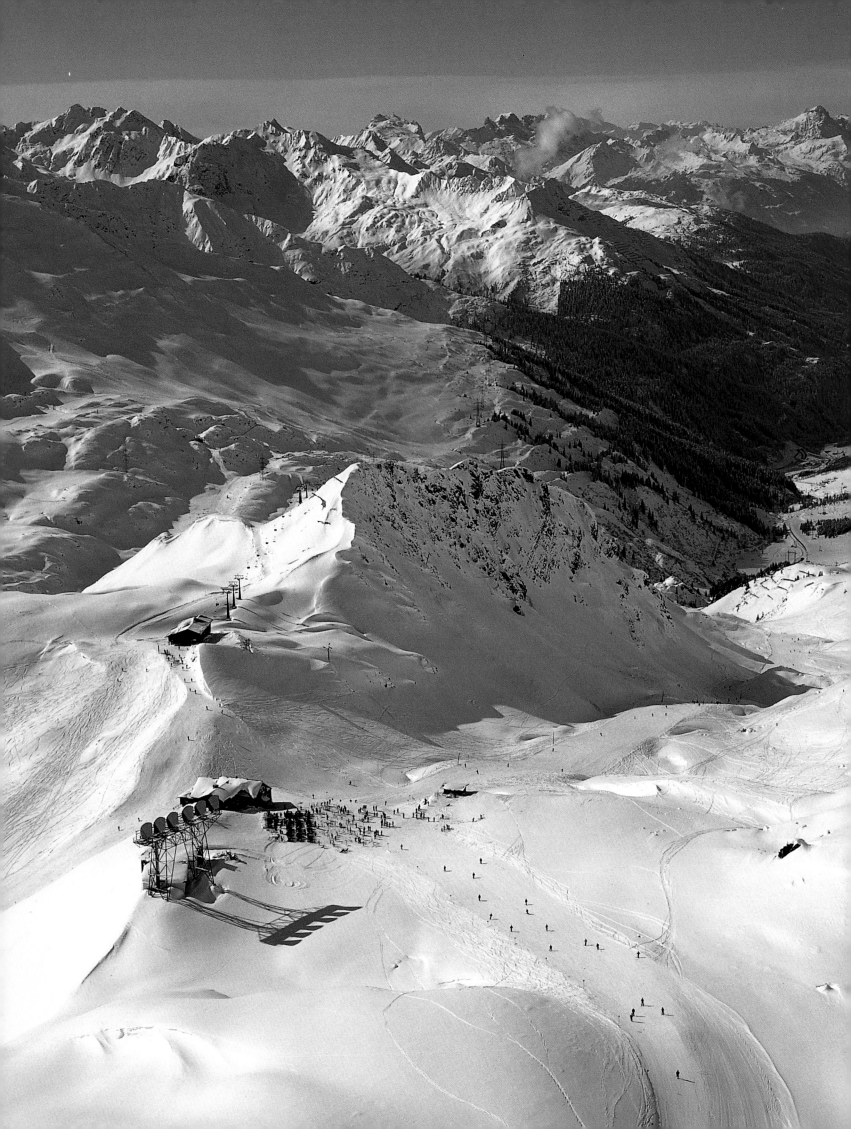

Left:
At 1,793 m (5,883 ft) Arlberg Mountain guards the frontier between Vorarlberg and Tyrol. A meteorological divide, snow is more or less guaranteed each winter, with the massif served by a vast number of lifts and cable cars. The trip up from Arlberg to the dizzy heights of the Valluga is rewarded by breathtaking views out west across the icy peaks.

Hinterriß in the Riß Valley, the only village in the Karwendel nature reserve inhabited all year round, can be reached by car from the Isar Valley in Bavaria. If you then follow the toll road up the valley for a further 15 km (9 miles) you come to the Großer Ahornboden and the Eng.

The Gerlosbach burbles through the hamlet of Gerlos in Ried at 1,240 m (4,068 ft). The pass links Krimml in the Salzach Valley with Zell am Ziller and the Zillertal.

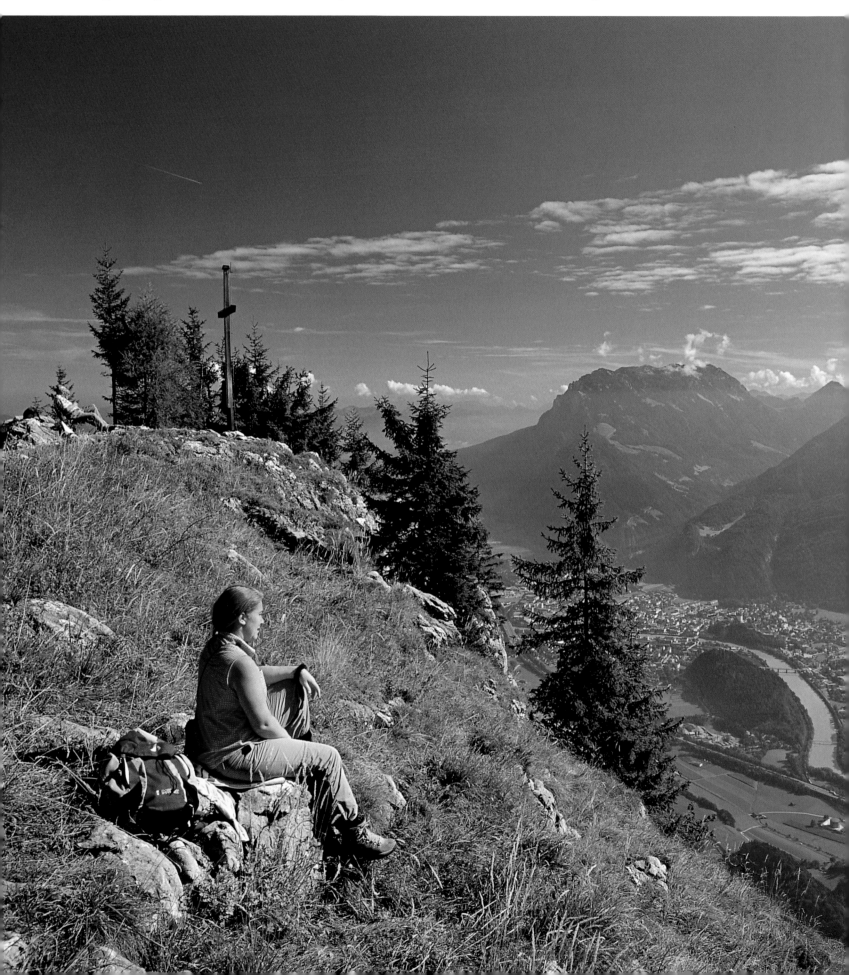

Below:
Pendling Mountain, the Alp closest to Kufstein, is 1,563 metres (5,128 feet) high. From its gnarled ridge there are grand panoramas of the Inn Valley and the Kaiser Range (in the background), the Zillertal Alps, the Hohe Tauern and the Kitzbühel Alps.

Top right:
Woodcarver Karl Wasle from Elbigenalp in the Lech Valley still practises the traditional craft of his village.

Centre right:
Alpine farms and pastures, such as this lonely mountain hut up above Kaltenbach in the Zillertal, cover 10% of Austria's surface area.

Bottom right:
Alpbach lies 973 m (3,192 ft) above sea level in the Alpbach Valley south of Brixlegg and boasts the official title of "most beautiful village in Austria". The farmers here are among the 6% of the Austrian population who live above 800 m (2,625 ft).

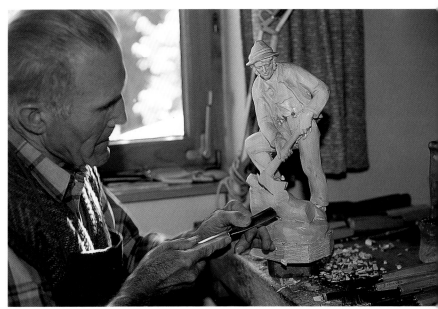

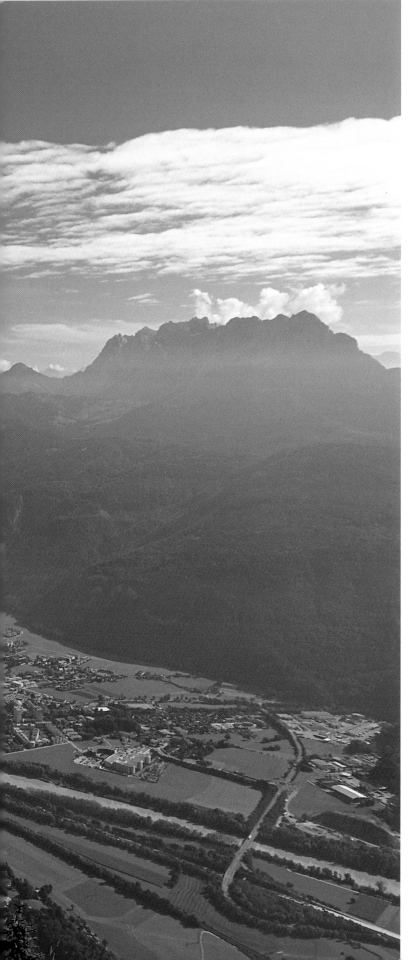

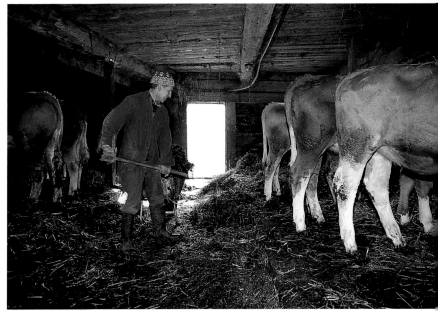

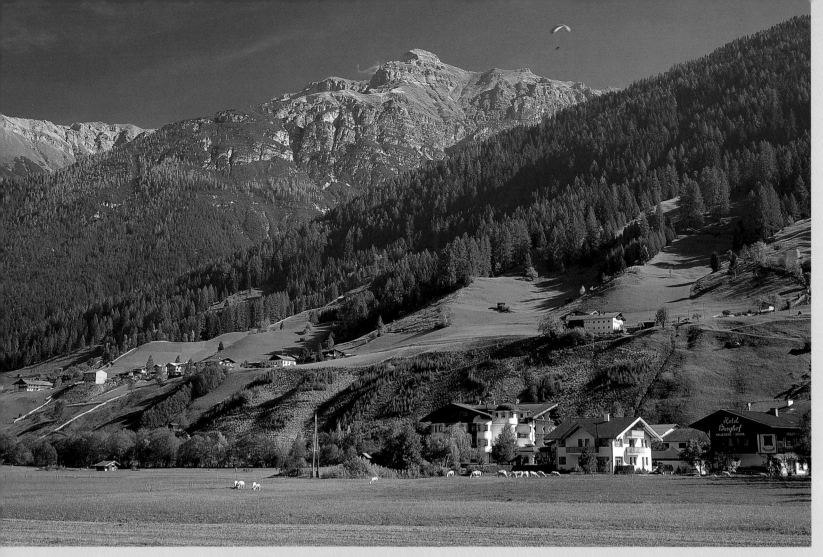

Above:
Neustift in the Stubai Valley is popular with sports fanatics in both winter and summer. The village is a popular starting point for tours on foot or mountain bike of the surrounding slopes and peaks.

Right:
In the lower Ötz Valley at Zwieselstein the high-lying valley of the Venter Ache branches off from the Ötztaler Ache, dividing again at the end of the valley beyond Vent. At the heart of the Vent Valley is the village of Heiligkreuz at 1,711 m (5,614 ft).

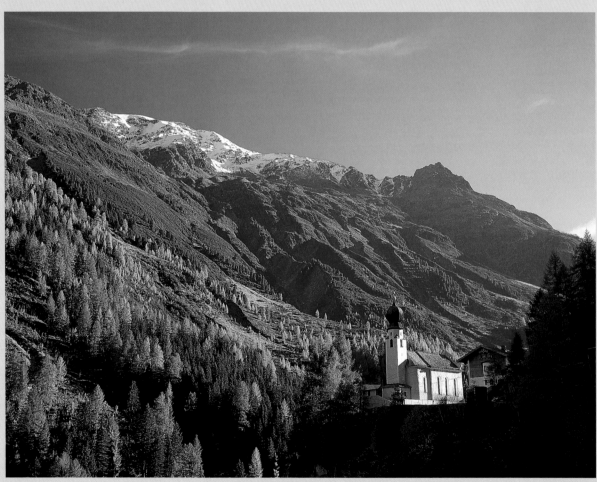

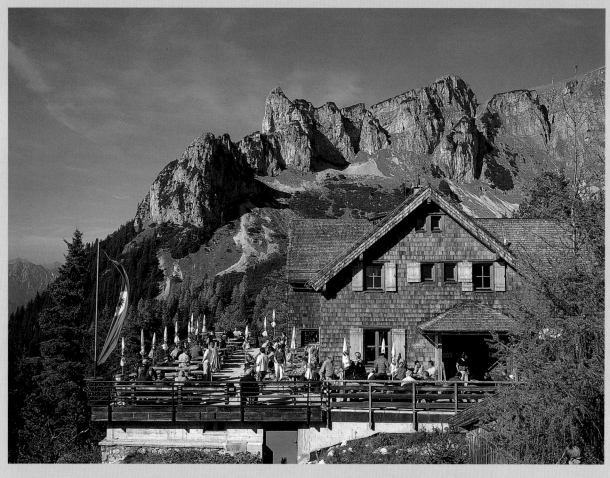

Left:
The Erfurter Hütte on Mauritz-köpfl in the Rofan Alps lies 1,831 m (6,007 ft) above sea level and can be reached quickly by cable car. The climb up trail 401 from Maurach on Lake Achen is considerably longer at 2 1/4 hours.

Below:
South of the Großvenediger the River Isel runs through the Virgen Valley in East Tyrol from Hinterbichl to Matrei, where the Tauernbach flows into the Isel.

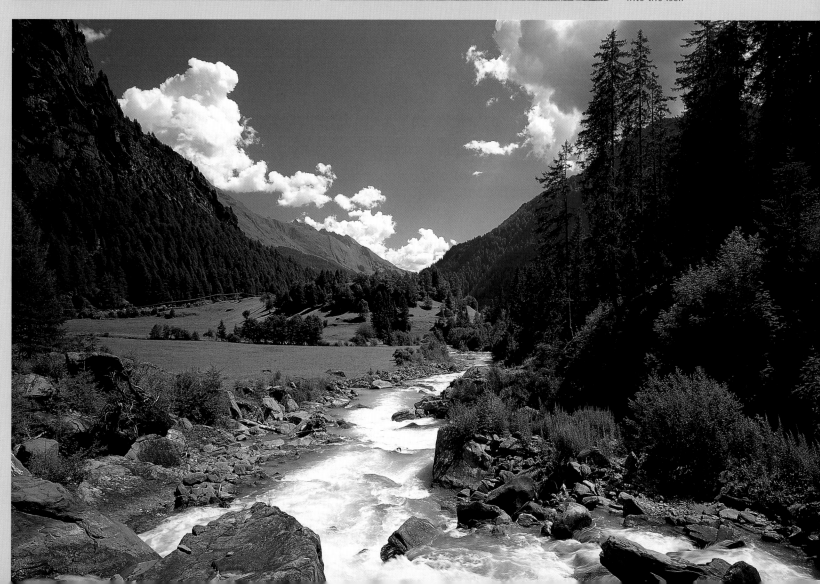

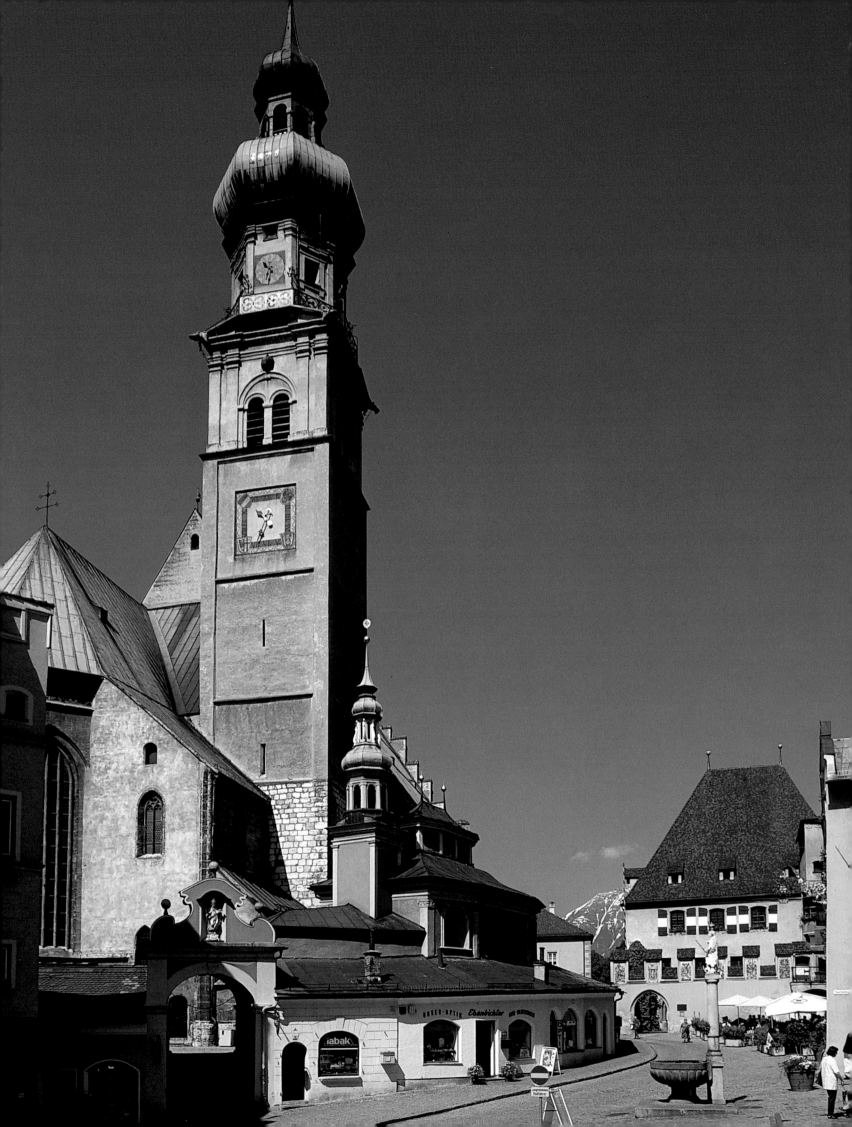

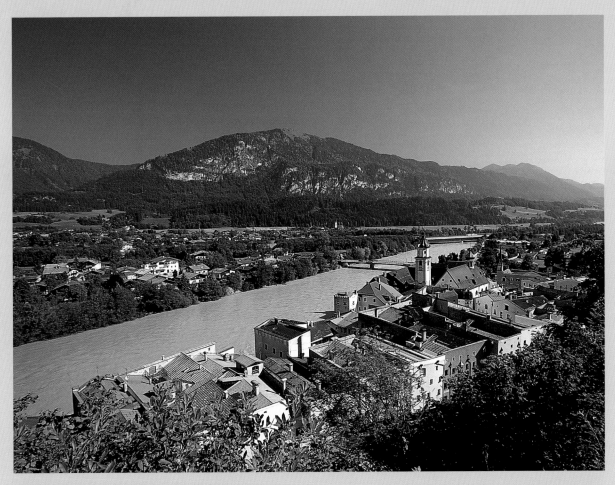

Left:
East of Innsbruck is Hall in Tyrol, where salt was mined until the 1960s. On Oberer Stadtplatz stands the late Gothic parish church with its Rococo interior from 1752. St Joseph's Chapel next to it still contains part of the old cemetery arcade.

On the south bank of the Lower Inn near Wörgl is the town of Rattenberg, famous for its compact medieval nucleus. A bridge spans the river to Kramsach on the north bank.

Burg Heinfels in the valley of the Puster stands tall above the village of the same name. Legend dates it back to the 5th century; written records first mention the castle in 1243. After changing hands many times down the centuries the building is now in private ownership.

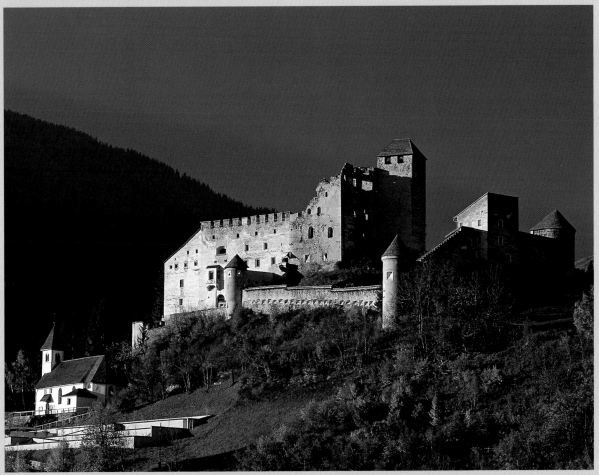

AUSTRIAN CUISINE EXPLAINED –
"RIBISELKIPFERLN" & "LIWANZEN"

Centre:
St Peter in der Au, east of Steyr, lies in the heart of the Mostviertel between the Danube, Enns and Vienna Woods. A hearty lunch here consist of a local platter and a glass mug of fermented must.

Austrian cuisine is not particularly renowned for its lightness. Delicacies savoured on Austrian soil are not compatible with dieting; when you find one of the country's famous, totally irresistible sweets on your plate it's best to throw your calorie counter away. Simmered, fried, baked, with or without yeast, these sugary delights are popular all-rounders: as a main course, for dessert and with afternoon coffee. If you've come to Austria to shed a few pounds, forget it!

Regional differences aside, generally speaking Austria appears over the years to have digested the "crème de la crème" of culinary titbits from its neighbours and former Habsburg estates. It has even poached ideas from its adversaries, many of which have become firm features in Austria's kitchens. It is a known fact, for example, that coffee is a legacy from the wars with the Turks but did you known that the wafer-thin strudel is also based on a Turkish recipe? Austrian pastry chefs have turned the strudel into a fine art, filling it with apple, quark and many other delicious ingredients.

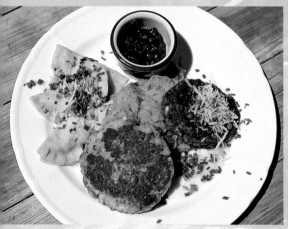

Above:
The Tyroleans love their hearty cuisine which includes an entire battery of puddings and dumplings. Among them are "Schlutzkrapfen", "Kaspressknödel" and "Spinatknödel", on offer here.

Another famous Austrian pudding is "Palatschinken", a thin pancake spread with jam and rolled into a fat cigar. Its name goes back to the Hungarian "palacsinta", itself derived from the Latin "placenta" for "flat cake" for which the German "Fladen" has given English the word "flan". "Husarenkrapferln", "hussar" biscuits, are also of Hungarian origin; "Powidltascherln" (see recipe),

however, contain a reference to the Czech term for plum jam. Other neighbourly cooking techniques to have been adopted by Austria's chefs are "Böhmische Dalken" and "Liwanzen", small yeast buns, and "Dalmatinische Kugeln". The first half of the word "Ribiselkipferln" betrays a Roman influence, "Ribis rubrum" being the Latin for redcurrant and originally used to refer to a plant with a tart bitterness.

What is most unusual about the many strange appellations for the sweets of Austria – "Buch-

teln", "Kolatschen", "Pogatschen", "Nockerln", "Knödeln", "Schöberln", "Striezeln" and "Strudeln", to name but a few – is not just the foreign element but the frequent use of the diminutive "-eln" or "-erl". The names of cuts of beef, decipherable only to those in the know – "Drüstel", "Meisel", "Kruspelspitz", "Kügerl", "Hüferschwanzel", "Scherzel", "Pratzel" – are just as belittling – perhaps in an attempt to convince would-be weight-watchers that the enormous schnitzel hiding your plate is not as fattening as it looks…

"Germknödel", a sweet dumpling dusted with poppy seeds and icing sugar, is best washed down with a glass of pink "Schiwasser" – here at the Jochdohle in the Stubai Alps.

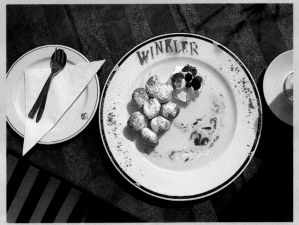

Café Winkler in Salzburg serves yeast dumplings filled with jam, poppy seed or quark with vanilla sauce with their "Einspänner" – a double mocha in a glass mug with whipped cream.

A "Melange" is a cup of coffee with lots of frothy milk, here drunk with a slice of "Sachertorte" at Café Bazar in Salzburg. This Viennese chocolate gateau has a filling of bitter-sweet apricot jam.

Powidltascherln / Plum turnovers (serves 4)

Powidl (plum jam)	30 g (1 oz) butter
Cinnamon, sugar	Salt
2 tbs. rum	*For the topping:*
500 g (1.1 lb) potatoes	100 g (4 oz)
120 g (4 oz) flour	breadcrumbs
30 g (1 oz) semolina	80 g (3 oz) butter
1 egg	Sugar

Mix the plum jam with the cinnamon, sugar and rum. Boil the potatoes, peel while still warm and squeeze through a potato press or sieve. Mix with the remaining ingredients to make a smooth dough. Leave to stand for a few minutes. Roll out the dough until ca. 3 mm thick and cut out rounds with a glass tumbler. Place 1 tsp. of plum jam in the centre of each round and fold the dough over in the centre to make a mini turnover. Press the edges together. Place the finished turnovers in simmering salt water and leave for 6 minutes. Remove with a slotted spoon. Brown the breadcrumbs in the butter and toss the turnovers in the mixture. Serve dusted with sugar.

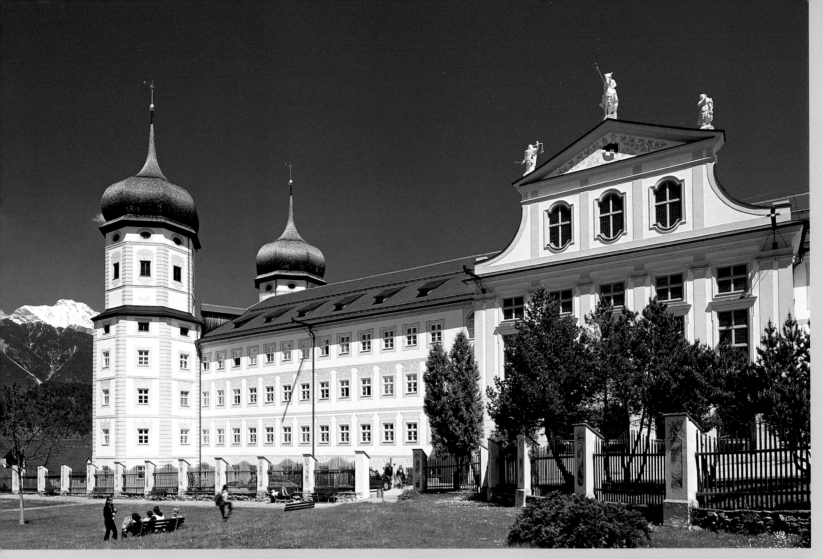

Above:
The Cistercian monastery of Stams was founded by Elisabeth of Bavaria in 1273 as a mausoleum for the princes of Tyrol. The monastery church with its distinctive towers and high altar from 1613 is well worth a visit.

Right:
One of the streets not to missed on a visit to the old part of Kufstein is Römerhofgasse running parallel to the River Inn, with its abundance of inviting wine taverns.

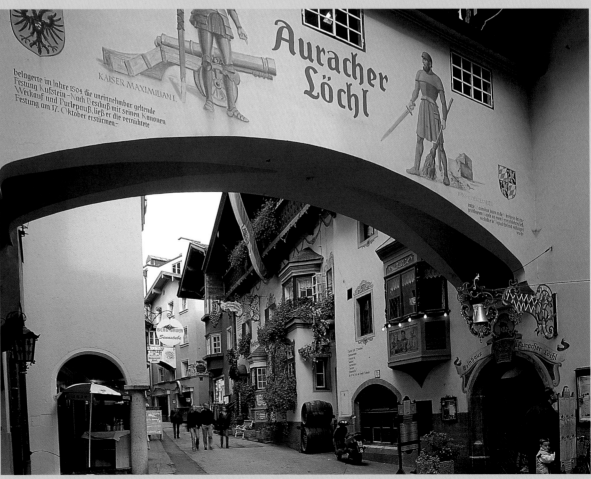

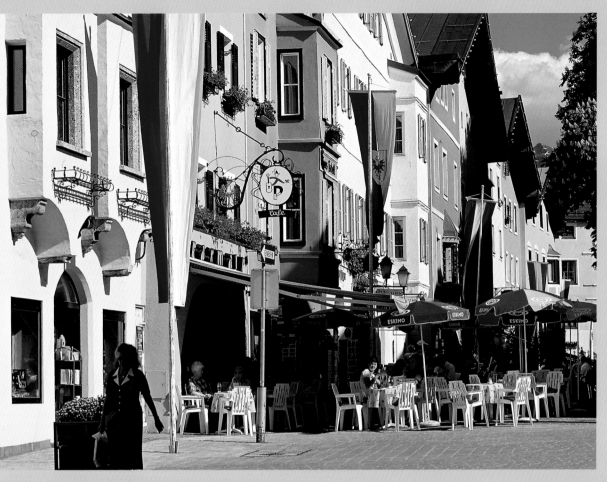

Left:
At the intersection of
St Johann in Tyrol and Pass
Thurn is Kitzbühel, whose
centre consist of two long
streets named Vorderstadt
(upper town) and Hinterstadt
(lower town). Many examples
of Lower Inn Valley architec-
ture have been preserved
here.

Below:
A few miles south of Inns-
bruck Schloss Ambras rises
up above the Inn Valley,
the present palace erected
on the ruined castle of the
counts of Andechs which
was destroyed in 1133. In the
16th century Ferdinand II had
the fortress refurbished as a
place of residence for his
wife Philippine Welser.

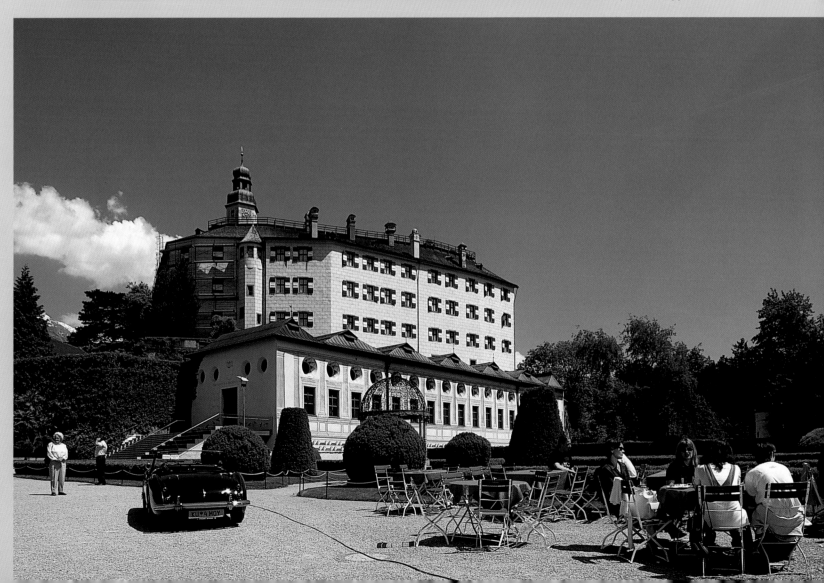

Below:
From the Stadtturm in the heart of old Innsbruck you look down to the end of Herzog-Friedrich-Straße with its arcades and late Gothic oriel adorning the Neuer Hof,

its famous Golden Roof sparkling in the sunlight. Refurbished in 1822, the former home of Innsbruck's royalty is now the Maximilianeum Museum.

Top right:
With the impressive Karwendel acting as a backdrop, Maria-Theresia-Straße is lined with magnificent buildings from the 17th and 18th centuries. Among them is the high

baroque palace of the Altes Landhaus, built between 1725 and 1728 by Georg Anton Gumpp and now the seat of the provincial government of Tyrol.

Centre right:
The summit of Serles Mountain peaks out over the top of the monumental arch at the end of Maria-Theresia-Straße.

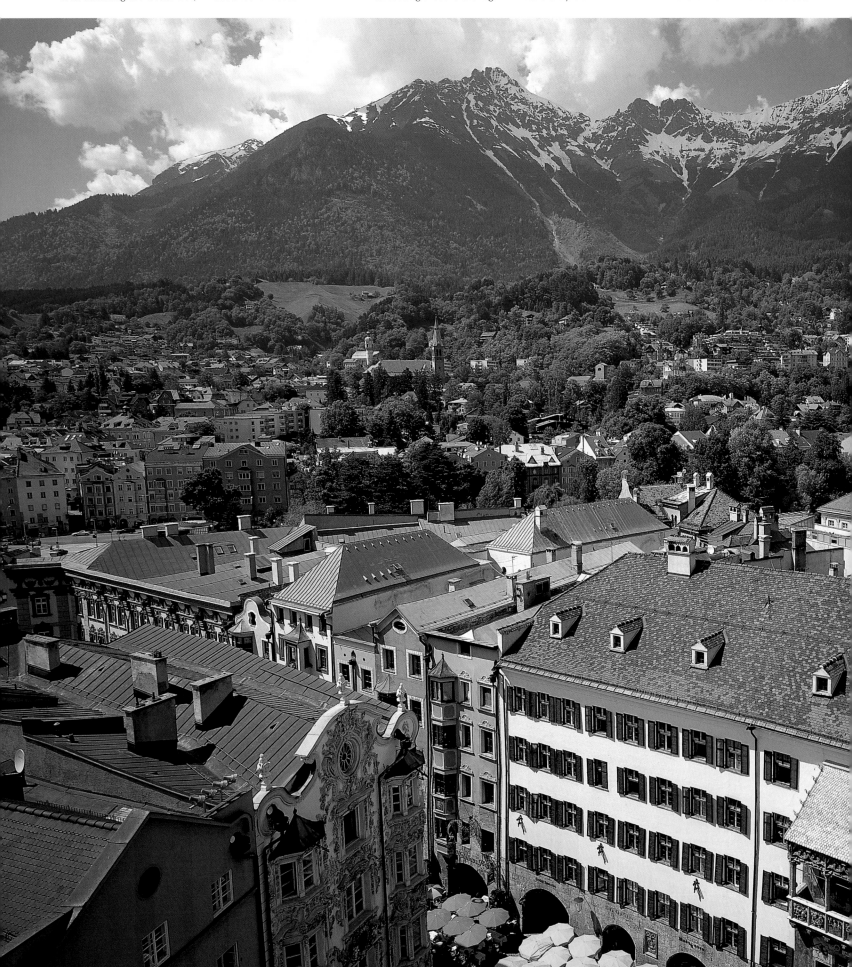

Bottom right:
At the request of Emperor Maximilian I this splendid oriel was built as a spectator's loggia on Stadtplatz in the late 15th century, its Golden Roof tiled with no less than 2,738 gilded copper shingles.

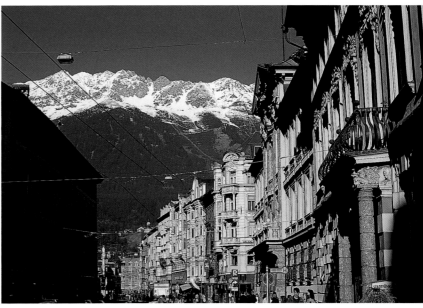

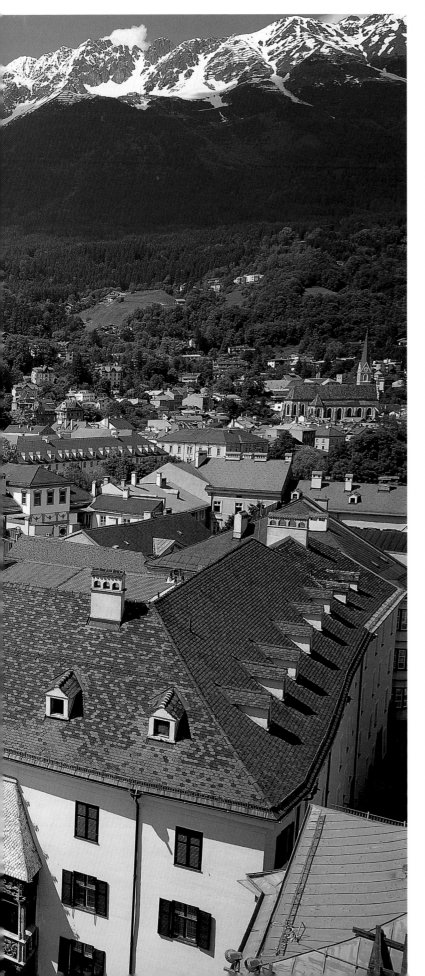

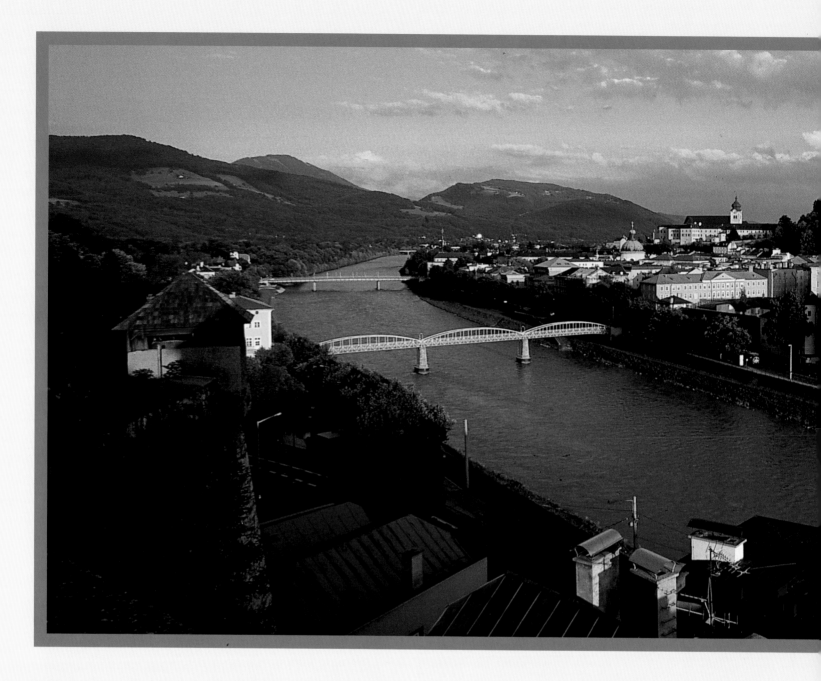

SALZBURG AND UPPER AUSTRIA, STYRIA AND CARINTHIA – THE HEART OF AUSTRIA

The south of the province of Salzburger Land is characterised by the broad valley of the Salzach River running from west to east from the Kitzbühel Alps through the Pinzgau. In the Pongau the once meandering rapids make a sharp 90° turn north towards Salzburg, later forming the boundary to Germany and flowing into the Inn at Burghausen. Once the ca. 225 kilometres (140 miles) of river have mastered the narrow confines of Pass Lueg the hinterland of Hallein and Salzburg opens out onto Alpine foothills.

This stretch of Austria, sheltered on almost all sides by mountains, has the provincial capital of Salzburg as its historic and political centre,

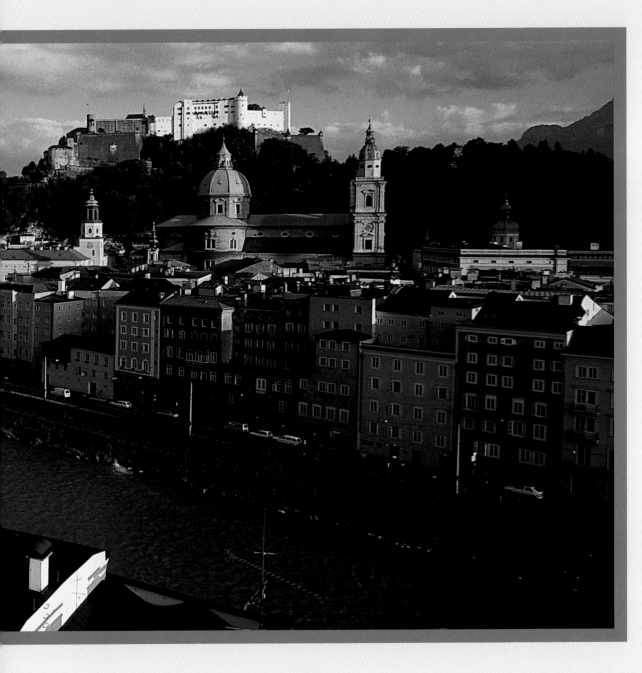

From the top of the Kapu-zinerberg there are grand views out south over the Salzach River, old Salzburg and the impenetrable fortress of Hohensalzburg. The provincial capital has ca. 146,000 inhabitants and attracts ca. 6.9 million visitors a year.

where for over 1,000 years – until its secularisation in 1803 – the archbishop held sway, keeping Salzburg safe from the clutches of the Habsburgs for the longest period in their history. The roots of the city go back to the New Stone Age, with the Celts discovering an early settlement here; this was later occupied by the Romans and given the name Juvavum. As elsewhere in the Danube region, after the Romans retreated in the 5th century AD the area fell into a steady state of decline before a new period of development was heralded by the founding of two monasteries in c. 700. In 798 the city of what was now Salzburg was made an archbishopric which it has remained to this very day.

A UNIQUE ARCHITECTURAL ENSEMBLE

Thanks to heavy investment on the part of the archbishops and hard work on the part of its citizens Salzburg today is a unique architectural ensemble dominated by the fortress of Hohensalzburg, splendid churches, medieval town houses and magnificent promenades along the river front. Also the venue of the famous Festspiele, Salzburg's Italianate flair is partly down to Archbishop Wolf Dietrich von Raitenau (1587–1612), who was brought up in Rome and initiated the building of many of the city's baroque edifices.

57

The Pasterze Glacier, the largest in the eastern Alps seen here from Franz-Josephs-Höhe, is a truly magnificent sight. Yet over the past 150 years the glacier on Großglockner Mountain has gradually receded – by as much as 32.5 m (107 ft) from 1997 to 1998. Legend has it that the glacier was once fertile Alpine pasture which God subjected to terrible storms and turned to ice to punish its sinful inhabitants.

To the east and southeast of Salzburg lies the lake district of the Salzkammergut with the celebrated spa of Bad Ischl once frequented by the Austrian emperor, now part of Upper Austria. The third-largest of the country's provinces borders on Bavaria with the Salzach and Inn rivers; north of the Danube the region stretches as far as the Czech Republic. Neighbours to the south and east are Styria and Lower Austria. The scenery gradually settles from the northern limestone Alps with the Dachstein Massif and the Ennstal Alps to undulating Alpine foothills, with the Innviertel petering out into the valley of the Danube. On the other side of the river is the wooded Mühlviertel sandwiched between the Bavarian Forest and the Waldviertel, the latter part of the Bohemian granite massif.

During the Middle Ages the Danube Valley between Passau and Linz, where the river squeezes its way through several narrow gorges, was exposed to a number of cultures. The influence of the duchy of Bavaria spread well into the east and south, with Duke Tassilo III founding several monasteries of missionaries before being deprived of power by Charlemagne. Linz, with its church dedicated to St Martin from the 8th century, fell to the Babenbergs in c. 1205 yet remained under the authority of the bishopric of Passau until 1784. Linz, Roman Lentia, whose name means „settlement on the bend in the river", is today the third-largest city in Austria and provincial capital.

FROM THE DACHSTEIN TO THE LOWER TAUERN

In the heart of Austria, spreading as far as the Slovenian border in the southeast, is Styria, an area of farming and mining. From the Dachstein in the northeast to the Lower Tauern to Bad Radkersburg in the far southeast the land drops almost 2,800 metres (9,186 feet) in altitude. Austria's second-longest river, the Mur, follows a similar course, covering almost 350 kilometres (220 miles) from its source at Lungau in the pro-

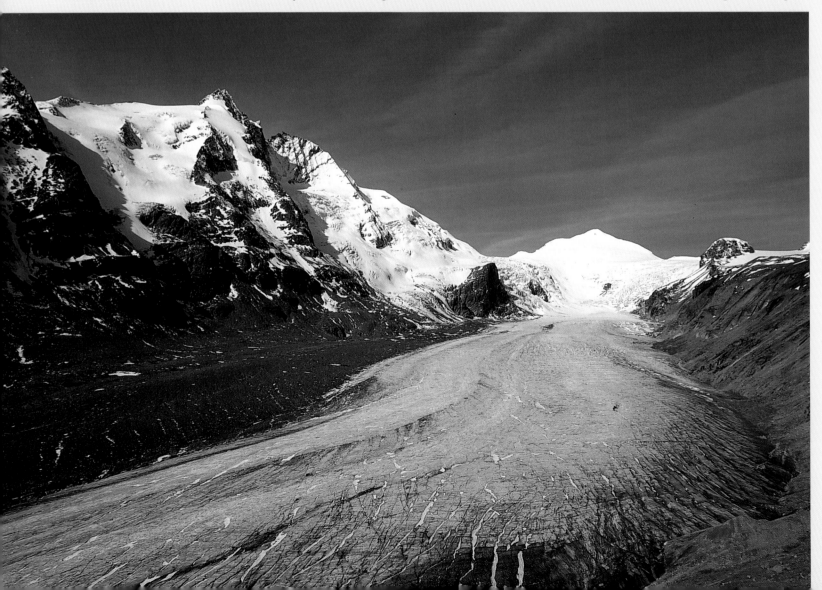

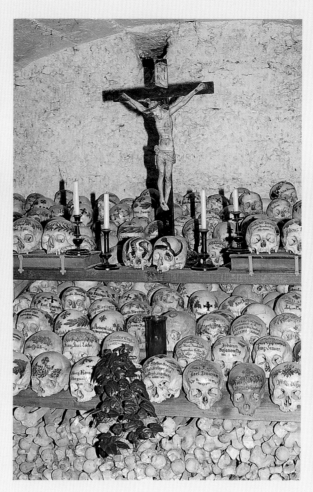

Left:
Behind the Gothic parish church of St Michael's in Hallstatt is a charnel house containing ca. 1,200 skulls and bones, many of them richly ornamented. Locals began storing the mortal remains from the graves in the churchyard here in 1600.

vince of Salzburg to Bad Radkersburg, finally merging with the Drava. At Bruck an der Mur the river bends south, curving through a narrow valley before reaching Graz, Styria's regional capital.

ITALIAN ARCHITECTS IN STYRIA

Styria (or Steiermark in German) gets its name from the Traungau dynasty from Upper Austria's Steyr who governed a number of frontier zones here during the 10th century. After the Traungauer had died out in 1192 the region came into the possession of the Babenbergs. Under Habsburg rule Styria was part of Inner Austria, falling into the hands of various collateral lines until in 1619 Emperor Ferdinand II reunited the Inner Austrian and Danube branches of the family. From the 16th century onwards many of Styria's major cities were gradually fortified in an attempt to deter Turkish incursions. The Italian architects brought to the area for this purpose also left their mark on the non-military buildings of Styria's bourgeoisie and aristocracy.

THE ALPS OF CARINTHIA

Between Tyrol and Styria in the south of Austria is Carinthia, a region riddled with lakes and surrounded by mountains, from the Großglockner and the Lienz Dolomites in the west to the Carnic Alps and Karawankas in the south to the giddy precipices of the Saualpe and Koralpe in the east. The main ridge of the Alps shields the entire area to the north. The River Drava is another of Carinthia's distinguishing features, flowing east through the province from the Puster Valley and eventually running into the Danube. This natural waterway once enticed Celtic settlers to the area. They were followed by the Romans and then Slavonic immigrants who primarily set up home in the Klagenfurt Basin. The ancient Slovene principality of Carantania was long able to cling to its independence in the tussle for power between Bavarians, Franks and Avars, only losing its autonomy under Frankish administration after years of conflict. Made a duchy in 976, Carinthia fell to the Habsburgs as late as 1335.

Above:
Austrian composer Ralph Benatzky made the Weißes Rössl famous with his operetta of the same name premiered in Berlin in 1930. The romantic hotel clings to the northeastern shores of Lake Wolfgang, southeast of Salzburg, its history dating back to a tavern set up here in 1878.

Top left:
Beyond Passau and the provincial border to Upper Austria the Danube squeezes its way round a narrow bend before meandering on to Linz. Cyclists can cross the river here by ferry.

Below:
On the left bank of the Salzach, at the centre of Salzburg's old town, Mozartplatz and Residenzplatz form a harmonious ensemble, with the cathedral on the south side of Residenzplatz, the former residence of the archbishop to the west, the church of St Michael's opposite the cathedral and, looking out onto Mozartplatz, Café Glockenspiel.

Top right:
Much of the residential palace in Salzburg was built between 1596 and 1619. The audience chamber on the second floor is fitted out with Flemish tapestries and Parisian furniture.

Centre right:
Archbishop Wolf Dietrich von Raitenau had Schloss Mirabell erected for his mistress Salome Alt; the gardens were added in c. 1690.

From 1721 to 1727 the palace was refurbished in baroque; it burnt down in 1818 and was later rebuilt in its present neoclassical guise.

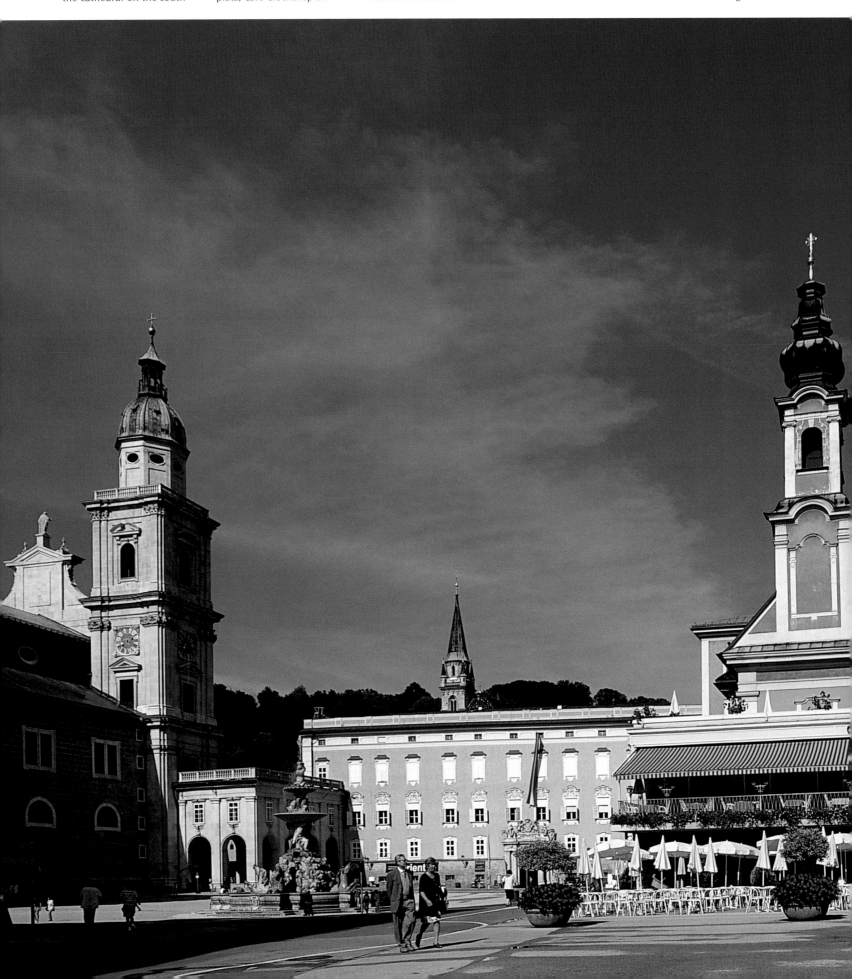

Bottom right:
Not far from Salzburg is
Schloss Hellbrunn, built bet-
ween 1612 and 1615 in the
style of the early baroque
by Santino Solari for prince-
archbishop Markus Sittikus
von Hohenems. The ballroom
of the palace is sumptuously
decorated with magnificent
mannerist frescos.

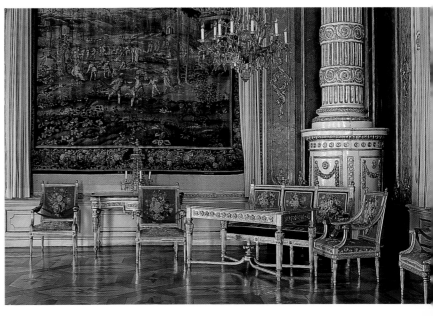

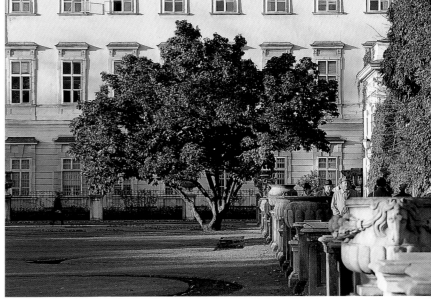

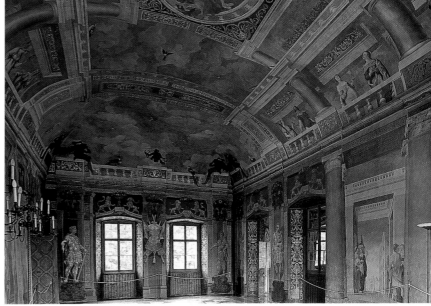

61

Right:
A few miles northwest of Salzburg is baroque Schloss Kleßheim, built from 1700 to 1709 from plans drawn up by Johann Bernhard Fischer von Erlach. The palace is now a casino.

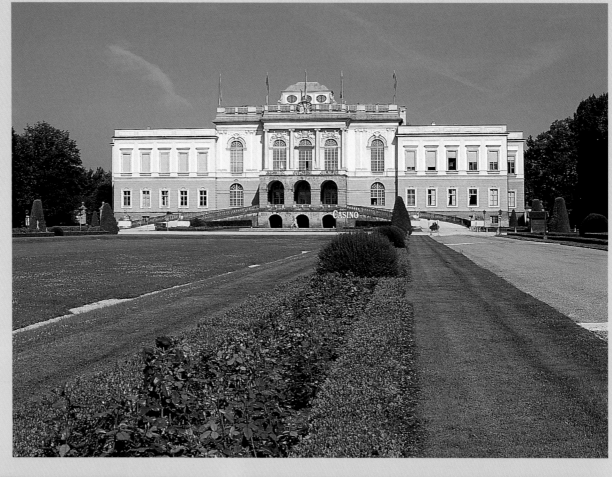

Below left and right:
On the hill at Schloss Hellbrunn, abundant in water with its many springs, an Italianate park was laid out whose famous fountains make good use of the natural resources. Many mythical figures adorn the gardens, among them Neptune, god of the sea, in his watery grotto (right).

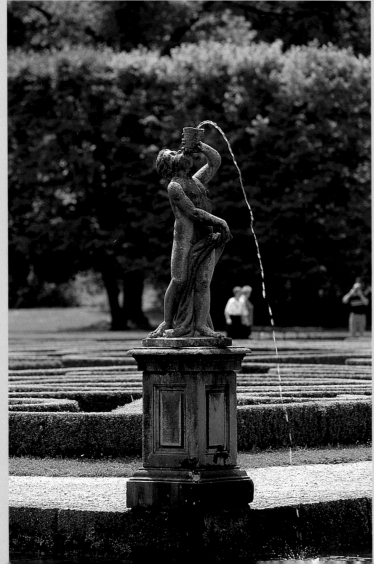

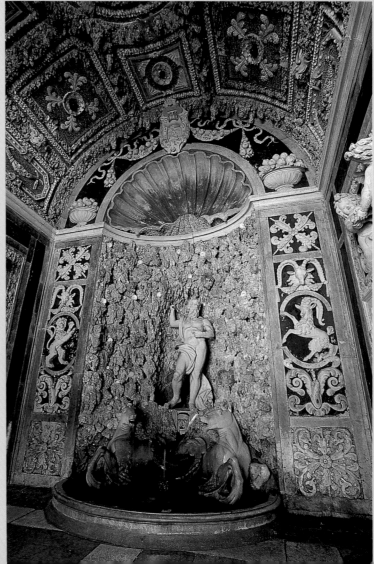

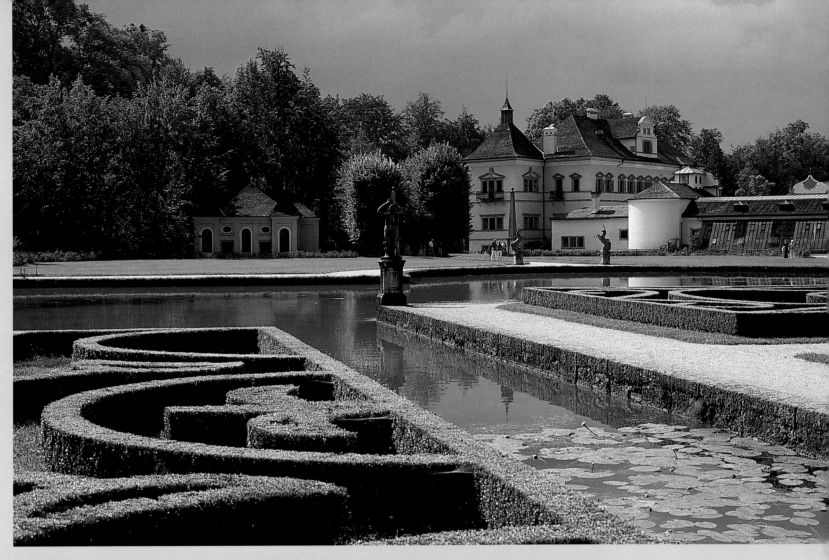

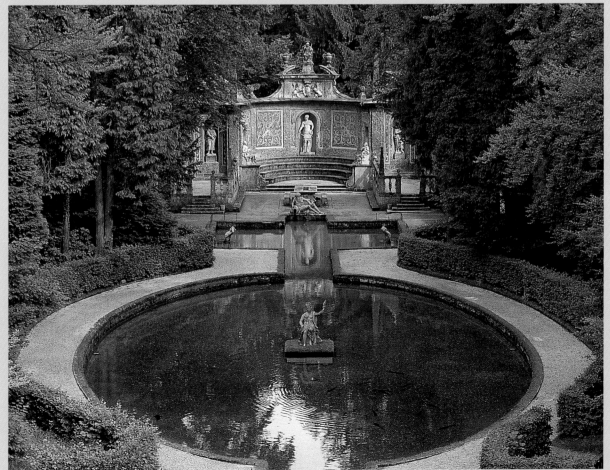

The spacious park surrounding what has been called "the most beautiful palace north of the Alps", Schloss Hellbrunn, is full of surprises; figures squirting water, Turkish fountains and statues of gods and heroes mirror the tastes of the 17th and 18th centuries. In the Roman Theatre (below) hidden jets of water used to shoot out of the stone seats, giving the archbishop and his unsuspecting guests a light sprinkling.

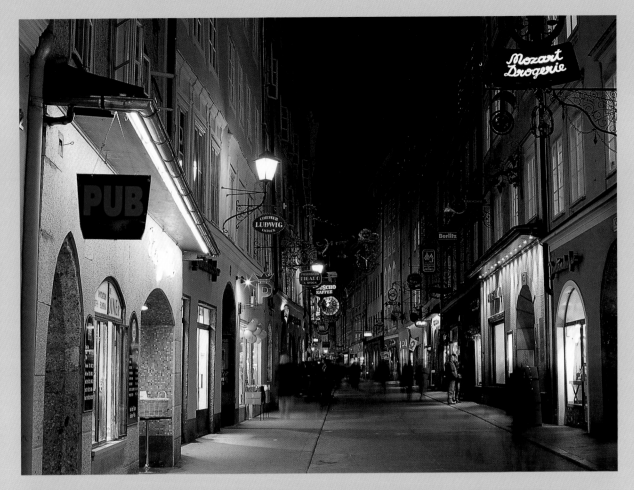

Left:
Atmospheric moments in old Salzburg: an alleyway leading off from Getreide-gasse bathed in lamplight.

Getreidegasse with its many shops, boutiques and town houses from the 15th to 18th centuries, so busy during the day, is completely deserted at night.

The Dutch stove in the Golden Chamber of Hohen-salzburg Fortress is from 1501, when Archbishop Leonhard von Keutschach had the castle rebuilt and refurbished.

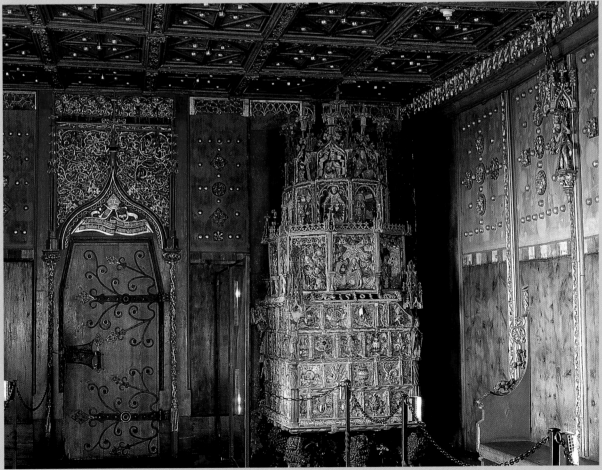

THE MYSTERY OF GENIUS –
WOLFGANG AMADEUS
MOZART

"For us, Mozart will remain eternally silent, eloquent only in diversion and expressive only in his works which he has speak of many things other than their creator." (Wolfgang Hildesheimer)

Although a lot has been written by and about Mozart, such as his letters and various contemporary documents which have survived the centuries, much of the life of this extraordinary man

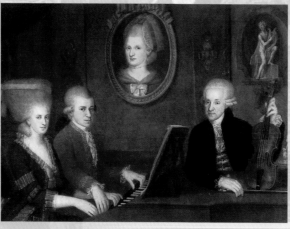

Above:
At the age of 21 Mozart had his portrait painted in Salzburg as a knight of the Order of the Golden Spur. Not long afterwards he quit his post at the episcopal palace and left the city.

Above right:
This family portrait, painted in c. 1780, depicts Nannerl and Wolfgang at the piano, Leopold holding his violin and a picture of the children's mother who died in 1778.

remains a riddle. Mozart's demise in particular is shrouded in mystery, with neither his place of death nor the cause of his untimely end known to us. The study of recorded symptoms and lists of medicines has prompted around 150 possible diagnoses to have been made as to the cause of death, with suspected trichinosis the most recent; not so long ago an American immunologist suggested that the consumption of pork schnitzel was responsible for Mozart's contracting the fatal disease which ended his life on 5 December 1791.

FALL FROM GRACE AND FINANCIAL RUIN

In the year preceding his death the "imperial court composer" lived a life of seclusion on the verge of financial ruin. The Vienna of Emperor Joseph II, where Mozart had lived since 1781 and was at first much celebrated – particularly with the premiere of his "Entführung aus dem

Serail" in 1782 – brought him increasingly bad fortune. Shunning convention more and more in his later years, the musical genius found himself with neither a steady income nor a generous patron and slowly slithered down the social ladder.

THE CELEBRATED CHILD PRODIGY

Born on 27 January 1756 in Salzburg, child prodigy Mozart had performed for enthusiastic gatherings of the nobility at the tender age of six, together with his 11-year-old sister. Pushed by an ambitious father, the young musician mastered both the tough training of his guardian and an exhausting schedule of concert tours with apparent ease. He initially fulfilled the wishes of father Leopold, who was in service to the archbishop, when in 1769 he was made "Konzertmeister" to the archbishop of Salzburg – albeit without payment. Mozart escaped the constraints of his post and his native city by embarking on numerous journeys yet his search for a position with prospects remained fruitless. In 1781 Wolfgang Amadeus eventually resigned in Salzburg, travelling to Vienna and finally breaking with his father when in 1782 he married Constanze Weber against Leopold's will.

Despite the often chaotic and seemingly disastrous state of Mozart's life and his allegedly frequent infantile and eccentric quirks of nature, his musical prowess steadily developed. The Köchelverzeichnis, which lists over a staggering 600 works, is probably far from complete.

It illustrates that Mozart's compositions followed on from one another in quick succession, with his creativity peaking in the years between 1784 and 1787. His manuscripts are also surprisingly devoid of corrections; the composer had already completed the work in his mind before putting pen to paper, a task he found extremely onerous by his own accounts. Yet as brilliant as he was, the following words of Wolfgang Hildesheimer, taken from his biography of Mozart, hold a certain truth: "Rational contemplation was not in Wolfgang's power. Right from the beginning he was destined to be the cause of his own ruin."

eburtshaus

Centre:
Leopold Mozart lived at no. 9 on Getreidegasse on the third floor from 1747 to 1773. The house was dedicated to his famous son in 1880.

Left:
This shop window on Salzburg's Alter Markt displays variations on a bestseller; in 1890 local pastry cook Paul Fürst created his famous "Mozartkugel" in marzipan, hazelnut nougat and plain chocolate.

Below left:
One of Mozart's last manuscripts. The death of the genius remains shrouded in mystery; was it a bad bout of flu, rheumatic fever, kidney failure or trichinosis?

Below:
In St Gilgen on Lake Wolfgang, where Mozart's mother Anna Maria Pertl was born, a bronze figurine keeps the memory of the great composer alive.

Below:
Narrow Judengasse with its
excellently preserved town
houses is one of the main
shopping streets in Salzburg
and leads to Mozartplatz.

Below:
On Salzburg's Alter Markt
in the old town stands the
smallest house in the city.
The square was laid out at
the end of the 13th century.

Right:
Salzburg's big yearly event is
the festival which takes place
from the end of July to the
end of August. The main Fest-
spiele venues are now on
Hofstallgasse (top left), where
the palace stables stood in
the 17th century, and on
Max-Reinhardt-Platz. The
Großes Festspielhaus was
built between 1956 and 1960
by Clemens Hofmeister and
has five bronze doors for con-
cert-goers which open out
onto Hofstallgasse. Hugo von
Hofmannsthal, Max Reinhardt
and Richard Strauß were
among the founders of the
festival which was launched
on 22 August 1920 with a
performance of "Everyman"
on the cathedral square.
Since then Hofmannsthal's
"play about the death of
a rich man" has become a
permanent fixture in the
Festspiele repertoire (top
right, centre left, bottom
right). Works by Mozart are
naturally also often featured,
such as this staging of his
opera "La Clemenza di Tito"
which was premiered in
Prague in 1791 (centre right,
bottom left).

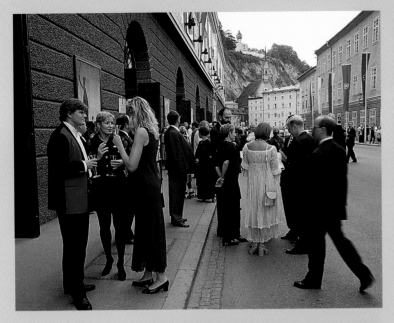

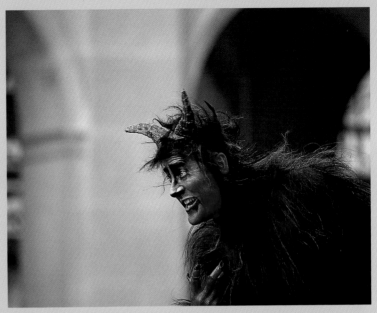

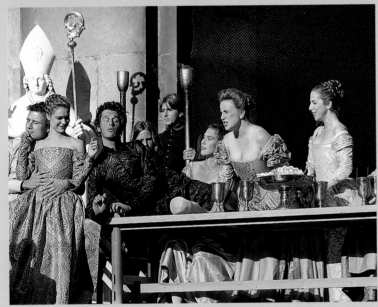

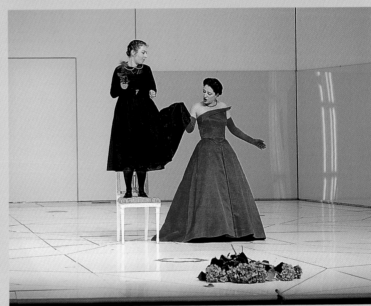

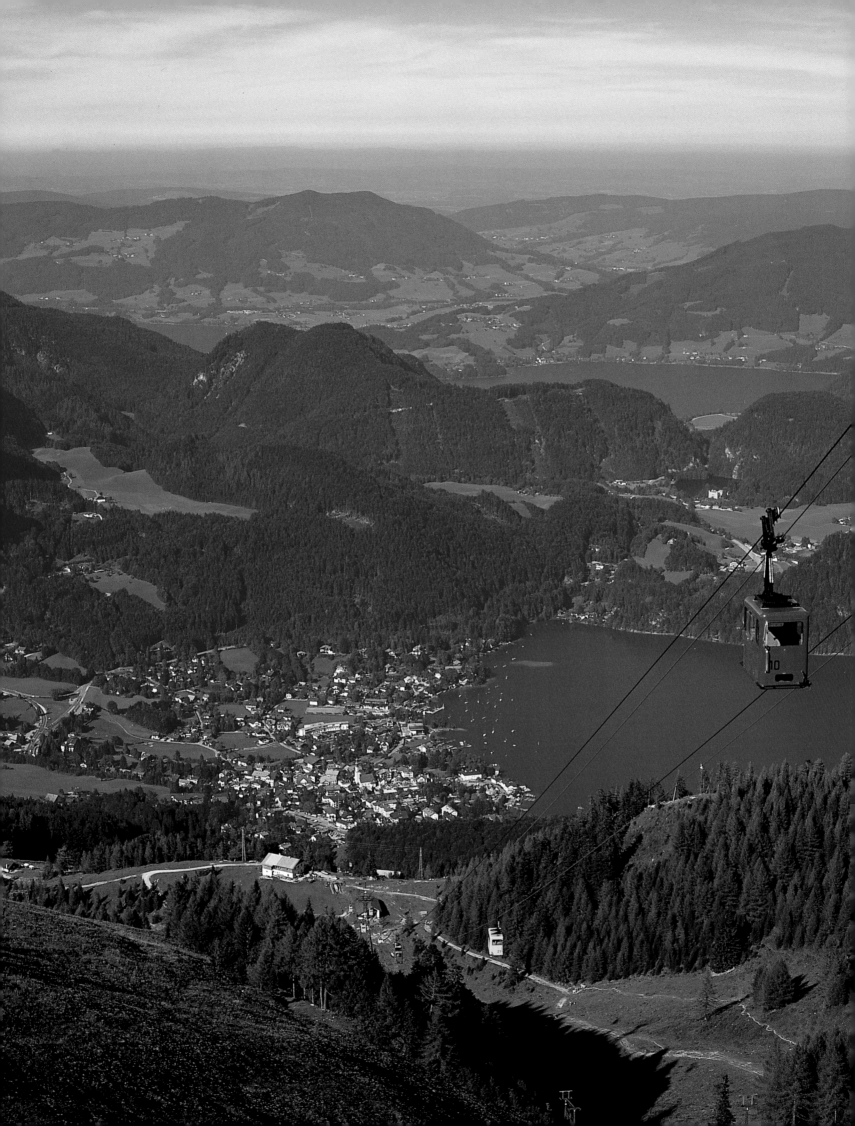

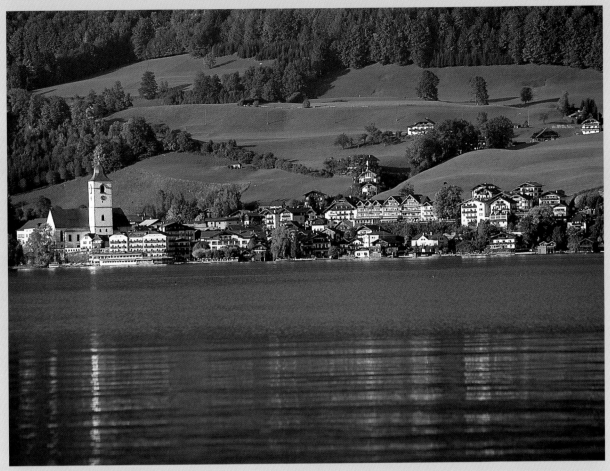

Left:
Lake Wolfgang or Abersee is
10 km (6 miles) long, 2 km
(ca. 1 mile) wide and up to
114 m (374 ft) deep. At the
western end of the lake is
St Gilgen and the Zwölfer-
horn which can be reached
by cable car.

Opposite St Gilgen is the
ancient pilgrimage town
of St Wolfgang, tucked in
between the lake and Schaf-
berg Mountain. The late
Gothic parish church is also
dedicated to St Wolfgang,
the patron saint of shepherds
and carpenters.

One of the over forty small
lakes dotted about the Salz-
kammergut is Lake Fuschl,
northwest of Lake Wolfgang,
whose wooded shores have
been made a natural conser-
vation area.

71

Right:
Despite its relatively modest elevation of 1,783 m (5,850 ft) the Schafberg, rising up above the Wolfgangsee, Mondsee and Attersee lakes, boasts fantastic panoramic views. On a clear day – and with a strong pair of binoculars – it is said that you can see the onion domes of Munich's Frauenkirche from the top.

South of St Wolfgang in the Salzkammergut stretches the largest compact area of Alpine pastureland in Austria, the Postalm, which is extremely popular with hikers.

The rack railway travelling up Schafberg Mountain via the Schafbergalm from St Wolfgang was opened in 1893. The track is 5.8 km (3.6 miles) long and reaches an altitude of 1,732 m (5,683 ft).

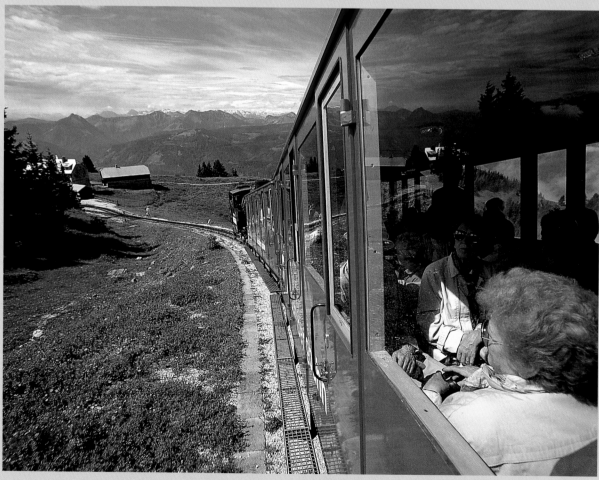

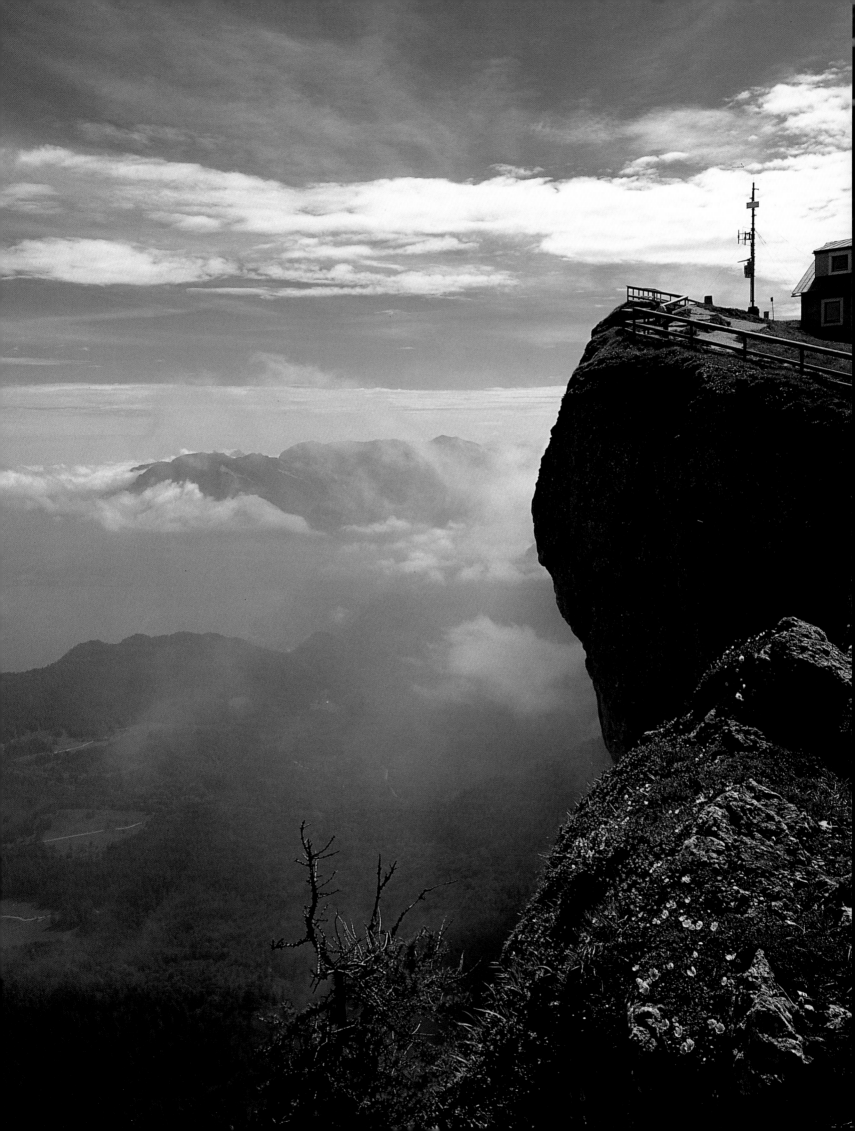

The Pinzgau stretches from the upper Salzach Valley to the Gastein Valley. At the far end of the wide vale is the village of Wald im Pinzgau with its ancient farmhouses.

In Oberndorf northwest of Salzburg tradition on Corpus Christi requires local skippers and the "protectors of the host" to row out onto the Salzach to deliver their consecrated offerings to the river.

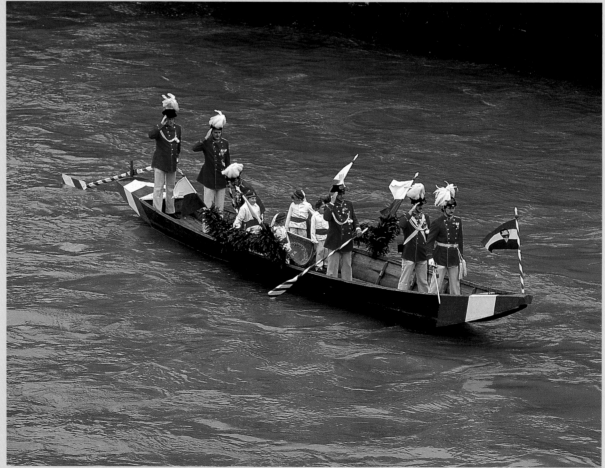

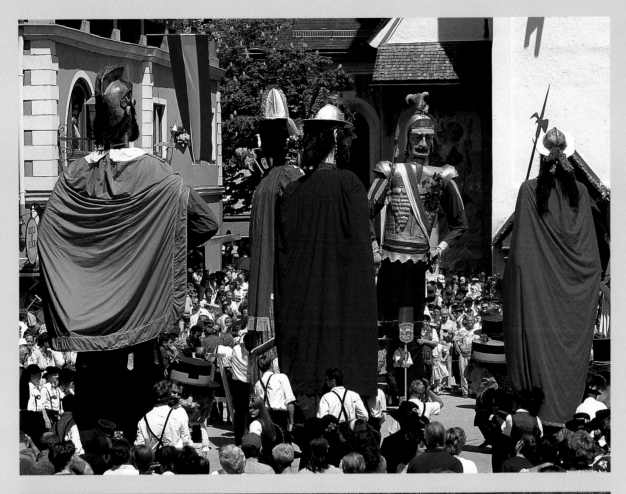

On Corpus Christi and various other occasions the market town of Mauterndorf in the Lungau puts on a "Samson-treffen", a procession of giant figures said to be symbols of fertility, flanked by two dwarves.

St Margarethen in the Lungau lies 1,064 m (3,491 ft) above sea level south of the River Mur. The village probably dates back to an early settlement erected close to a Roman watchtower on the alluvial fan of the Leißnitz-bach.

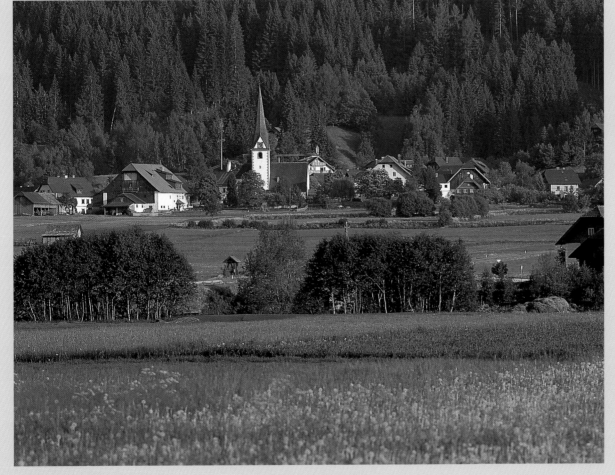

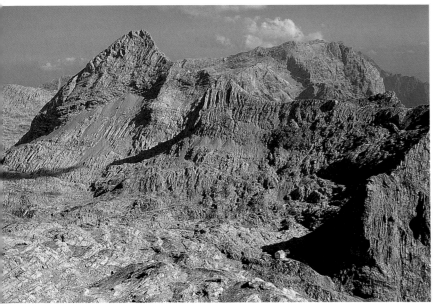

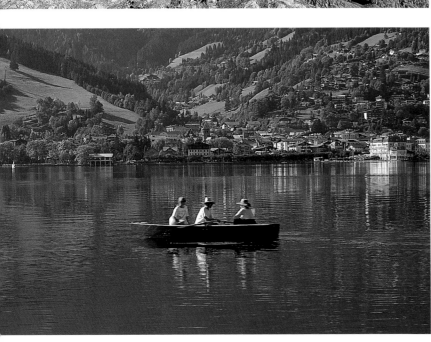

Top left:
Krimml lies at the end of the lower Salzach Valley at an altitude of 1,076 m (3,530 ft). From the end of the village you can walk along breath-taking cascades up to the upper falls of the Achen in less than two hours.

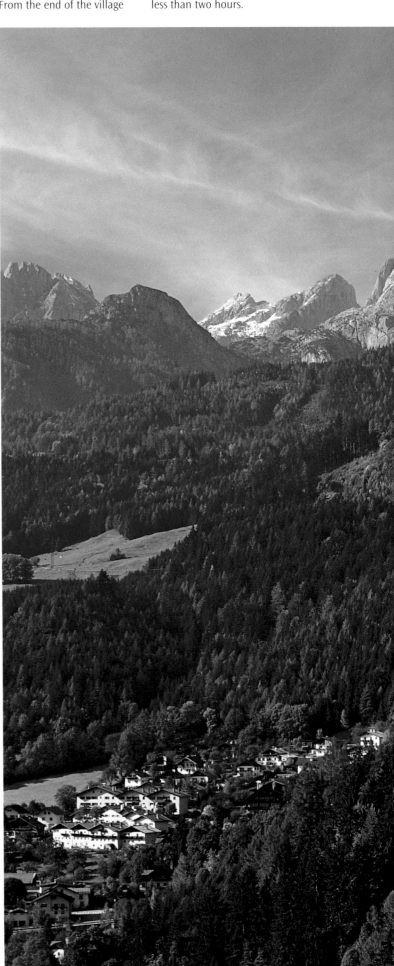

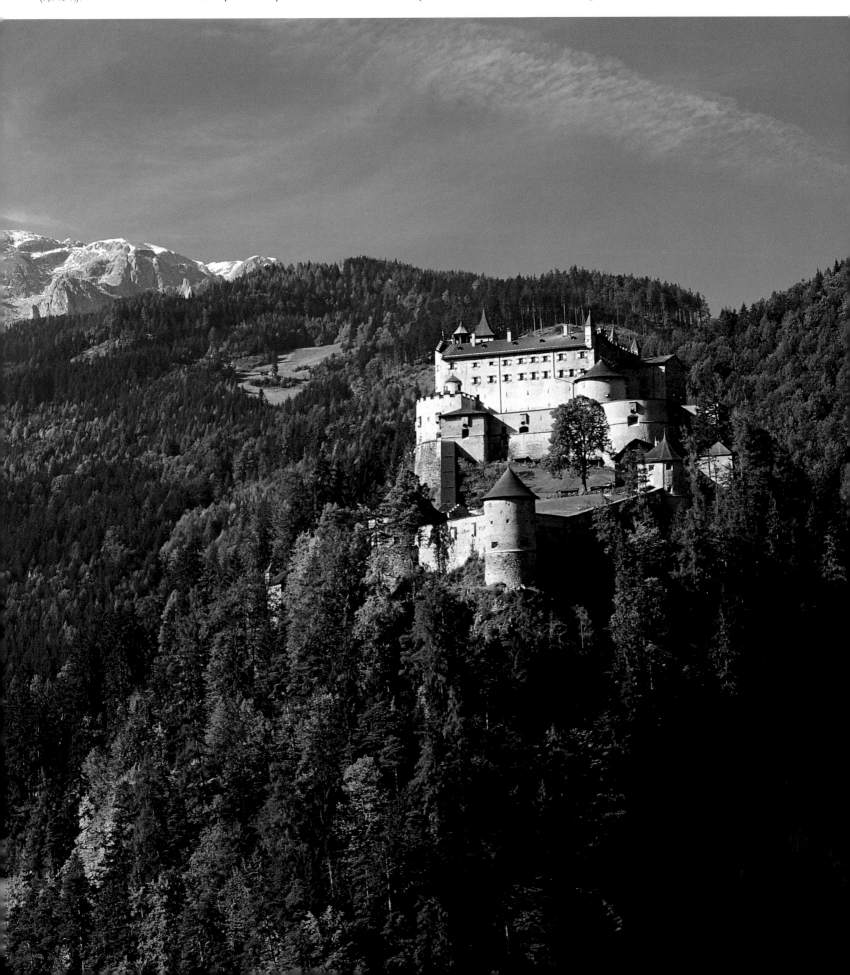

Centre left:
Above Saalfelden in the Pinzgau is the Steinernes Meer, a high-lying karst plateau, at the west end of which is the Riemannhaus at 2,177 m (7,143 ft).

Bottom left:
Lake Zell is up to 68 m (223 ft) deep, the quality of the water legendary among the divers who explore its depths.

On the western shores, where the Schmittenbach flows into the lake, the regional capital of Zell am See juts out into the water like a peninsula.

Below:
The Pongau stretches from the Gastein Valley to the rise of the Salzach between the Hagen and Tennen mountains. Near Pass Lueg above the Salzach River is Hohenwerfen Fortress, built in 1077 by Archbishop Gebhard. It took on its present form in the 16th century.

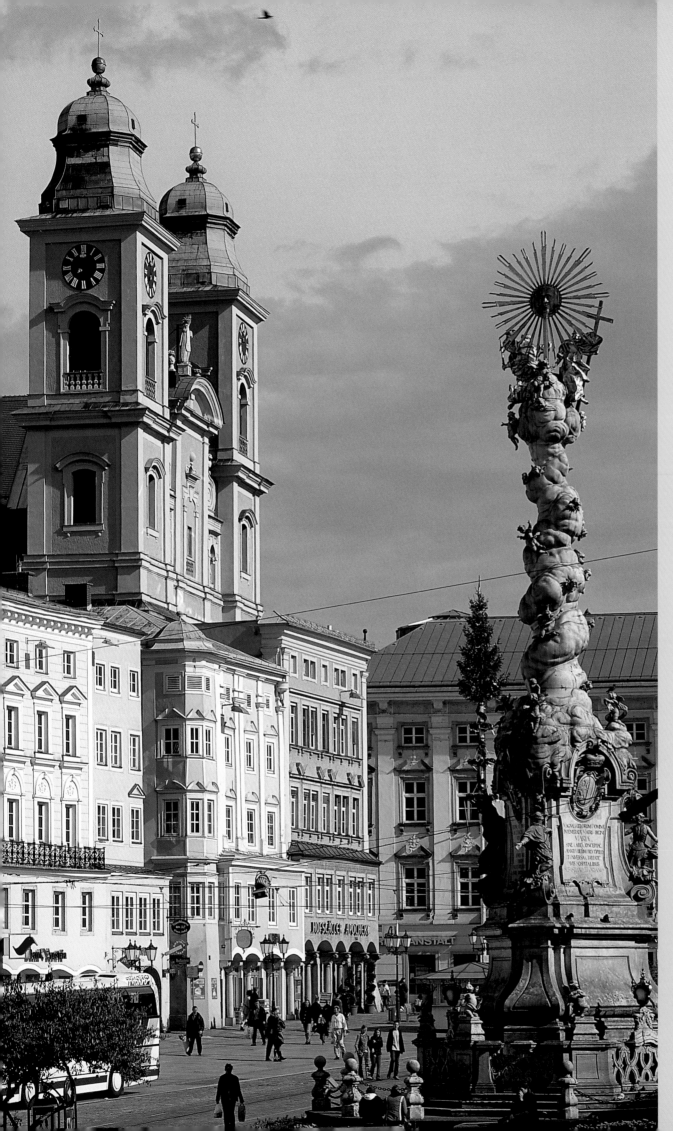

Left:
In 1723 the citizens of Linz gave thanks for the fact that their city had been spared war and the plague by erecting a pillar dedicated to the Holy Trinity on the main square. The pillar is 20 m (66 ft) tall and made of Untersberg marble. Behind the houses lining the east side of the square rises the steeple of the Ignatiuskirche or "old cathedral", built between 1669 and 1678 in the baroque style of the Jesuits.

Right:
The town of Steyr evolved in c. 1000 at the confluence of the Steyr and Enns. Opposite the old town, on the north banks of the Steyr, Jesuits built the parish church of St Michael's between 1635 and 1677. Next to it stand what were once the local hospital and hospital chapel.

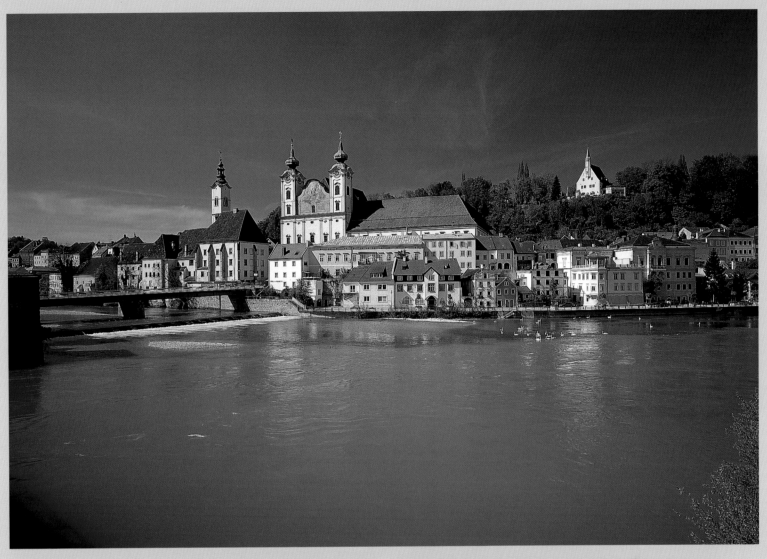

Freistadt in the lower Mühl-viertel is near the Czech bor-der on an ancient trade route leading to Prague. The mighty keep of the town's 14th-cen-tury castle juts out above the facades of the elegant houses lining the main square.

Salome Alt, the mistress of the Salzburg archbishop Wolf Dietrich von Raitenau, moved to Wels on the River Traun after the father of her 15 children died as the result of a bad fall in 1611. She her-self lived until 1633 in this richly ornamented house known as the Hoffmannsches Freihaus.

Right:
Hallstatt is worth visiting
for its spectacular lakeside
setting alone, clinging to the
northern slopes of the Hoher
Dachstein. Like most of the
other lakes in the Salzkam-
mergut, Lake Hallstatt fills
an ice-age basin formed by
the Traun Glacier. The town
is famous for its archaeologi-
cal finds from the early days
of salt mining.

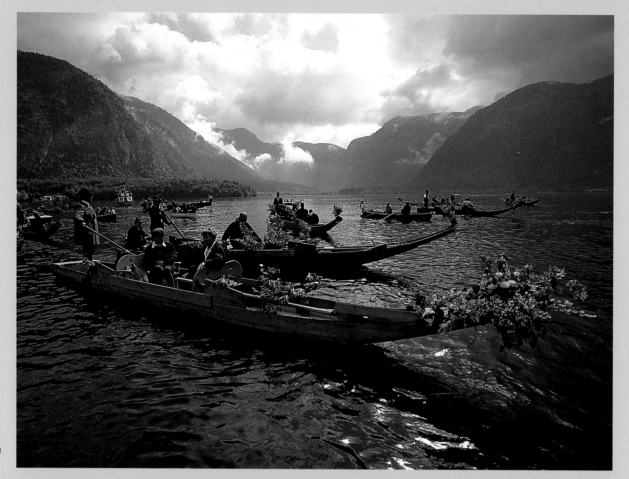

On the second Thursday after
Whit boats glide across Lake
Hallstatt in the Salzkammer-
gut in a traditional procession
celebrating Corpus Christi.

Lake Hallstatt, through
which the River Traun flows,
is up to 125 m (410 ft) deep.
The houses of Hallstatt
crowd the lakeside shores
at its southwestern end.

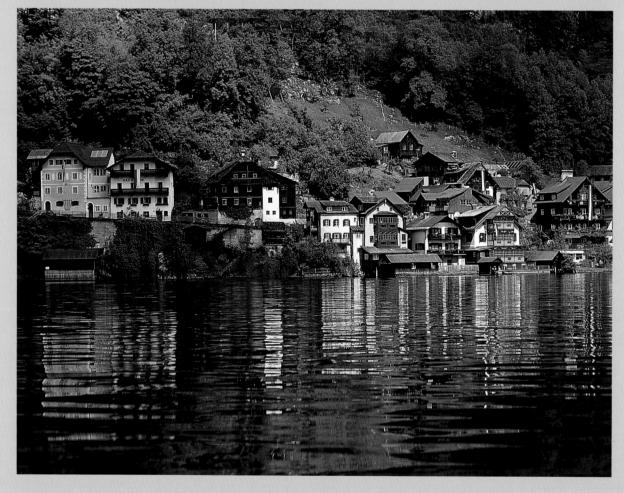

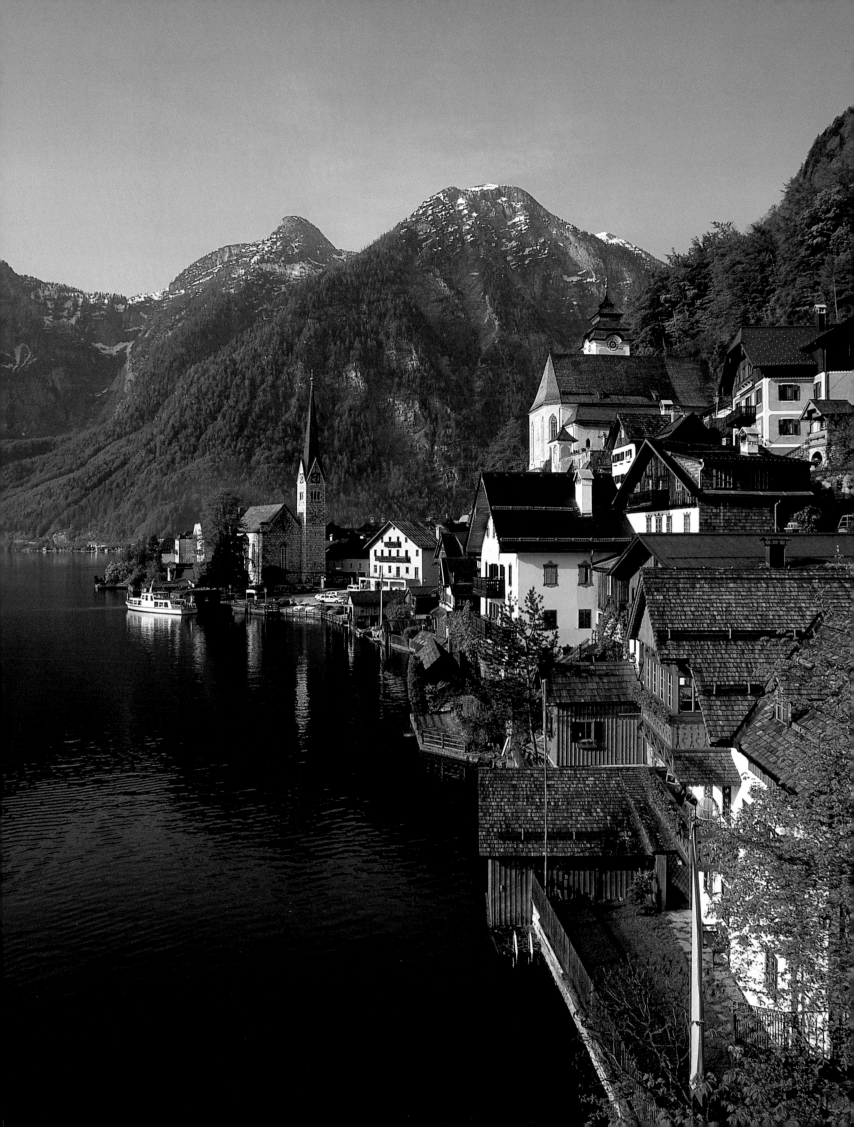

RELICS FROM AN ANCIENT AGE –
THE HALLSTATT PERIOD

Below:
Among the artefacts found among Hallstatt's graves were richly ornamented bronze vessels and pots, jewellery and weapons.

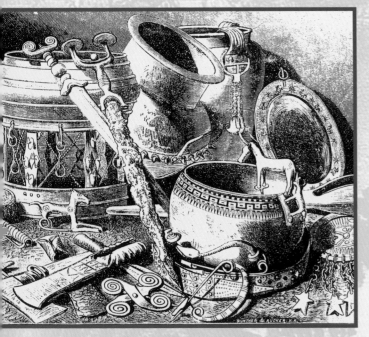

In the Salzkammergut in Upper Austria the little town of Hallstatt clings to the rocky shore of a glittering lake. Sleepy and seemingly insignificant, this romantic spot is in fact of great prehistoric importance, giving rise to the term the Hallstatt Period; "hal" is Middle High German for "salt source" and refers to rich deposits of the mineral found in this area. Here on the northern slopes of the Dachstein Massif, where Austria's largest salt mine is now situated, people have been mining salt since the late Bronze Age (post-1000 BC) in galleries 17 metres (56 feet) wide and up to 215 metres (705 feet) deep. This incredible feat of engineering suggests that the indigenous population had access to extremely efficient tools and techniques. Excavations in the ancient mines have unearthed several types of wooden implements and pieces of clothing made of leather and cloth which have been preserved by the very commodity their one-time owners were attempting to extract.

Extremely lucrative and highly prized, from the 5th century BC onwards the precious mineral was transported via a number of trade routes to the Adriatic, the Black Sea, the North Sea and France.

HALLSTATT A–D AND THE URNFIELD CULTURE

Hallstatt's extensive trade relations made it the exponent of a culture which stretched from the northeast of France to the northwest peninsula

of the Balkans, dating back to the 7th to 5th centuries BC and the Iron Age. Researchers refer to this section of the period as Hallstatt C, with Hallstatt D beginning in c. 600 BC. A and B designate the centuries preceding these which overlap with the Urnfield Culture or early Bronze Age. A distinction is also made between the West and East Hallstatt Period, with Hallstatt itself part of the latter. It has been proved that both the Etruscans and the Greeks influenced the development of this culture, as did the connections its peoples had

with northern Europe, evident in the many finds of amber.

Important information on the culture of Hallstatt has been gleaned from the famous burial site here where excavation began in 1846 and where over 2,000 people were either cremated or buried, many with their personal belongings. The upper strata of society is thought to have been represented by noble warriors with their own fortified residences, the members of which were buried with helmets, armour and even their

horses, complete with bronze girdle mounts, demonstrating how important these animals were for work and transportation. Crafts, such as pottery (vessels were decorated with geometric patterns) and bronze worked on lathes, were highly developed. Conclusions can be drawn as to the religious and spiritual ideals of the people of the time from excavated sculptures of animals and the Chariot of Strettweg, now on display in the Joanneum Museum in Graz, the capital of Styria.

During the Hallstatt Period bronze was also used for various other artefacts; iron, then a recent discovery, was primarily reserved for the manufacture of weapons. The introduction of iron brought about a long-term change in the economy and trade of Europe, eventually heralding the dawn of a new age. Whereas the early Iron Age is contemporary with the Hallstatt Period, during the late Iron Age from c. 450 BC to the first years AD the Celtic La Tène culture gradually dominated, initiating the beginning of the West Hallstatt Period.

Centre:
Up above Hallstatt is a high valley with the town's salt mine and Dammwiese with its prehistoric graves.

Records of the excavations of the graves carried out by imperial royal councillor Ramsauer von Hallstatt contain sketches which were possibly made much later.

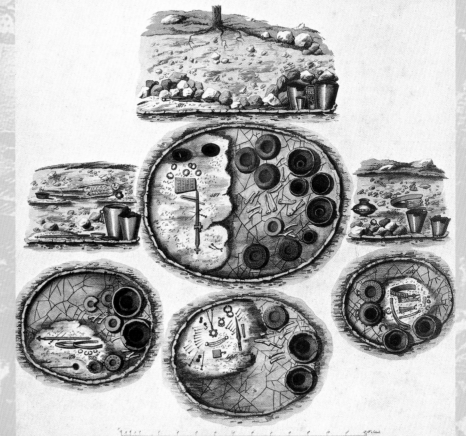

ALTERTHUMS AUSGRABUNGEN am SALZBERG zu HALLSTATT am 19ᵗᵉⁿ OCTOBER 1856.

In Beisein Seiner k.k. Apostolischen Majestæt des Kaisers FRANZ JOSEF, Ihrer Majestæt der Kaiserin ELISABETH S: kaiserl: Hoheit FERDINAND MAX von Österreich. Ihre königl: Hoheiten des Prinzen THEODOR, Prinzen KARL, Prinzeße HELENE, MARIA und MATHILDE von Baiern nebst hoher Suitte.

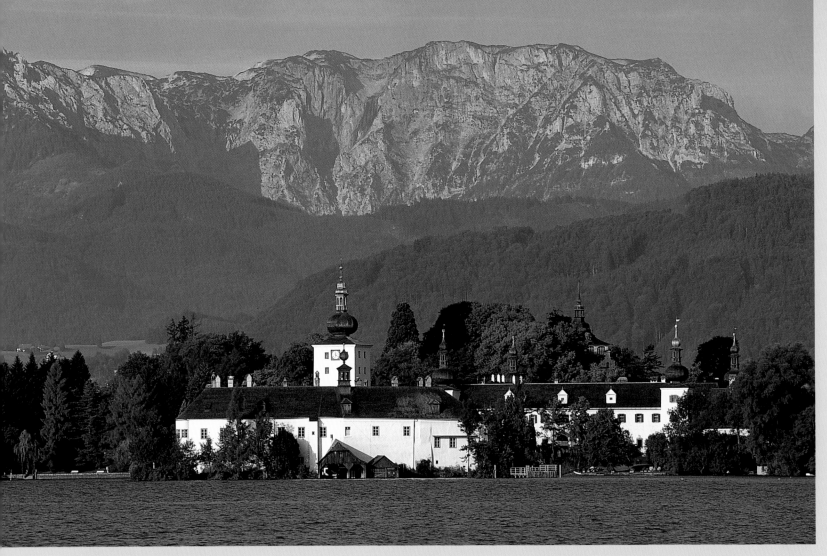

Above:

At Gmunden at the northern end of Lake Traun Schloss Ort straddles an island in the lake and the Toscana peninsula. The two halves of the complex, begun in the 17th century, are linked by a long wooden bridge.

Right:

The largest lake in the Salz-kammergut and the Austrian Alps, Attersee or Kammersee is 20 km (12 miles) long and 4 km (2 1/2 miles) wide. It plunges down to 171 m (561 ft) at its deepest point. The crystal clear water en-ables you to see down to a depth of 20 m (66 ft) in some places.

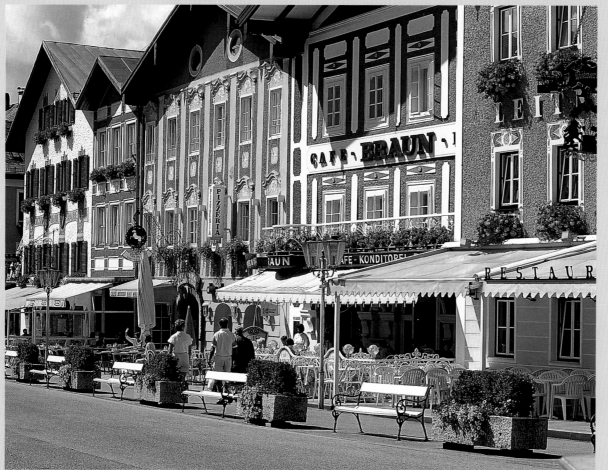

Above:
Northwest of the Schafberg is the Mondsee, a great place for swimming and fishing. On its southeastern shores the remains of a Stone Age settlement have been found, after which the Mondsee Culture was named.

Left:
The town of Mondsee dates back to a monastery founded here in 748 which was run by the Benedictines until 1791. The picturesque market place is not far from the shores of the lake.

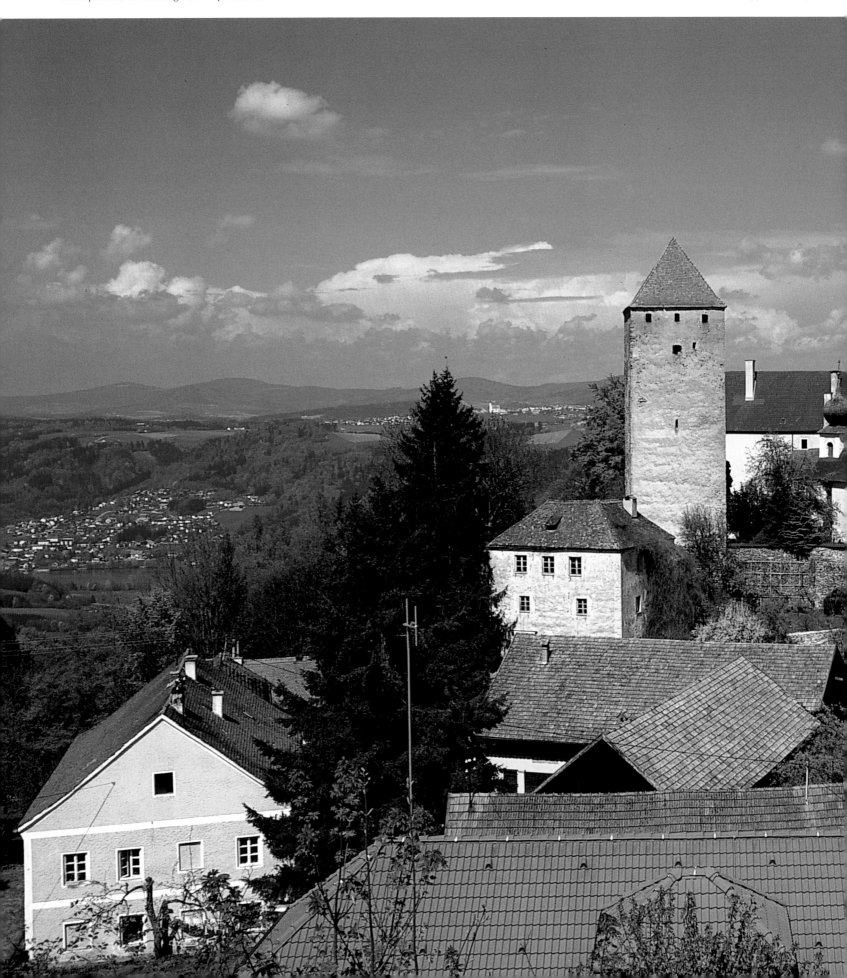

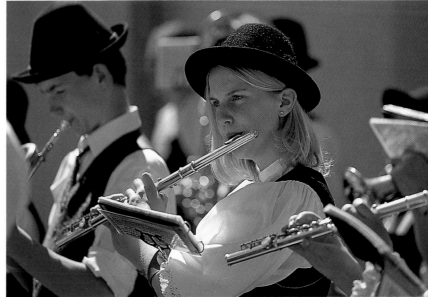

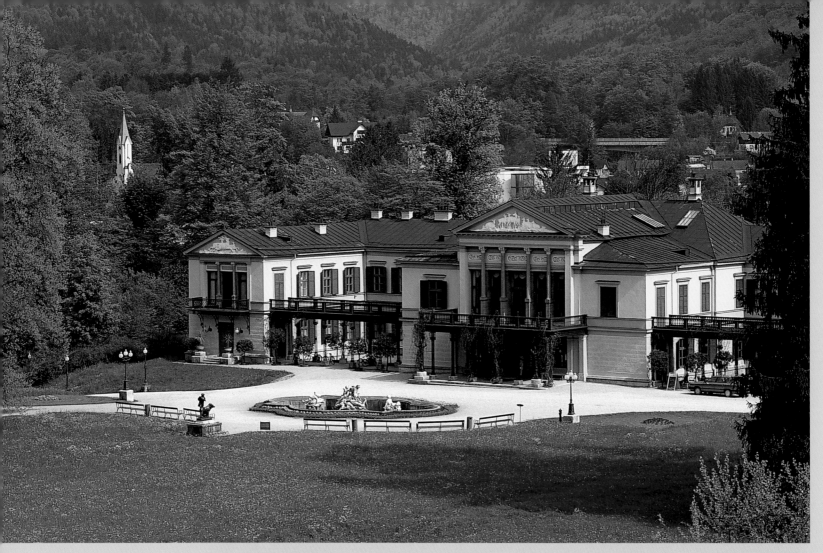

Above:
To celebrate the marriage of her son Francis Joseph I to Elisabeth Archduchess Sophie gave the couple an imperial villa in Bad Ischl to be used as a summer residence. Two wings were added so that the finished palace was in the shape of an E for Elisabeth.

Right:
Franz Léhar moved into a villa on the River Traun in Bad Ischl in 1912 where he lived until his death in 1948. The composer's study and various other rooms in the house are now a museum.

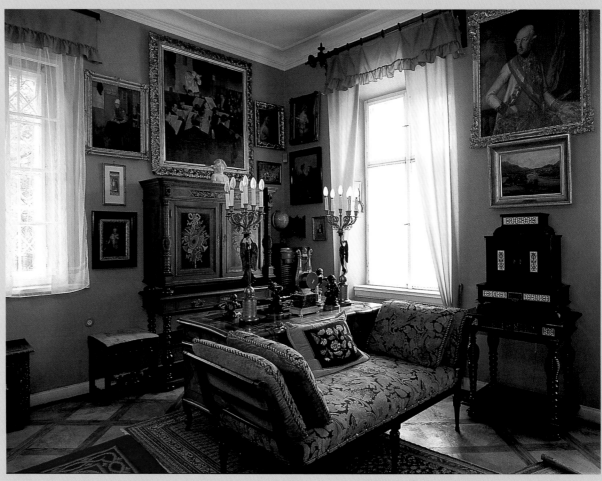

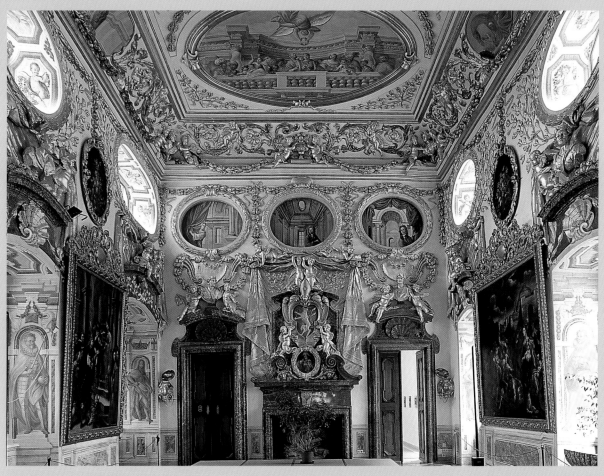

Left:
The Cistercian monastery of Schlierbach in the Krems Valley was set up as a convent in 1355, later abandoned and finally taken over by monks in 1620. Extensive restoration work began in 1674 with which the Carlone family from upper Italy were commissioned, resulting in a "gem of monastic baroque art".

Below:
The Katrinalm up above Bad Ischl has an altitude of 1,480 m (4,856 ft). It can be reached by cable car or in three hours on foot from Bad Ischl, the reward being spectacular views of the surrounding countryside.

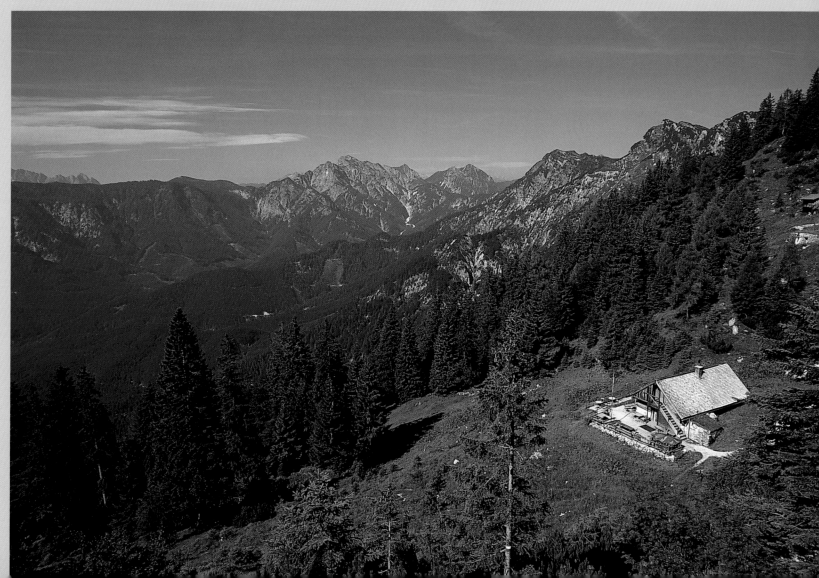

THE IMPERIAL MYTH — SISSI

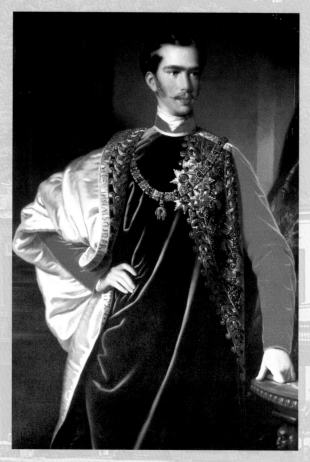

Elisabeth of Bavaria was not to be envied. At the tender age of 16 she was married off to her imperial cousin, giving up a life of freedom to don the regimental straightjacket of the Viennese court. Her aversion to royal protocol and the many conflicts with first her mother-in-law and then her husband are common knowledge, causing the woman whose beauty and charm were legendary across the globe to increasingly shun her duties as representative of the imperial family.

Elisabeth, or Sissi as she is affectionately known, sought a means of escape, passionately devoting herself to her riding, undertaking long journeys abroad and developing a then unprecedented obsession with her outward appearance. With hair down to her waist and a waspish figure which today smacks of anorexia (at 1.72 metres/5'6" she weighed just 49 kilograms/ 7 stone 11), her looks became all-important. She kept fit by working out in the gym – the ideal stress relief for an empress. She also successfully campaigned for the political Compromise with Hungary, developed republican ideas and excelled in her knowledge of the arts, becoming something of an expert on Heine, for example.

Her unhappy marriage was compounded in 1889 by the tragic loss of her son, Crown Prince Rudolph, the nature of whose death was unreconcilable with the honour of the Habsburg dynasty. In attempt to hush things up the court put the tragedy of Mayerling down to mental illness on the part of Rudolph, so that the family's black sheep who had murdered his lover and then committed suicide was at least able to be given a Christian burial and thus spared the eternal fires of damnation. Elisabeth herself was killed at the age of 60 in 1898 at the hands of assassin Luigi Luccheni, an anarchist out to murder the ambassador of the reactionary imperial household – a brutal demise which only served to strengthen the Sissi myth.

SISSI AND DIANA – TWO TRAGIC FIGURES

Sissi fever peaked 100 years after her death and in many ways emulates the mourning shown for Diana, Princess of Wales, who died in a Paris car crash in 1997. These are two women whose very public and terribly sad lives hold such a great fascination for a large section of the population that they have become nothing short of cult objects. Elisabeth, for example, has recently become the unwitting patron of a Miss Sissi contest

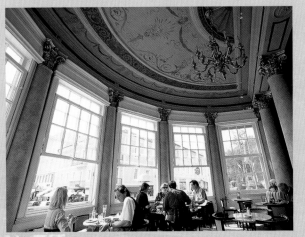

Left:
The spa town of Bad Ischl, famous for its salt cures and healthy climate, has many luxurious places to stay, such as the inevitably named Hotel Sissy.

Below:
The "Lyon Républicain" newspaper from 25 September 1898 published an illustration of the murder of the Austrian empress.

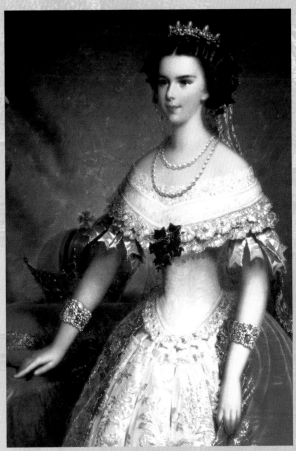

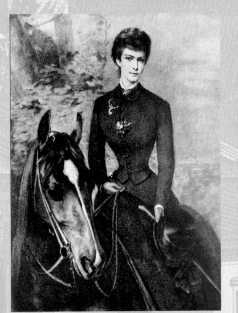

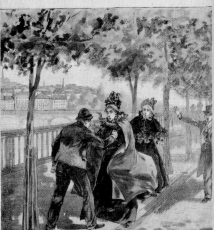

to be held in Styria; a suitable successor is to be chosen out of twenty contestants who will be judged on their elegance, strength of character and ability to present themselves to the public. The lucky winner should also be an expert on the life and times of her muse.

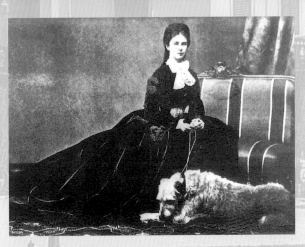

Above centre:
The empress loved horses and would not be kept from riding, even after remaining unconscious for several hours after a fall, during which those close to her feared for her life.

Left:
This photo taken after 1860 shows Sissi with her favourite dog, an Irish Airedale called Shadow.

SISSI PARFAIT, TRUFFLES AND SWEET PANCAKES

As regards the many souvenirs which cash in on the Sissi myth, perhaps the most popular in the culinary department are „Sissi-Taler", chocolates which are to Vienna what „Mozartkugel" are to Salzburg, and La Violetta parfait with champagne and violet truffle. Sissi is also said to be behind the creation of „Kaiserschmarrn", a sweet shredded pancake, which a desperate chef in Bad Ischl allegedly rustled up when the „Palatschinken" he was preparing for her majesty went drastically wrong…

Below:
On the upper reaches of the Mur, the main river flowing through Styria, the regional capital of Murau nestles between the peaks of the Frauenalpe and Stolzalpe.

The city church dedicated to St Matthew was built between 1284 and 1296 and contains valuable frescos from the 14th century and murals from the Renaissance.

Top right:
The Gothic Kornmesserhaus with its Venetian-style arcades and splendid loggia on the main square in Bruck an der Mur is a real eye-catcher. It was erected between 1499 and 1505 for iron merchant Pankratz Kornmeß.

Centre right:
Leoben lies west of Bruck on a bend in the River Mur beneath Massenberg Mountain. A frieze of coats of arms runs along the facade of the old town hall from 1485. The tower is later addition from 1568.

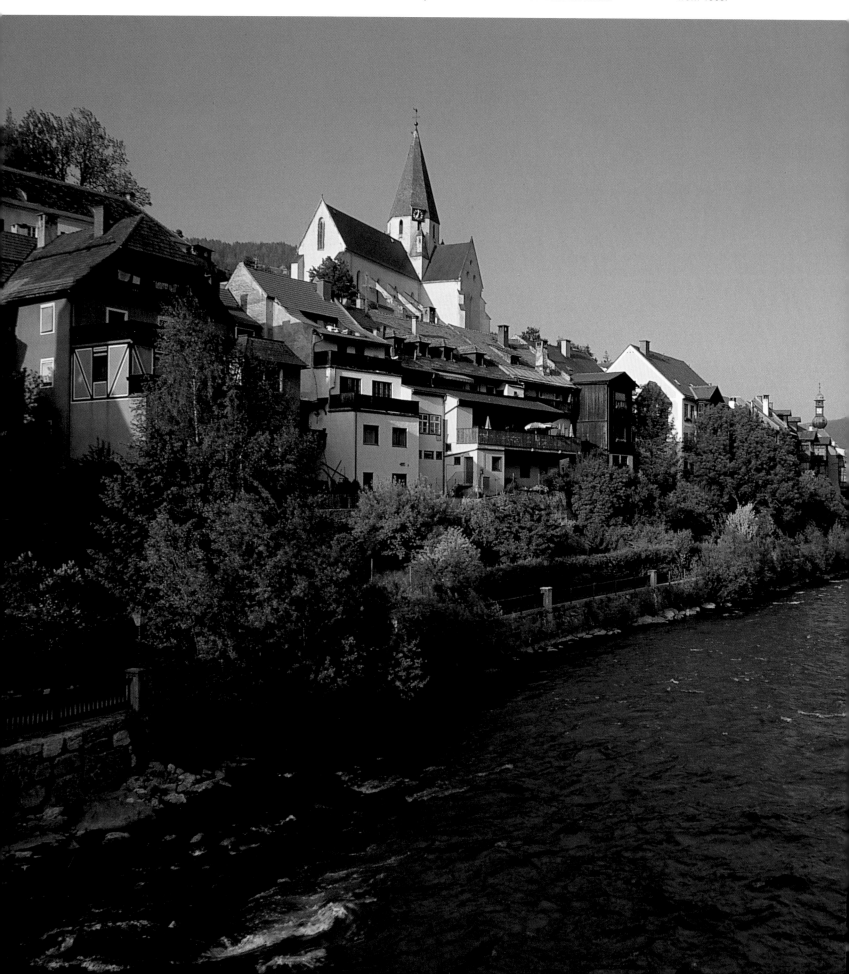

Bottom right:
Frohnleiten on the Mur between Bruck and Graz was originally a linear village whose medieval character has been preserved to this day. The parish church dedicated to the Assumption of the Virgin Mary was consecrated in 1701.

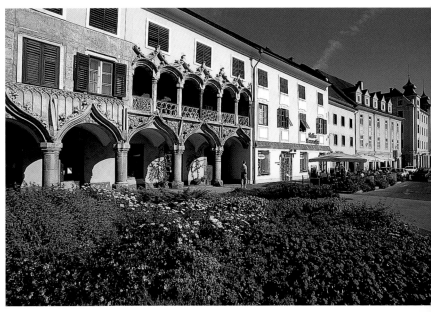

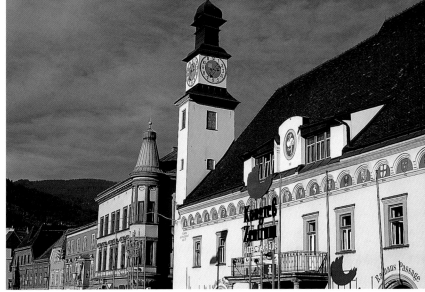

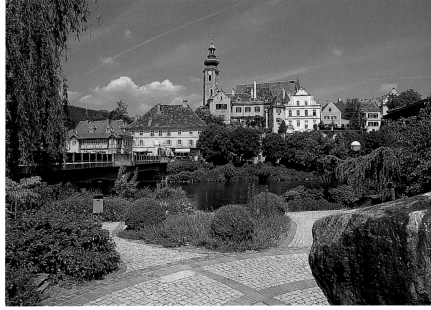

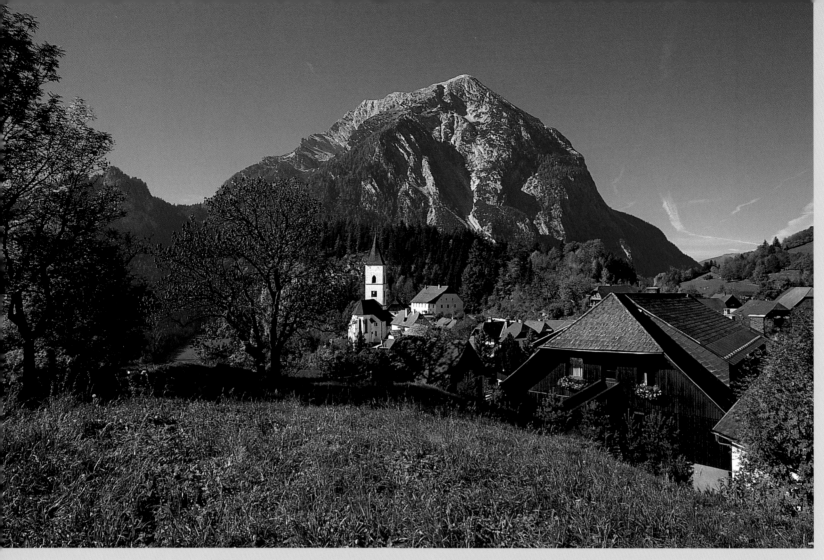

Above:
Pürgg is situated between Bad Aussee and Liezen on the edge of the Totes Gebirge. To the southwest of the village Grimming Mountain towers up into the skies. The parish church of St George's was built in 1130 and later refurbished during the Gothic period.

Right:
Peter Rosegger, who was born in Alpl in Styria in 1843, paid for the local school to be built in 1902. In the same year he also published a book entitled "Als ich noch ein Waldbauernbub war" (When I was a forest boy). He died in 1918.

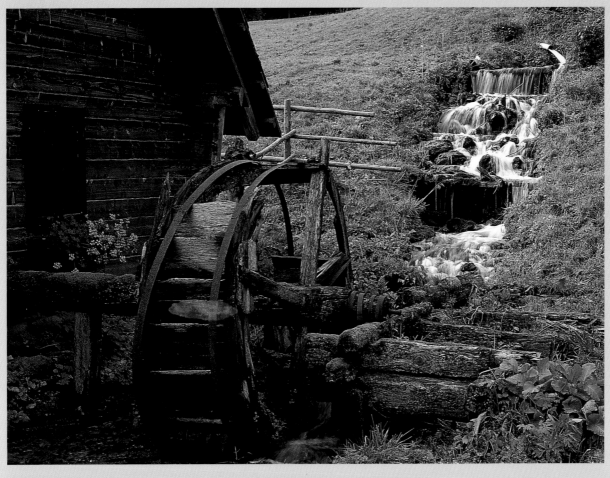

Left:
In the idyllic Feistritz Valley near Rettenegg, southwest of Gloggnitz in Styria, time seems to have stood still.

Below:
Against the spectacular back-drop of the Hochschwab (2,278 m/7,474 ft) north-west of Bruck a number of small lakes and pools have created a unique biotope in the valley basin of Tragöß.

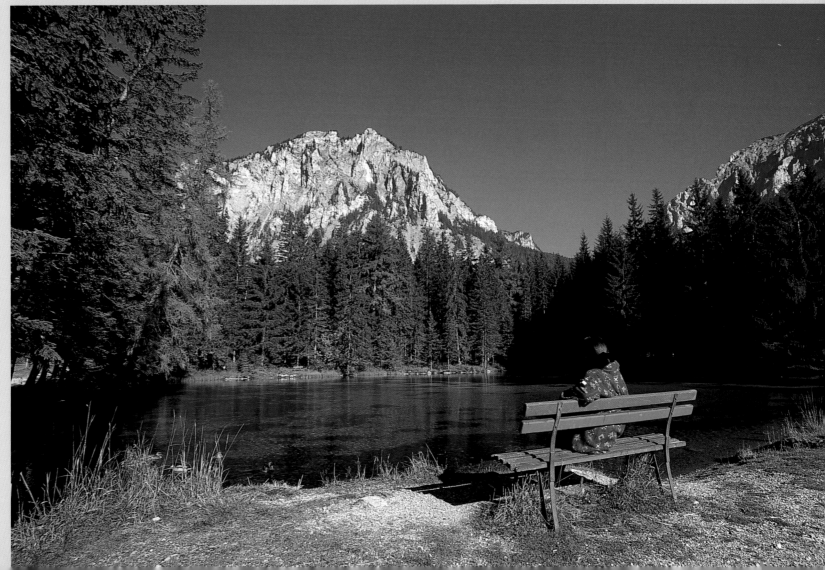

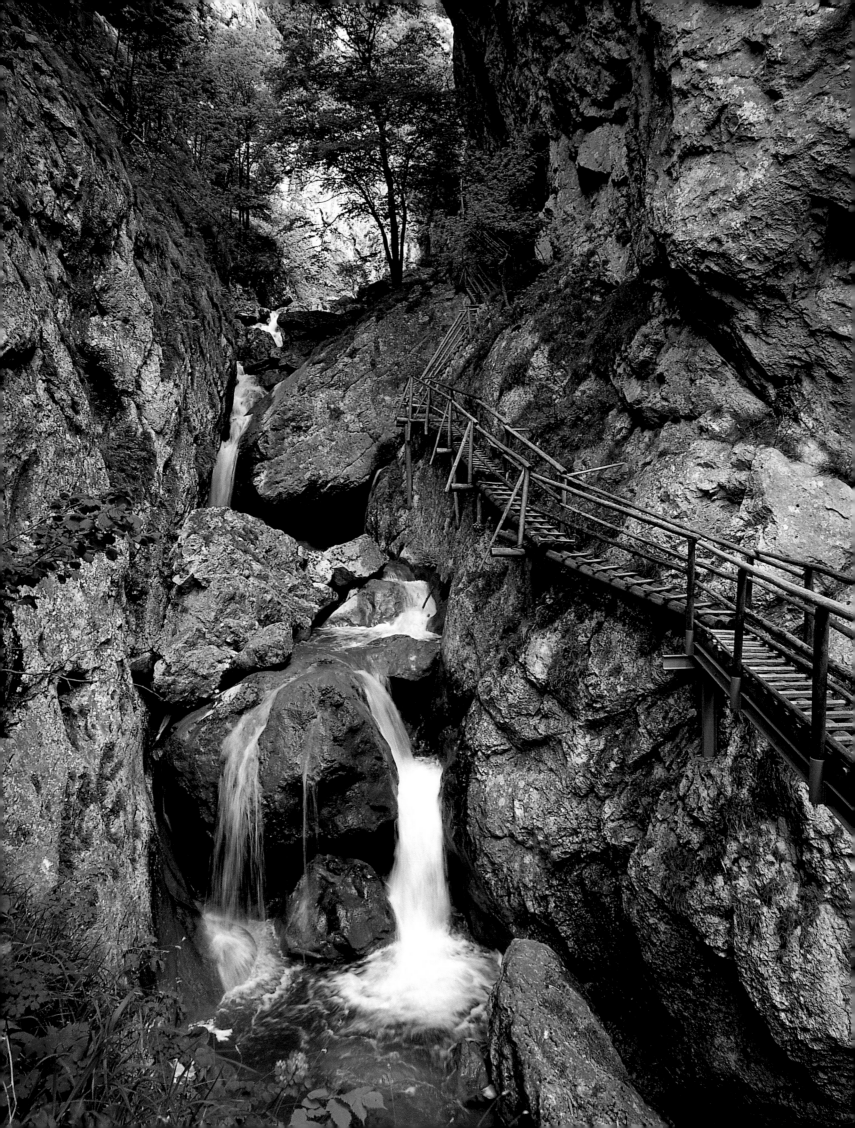

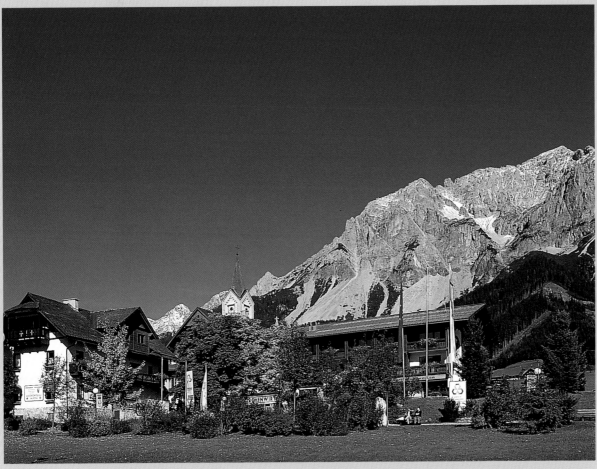

Left:
One fantastic four-hour hike in the mountains of Graz takes you from Mixnitz on the River Mur through the spectacular gorge of the Bärenschützklamm with its bridges, walkways and steps up to the top of the Hochlantsch (1,720 m/5,643 ft).

The village of Ramsau sprawls across a plateau of the same name, tucked in beneath the southern foothills of the Dachstein Massif and sloping down to the Enns Valley and Schladming.

At the foot of Loser Mountain (1,836 m/6,024 ft) in the Ausseer Land are the lush meadows of the Blaa Alm plateau. Together with the Totes Gebirge and Bad Aussee, this area of the Salzkammergut actually belongs to Styria.

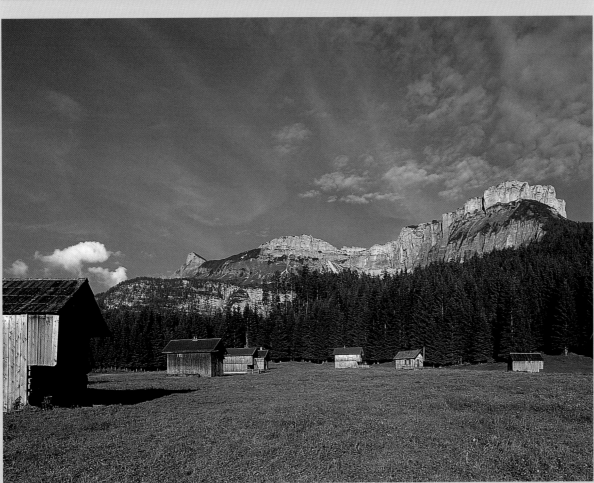

Below:
Graz has ca. 232,000 inhabitants, 28,000 of whom are students at the two universities and the conservatoire.

There are panoramic views of the city from the top of the Schlossberg which towers up above the main square on the left bank of the Mur.

Top right:
A railway whizzes up the Schlossberg in just three minutes to Graz's local landmark, its clock tower from

1561. The clock itself is from 1712. The tower, the remains of what were once the city defences, now houses a local museum.

Centre right:
The Landeszeughaus with its array of weapons, armour and war machines is one of the most impressive collections of its kind in the world. The 30,000 exhibits date back to the 15th to 17th centuries.

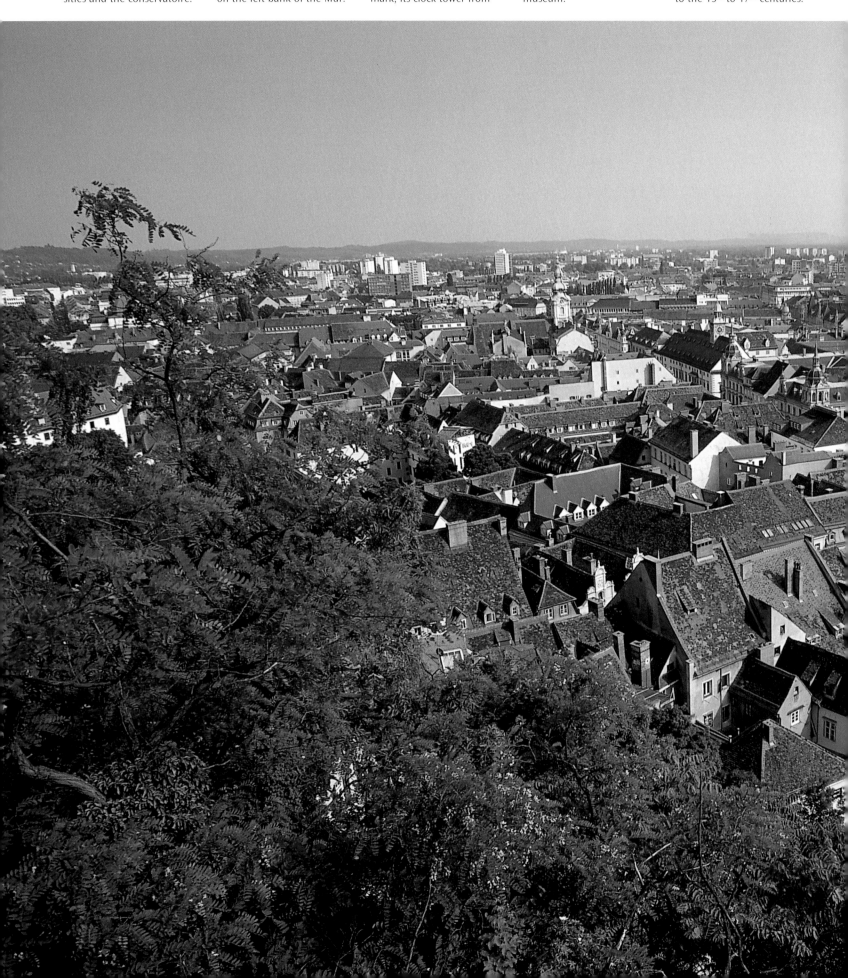

Bottom right:
Next to the armoury is the Landhaus, built from 1557 to 1565 by Domenico dell'Allio. The Renaissance edifice, today used by Styria's provincial government, boasts a marvellous courtyard with three-storey arcades running along two of its sides.

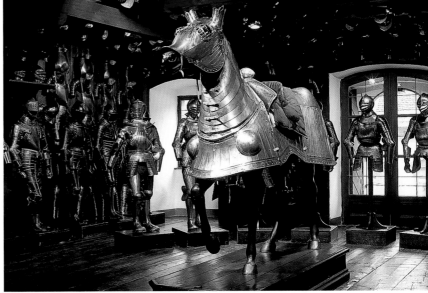

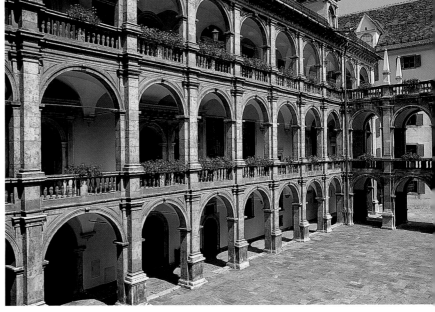

Left:

The Hotel Erzherzog Johann has been in Graz since 1852. During the 18th century one of the city's traditional taverns was converted into a baroque palace, complete with sumptuous ballrooms and a chapel. The wrought-iron balustrade in the inner courtyard is also from this period.

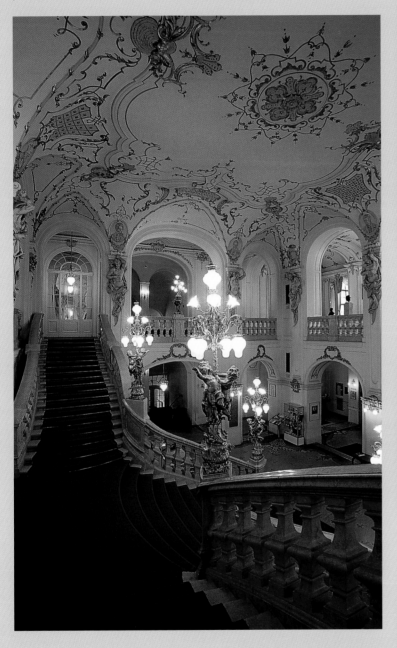

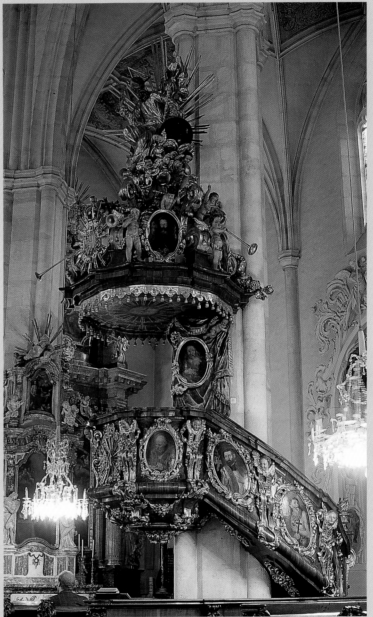

The opera house in Graz, reckoned to be one of the most beautiful in the world, was designed in neo-baroque by architects Fellner and Helmer in 1898/99. After several spates of restoration a new building was added by Gunther Wawrik in 1983/84.

Graz Cathedral, originally a parish church dating back to 1147, was commissioned by Emperor Frederick III and probably built as a late Gothic hall church by Hans Niesenberger between 1438 and 1464. The ornate pulpit from 1710 is a result of the later baroqueification of the building.

Top left:
The Klöcher Weinstraße passes through southeast Styria from Fehring to Bad Radkersburg, past Frutten-Gießelsdorf where wine and Ida Red apples are cultivated.

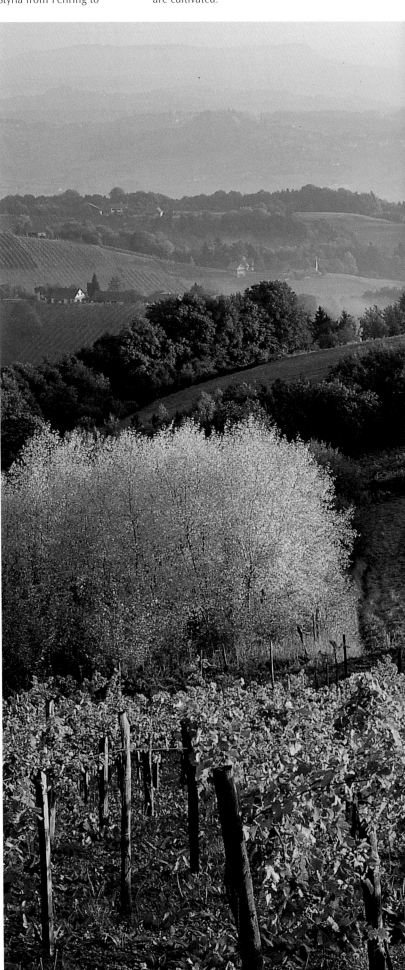

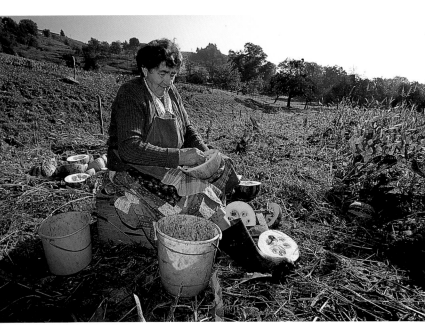

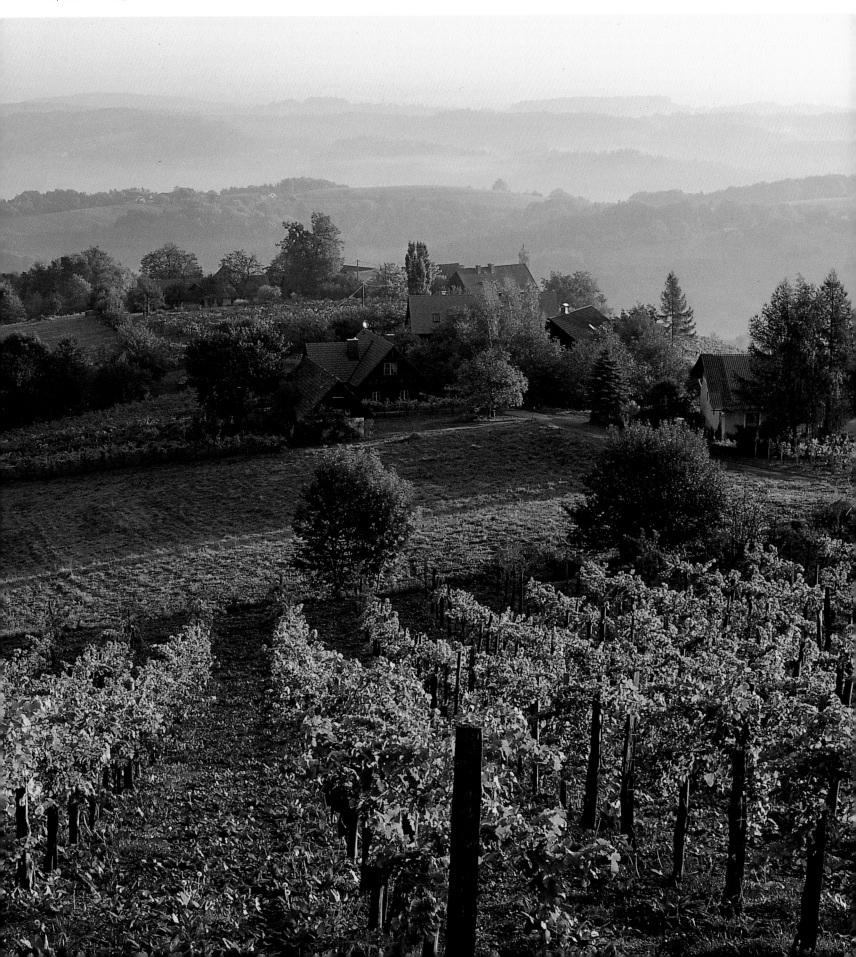

Centre left:
The Südsteirische Wein-straße, the oldest of Styria's wine routes, runs close to the border with Slovenia. "Klapotetz" or "klapotec" in Slovenian, noisy wooden windmills equipped with rattles and bunches of twigs, are erected in the vineyards to keep the birds at bay.

Bottom left:
Frau Prater from Langegg on the southern Styrian wine route harvesting pumpkin seeds for oil which is freshly pressed and has a characteristically nutty flavour.

Below:
In the Sausal area with its main town of Kitzeck, the highest-lying wine-growing community in Austria, late autumn is the time to savour sweet and heady grape must. Famous southern Styrian white wines include Sauvignon Blanc, Muscatel, Sylvaner, Chardonnay and Welschriesling.

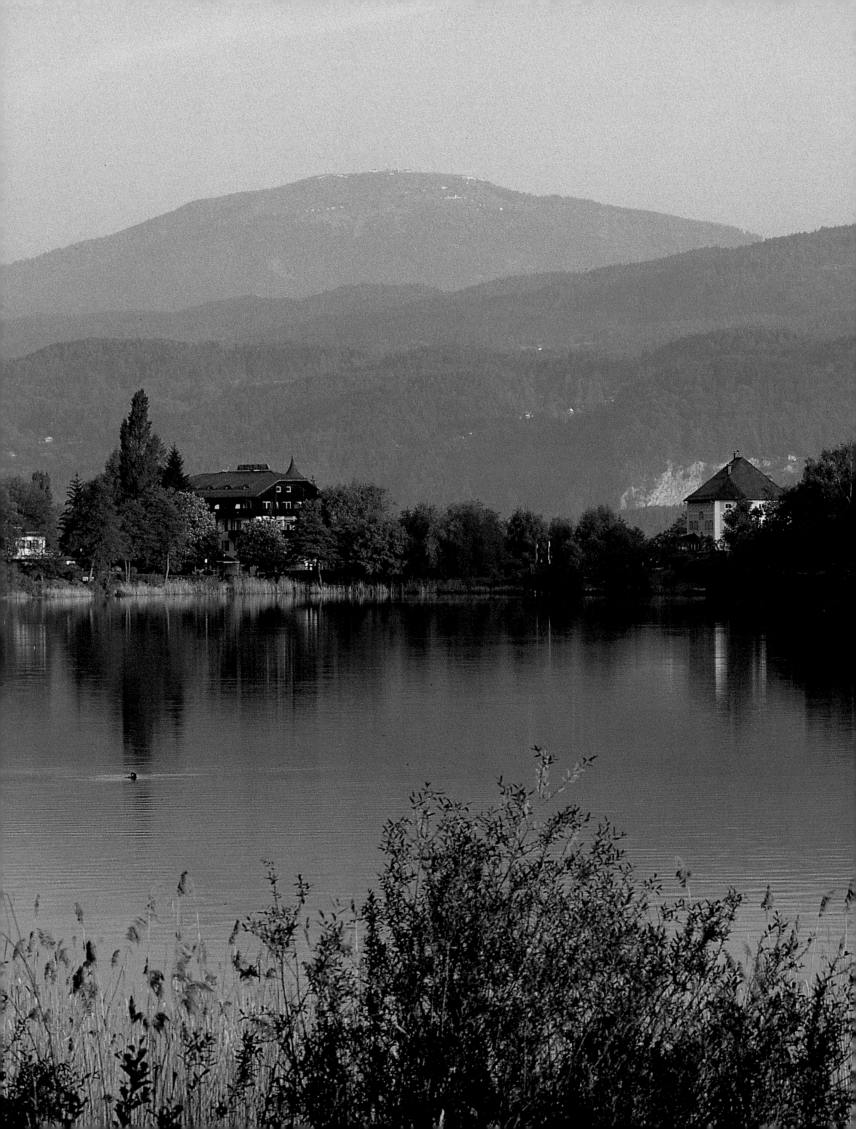

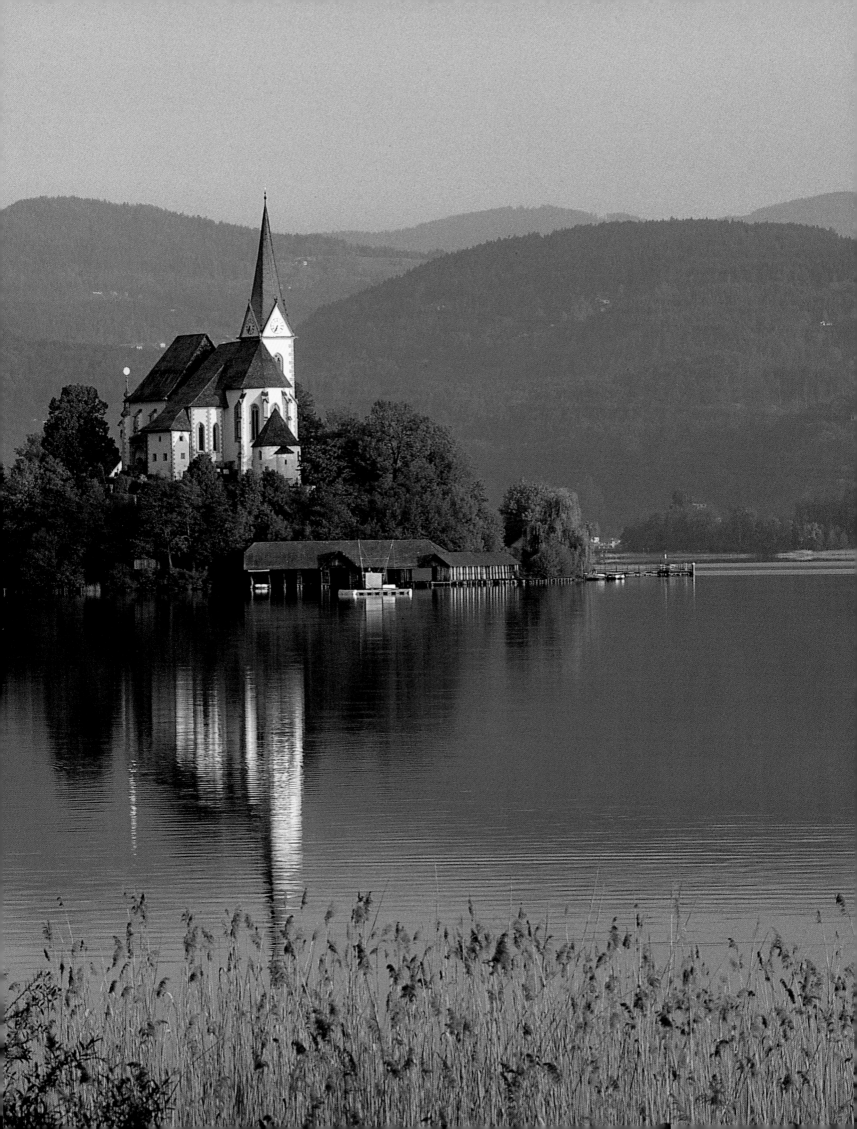

Page 104/105:
The largest Alpine lake in Carinthia, Lake Wörther, is up to 84 m (276 ft) deep and reaches temperatures of up to 28°C – right into October. On the southern shores of the lake the ancient core of the village of Maria Wörth clings to a peninsula.

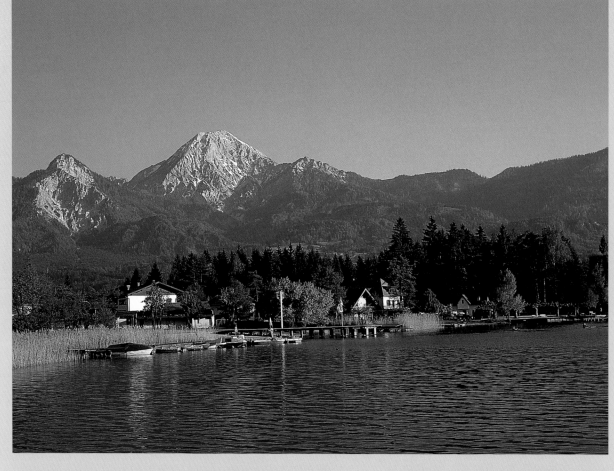

Southeast of Villach the Faaker See is a popular place to pursue all kinds of water sports. The Mittagskogel (2,143 m/7,031 ft) and Karawankas form an impressive backdrop to the lake.

Klagenfurt, the provincial capital of Carinthia, has dedicated a fountain on Neuer Platz to its heraldic animal, the lindworm. Ulrich Vogelsang created the beast in 1590 from a solid block of green chlorite slate, modelling it on the skull of a woolly rhinoceros found close by. It is said that a dragon was once slain on this spot.

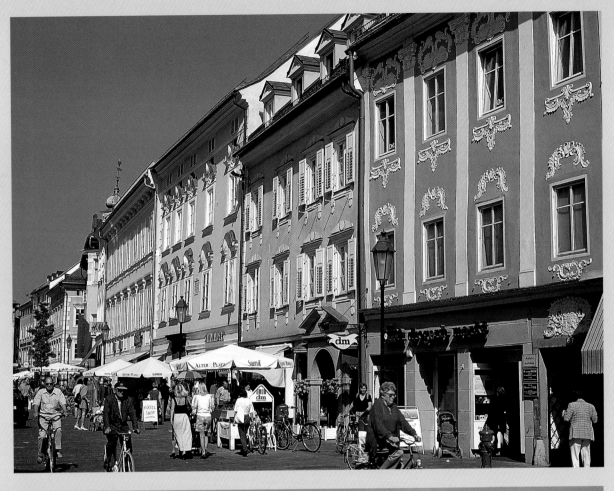

The elongated Alter Platz was once the bustling centre of Klagenfurt. The pedestrian zone with its baroque facades still hums with shoppers and visitors today.

The chic resort of Velden at the west end of Lake Wörther is dominated by its splendid Schlosshotel, a Renaissance creation from the 16th/17th century which was completely refurbished in 1920. Lake steamers dock nearby.

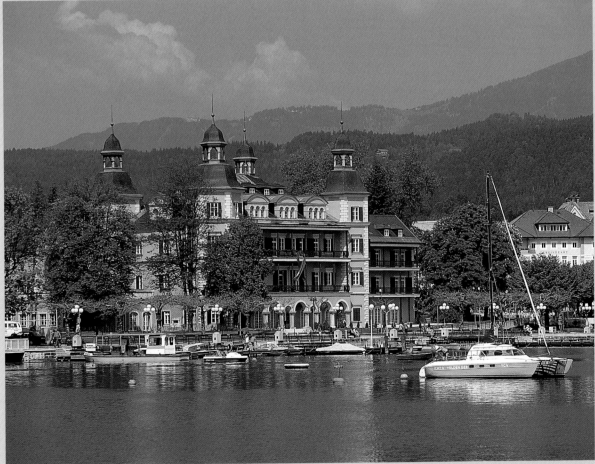

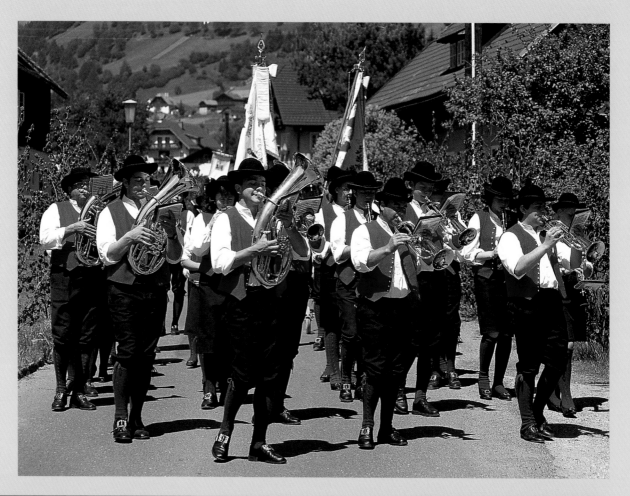

Right:
Corpus Christi procession in Rennweg on the Katschberg, the mountain pass between the Katsch Valley in Carinthia and the Lungau in the south-east of the Salzburger Land.

Below:
In 1987 Friedensreich Hundertwasser, whose real name was Stowasser (1928–2000), worked on the redesign of St Barbara's in Bärnbach west of Graz together with architect Manfred Fuchsbichler. Renovation work included gilding the onion dome and adding gilt balls of various sizes to the building.

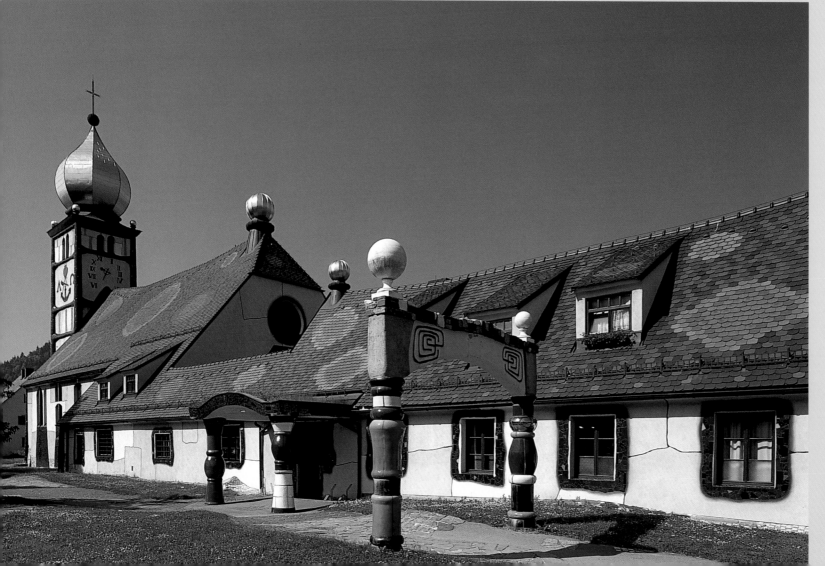

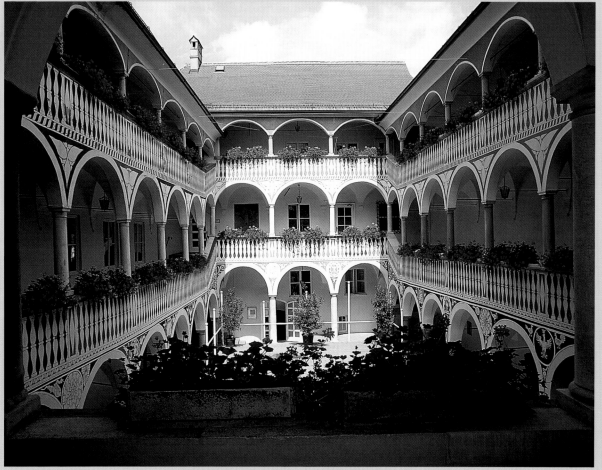

Above:
Out of the over 100 lakes in
Carinthia Lake Millstatt is
perhaps the best known.
To the north, where the main
town of Millstatt is situated,
the Nock Mountains shelter
the lake from cold winds.
The southern shores are less
densely populated.

Left:
St Veit an der Glan, north of
Klagenfurt, was the provincial
capital of Carinthia from 1170
to 1518, hence the splendour
of its 15th-century town hall.
The late Gothic building was
later given a baroque facade
and three-storey sgraffito
arcades running along all
sides of the inner courtyard.

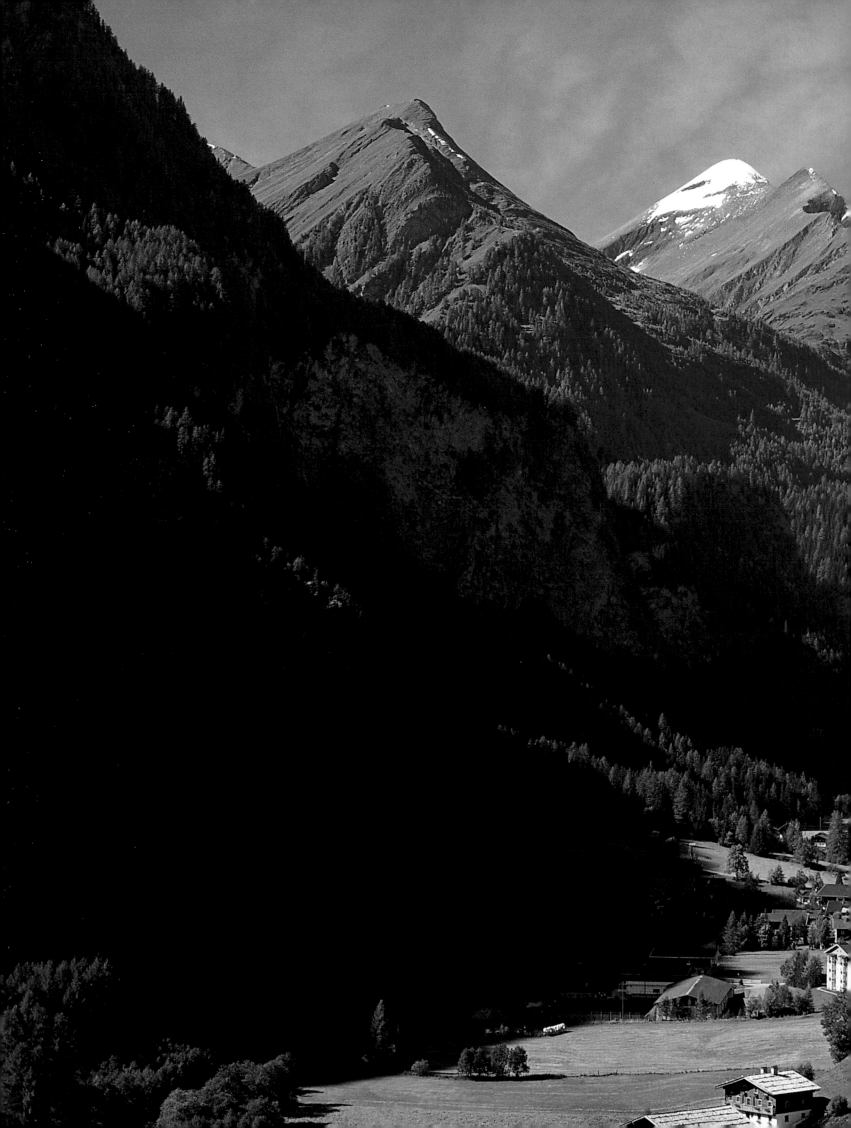

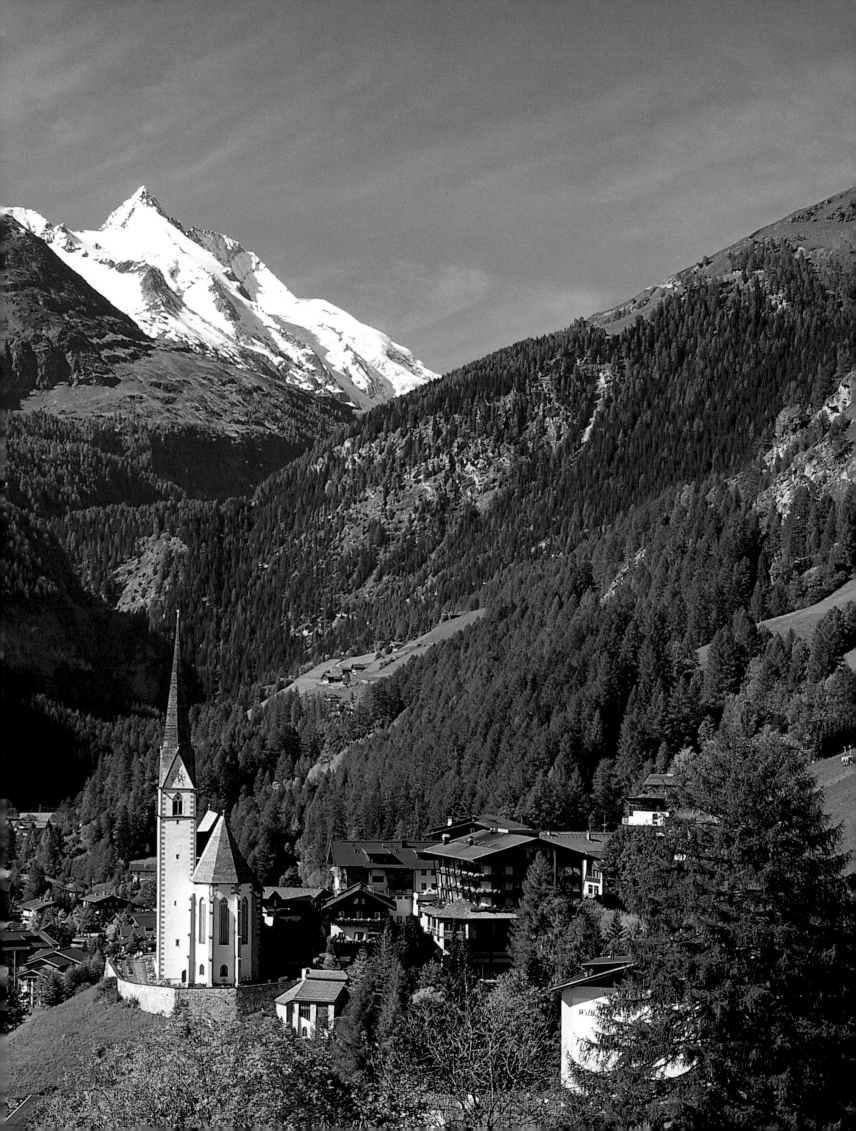

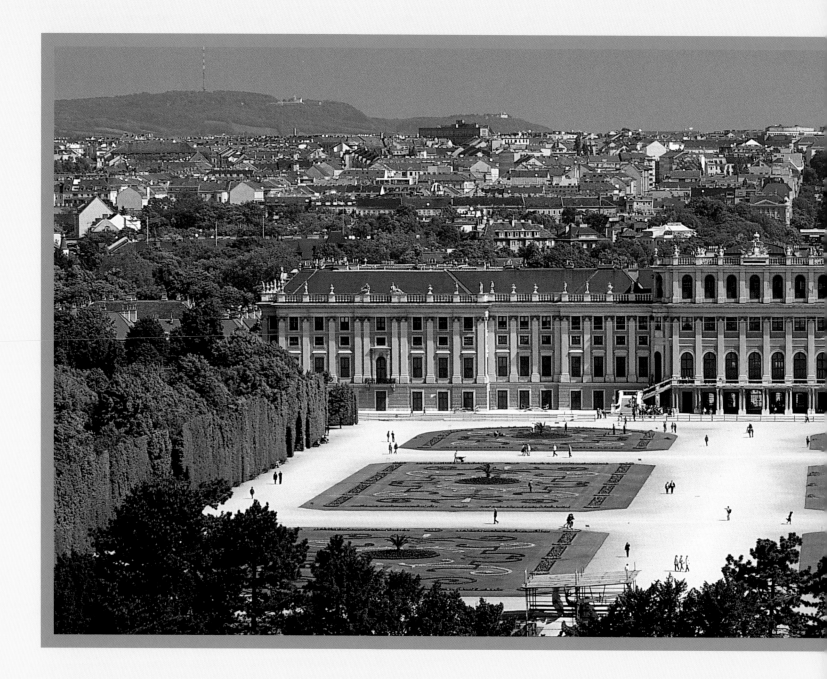

VIENNA, LOWER AUSTRIA AND THE BURGENLAND — THE EAST

"This city must be savoured like a sumptuous supper, slowly, piece by piece, with care; indeed, you have to have become a piece of it yourself before you can call the wealth of its substance and the charm of its environs your own."

(Adalbert Stifter)

Rich in history and rich in splendour, Austria's capital has countless admirers and is frequently showered with compliments. It also provokes hefty criticism, however, as in the words of Viennese writer Robert Menasse: "For how can you describe the impression this city makes [on you] as anything other than this: theatre and prison and suppressed or forgotten history.

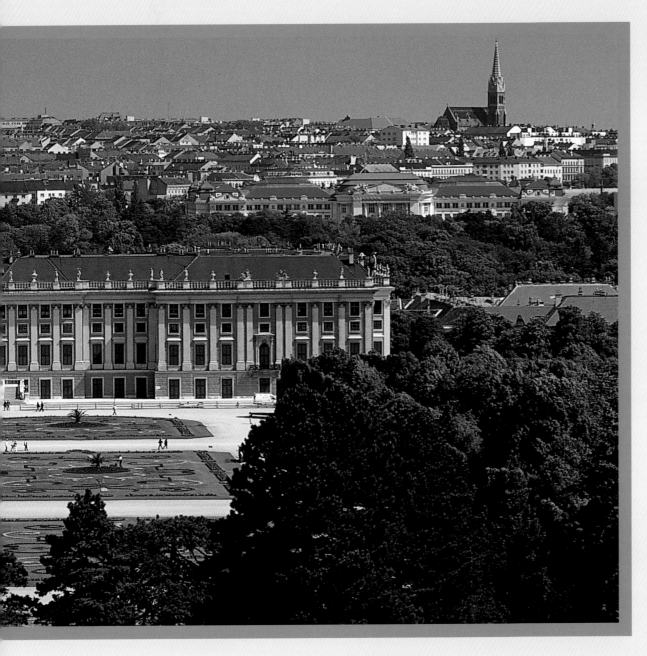

Page 110/111:
Heiligenblut in the upper valley of the River Möll lies at the end of the Großglock-ner-Hochalpenstraße in Hohe Tauern National Park. The Gothic pilgrimage chapel was erected between 1460 and 1491, its pointed steeple visible for miles around.

Schloss Schönbrunn with its expansive parkland was once on the outskirts of Vienna. The giant baroque edifice was designed as a summer residence by Johann Bernhard Fischer von Erlach the Elder and built in c. 1700. Maria Theresa had it refitted by Nikolaus Paccassi between 1744 and 1749.

Appearances are deceptive." Norbert Mappes-Niedieck, an Austrian by choice, approaches the subject in a more prosaic vein: "Vienna lies to the north of Munich yet east of the Oder-Neiße border, east even of the Croatian capital of Zagreb. It's as far from Vienna to the country's western frontier as it is from here to Uzhhorod in the Ukraine." This sober statement sheds a rather different light on Vienna and its relationship to its neighbours, pinpointing why this city, hovering on the boundary to southeast Europe, has throughout its existence absorbed diverse influences from a number of geographical and cultural sources – starting with the Romans.

FROM THE ROMAN CAMP OF VINDOBONA TO ROYAL SEAT

The Roman camp of Vindobona, established in c. 50 AD, took its name from the Celtic "vedunia" for "torrent". Its original boundaries are still traceable on the map today; the garrison town was situated between what are now the streets of Tiefer Graben, Salzgries, Rotgasse, Kramergasse, Graben and Naglergasse. After the Romans left the Danube area in the 5th century the town fell into ruin; during the high Middle Ages it blossomed into a bustling centre of trade, so much so that in the mid 12th century Henry Jasomirgott II

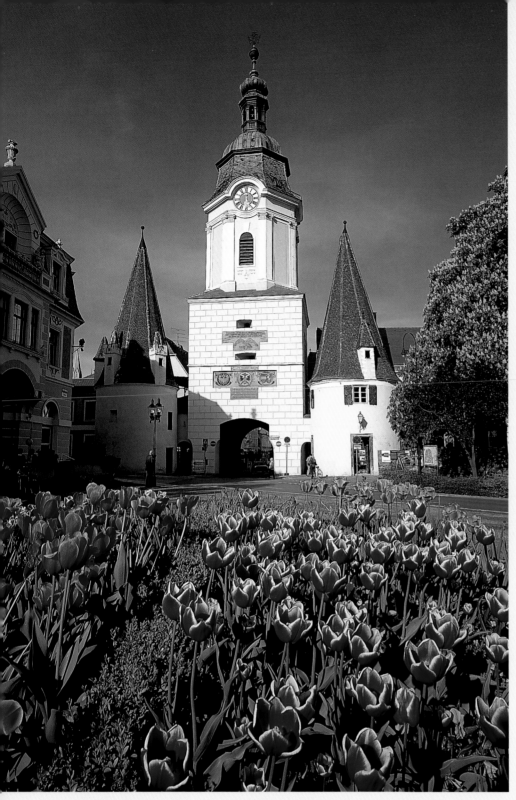

replaced in the 19th century by the prestigious edifices along Ringstraße, surrounded by spacious areas of green, which today so elegantly characterise the city.

ANCIENT LAND

Lower Austria begins where the Enns flows into the Danube, with St Pölten as its provincial capital. Covering an area roughly approximate to medieval Ostarrîchi, the ancient land along the banks of the river is riddled with archaeological finds and ruined settlements going back to the Stone Age. For centuries the northernmost boundary of the Roman Empire, many of the towns and villages here have their roots in this period, with some of them, such as Mautern, even dating back to the Celts. The area was converted to Christianity at a relatively early stage, with Lorch and Enns home to the oldest churches in Austria.

THE SPECTACULAR COURSE OF THE RIVER DANUBE

The countryside north of the Danube is hilly, with regions such as the Waldviertel and Weinviertel stretching as far as the Czech Republic. South of the river Alpine foreland and the foothills of the eastern Alps mould the landscape. Following the course of the Danube you pass through the lagoons of the Marchland and the steep granite ridges of the Strudengau before reaching the Nibelungengau at Ybbs where legend has it that Rüdiger von Bechelaren (Pöchlarn) once ruled as margrave.

In the Wachau between Melk and Krems – the oldest self-contained wine-growing area in Austria – the Danube carves its way through spectacularly narrow confines before opening out onto water meadows and the Tullner Feld beyond Krems. It then cuts through the final elevations of the Vienna Woods and enters the Vienna Basin, meandering through the centre of the capital and then on towards the Slovakian border and the Hainburg Gate marking the southern end of the Outer Carpathian Mountains.

Krems lies to the north of the Danube at the mouth of the River Krems where the Wachau becomes the Tullner Feld. To the west the old town is still guarded by a stone gatehouse, the Steiner Tor, built in 1480. The baroque tower was added in 1754.

was encouraged to move his imperial residence to Vienna.

THE FORTIFICATIONS, VILLAS AND PARKS OF ROYAL CAPITAL VIENNA

The royal capital boomed, soon spilling beyond the first set of city walls from the 13th century. Until 1857 newer fortifications erected in the 16th and 17th centuries formed the boundary to the older suburbs. The towers and walls were

THE "BURG" IN BURGENLAND

Not far from here a small strip of land runs south along the Hungarian border. The Burgenland, made up of the German-speaking areas of western Hungary, fell to Austria by ballot on the collapse of the Habsburg empire. It was given its present designation in 1920 after the "burg" in the town names of Pressburg (Bratislava), Öden-burg (Sopron), Wieselburg (Moson) and Eisen-burg (Vasvár). Eisenstadt, on the southern edge of the Leitha Mountains between Wiener Neu-

Left and centre left:
Horse-drawn carriages ("Fiaker") on Stephansplatz and Michaelerplatz in Vienna. The German word designating both the carriage and the driver in his traditional bowler hat comes from Rue Saint-Fiacre in Paris, the main hackney cab stand in Paris from c. 1650 onwards. The name of the Irish saint was soon applied to the coaches themselves and adopted in Vienna in 1693 with the introduction of the first horses and carts for private hire.

stadt and Lake Neusiedler, was made the capital of Austria's most sparsely populated province. In 1648 a family of Hungarian magnates, the Esterházys of Galántha, took up residence here, with whom Joseph Haydn spent over 30 years as "Hofkapellmeister". Another great composer, Franz Liszt, was born in Raiding in the central Burgenland in 1811.

The northern Burgenland with Lake Neusiedler, the only steppe lake in Europe, has a markedly continental character with its hot, dry summer climate typical of the Pannonian Basin. The south is an area of wooded medium-range hills, the eastern foothills of the Alps, crowned by numerous castles and ruins.

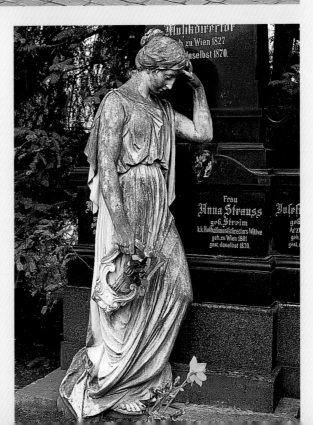

One of the graves at the main cemetery in Vienna is that of Josef Strauß (1827–1870), one of Johann's brothers, who himself composed over 300 pieces of music.

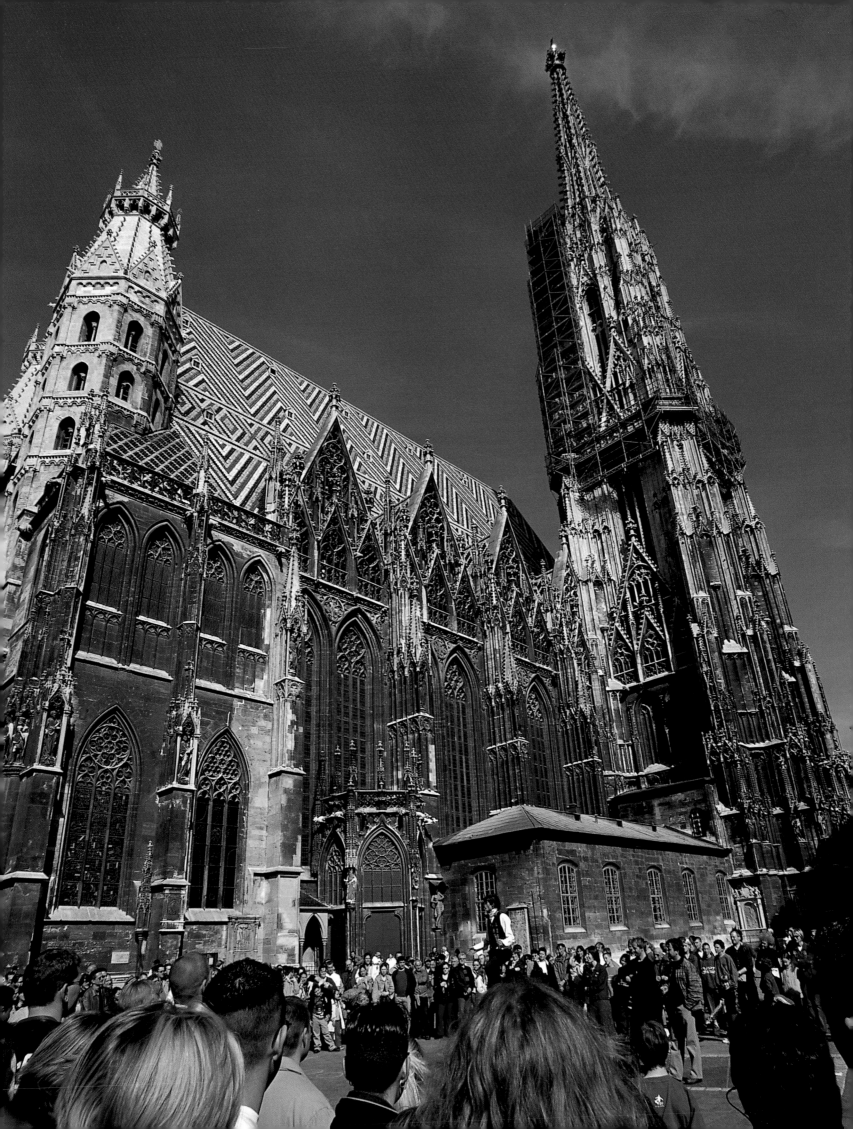

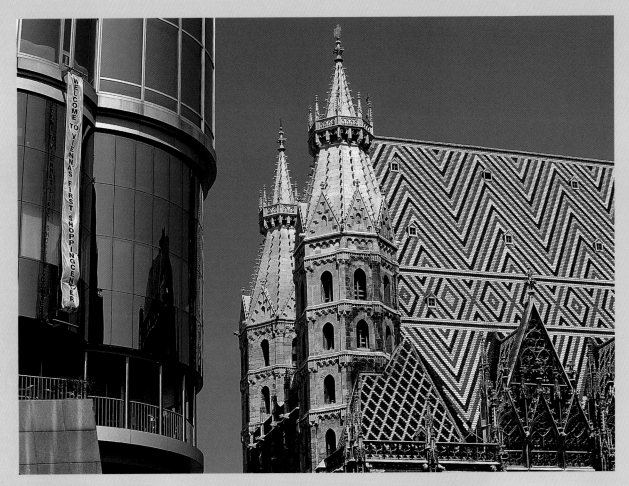

Left:
The pedestrian zone outside St Stephen's Cathedral in Vienna acts like a magnet on street artists of all kinds. The mighty Gothic building, begun by Duke Albrecht II and completed under Emperor Frederick III, evolved from an earlier church from the 14th and 15th centuries. Choosing St Stephen as the patron saint is a reference to the close ties Vienna then had with the royal bishopric of Passau.

St Stephen's and the Haas Haus in aesthetic juxtaposition. Hans Hollein's modern construction from 1990 stands in crass contrast to the Gothic spires of Vienna's cathedral.

In the nave of St Stephen's all eyes are drawn to the sandstone pulpit fashioned by Anton Pilgram in 1514/1515. On completing his work the sculptor from Brünn immortalised himself in stone, carving his own portrait into the foot of the structure.

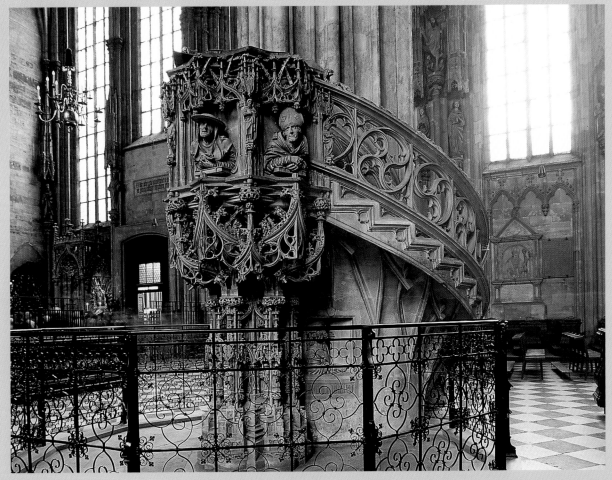

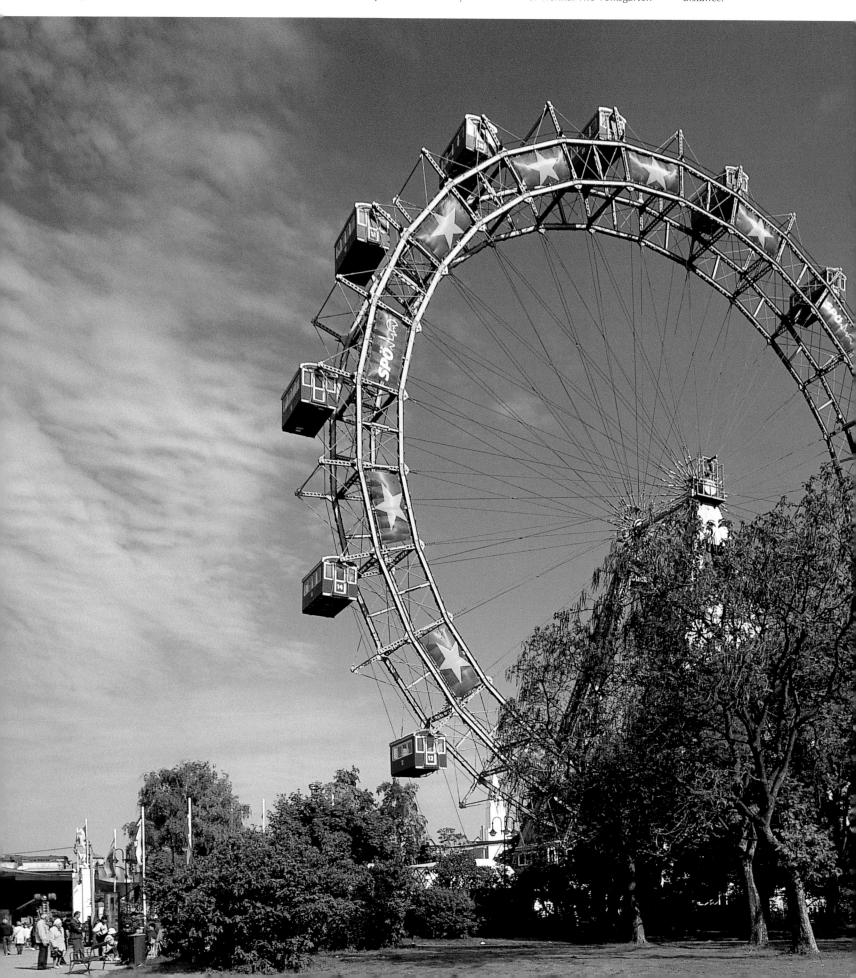

Below:
The big wheel at the Prater fun fair in Vienna is 65 m (213 ft) high at its vertex and 61 m (200 ft) in diameter. Since its installation by English engineer Walter B. Basset in 1896/1897 the giant iron construction has become something of a city landmark. Badly damaged by heavy bombing in 1945, the wheel was re-erected in record time.

Top right:
The Alte Hofburg, part of the Hofburg complex in Vienna, takes up several wings of the imperial palace. A bronze statue of Emperor Francis II, who died in 1835, stands proud in the courtyard.

Centre right:
Green parks stretch between the Hofburg and the town hall on the edge of the centre of Vienna. The Volksgarten starts just beyond Heldenplatz, running into the Rathauspark with the silhouette of the town hall in the distance.

Bottom right:
One of the main shopping boulevards in Vienna is the Graben, running northwest from the cathedral square. At its centre is the Pestsäule or column of the Holy Trinity, created by several artists in Salzburg marble between 1682 and 1694 in remembrance of those who fell victim to the plague here in 1679.

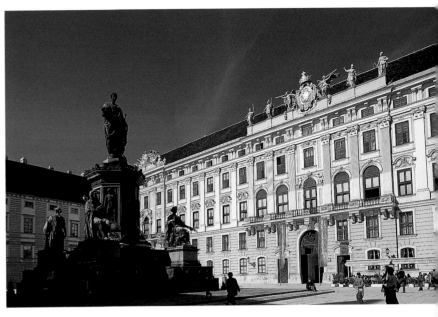

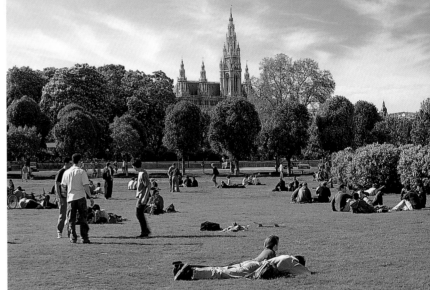

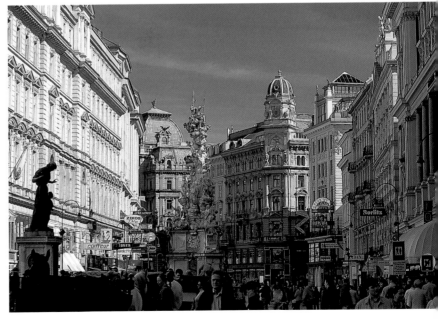

119

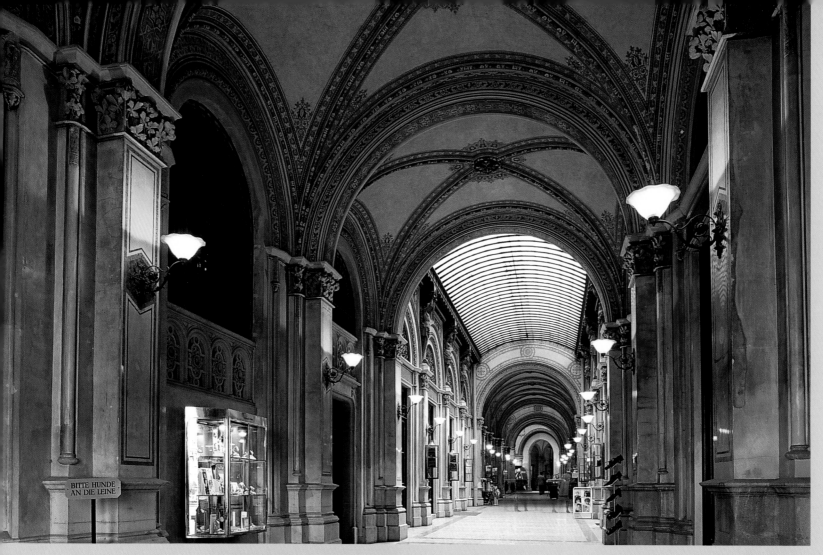

Above:
Even if it's raining you can still shop in the dry in Vienna – such as here under the elaborate rib vaulting of the Freyung-Passage.

Right:
Vienna's many shopping arcades are something of an architectural curiosity. Schönbichler tea merchant's, here on the Lugeck arcade, sells teas from all over the world.

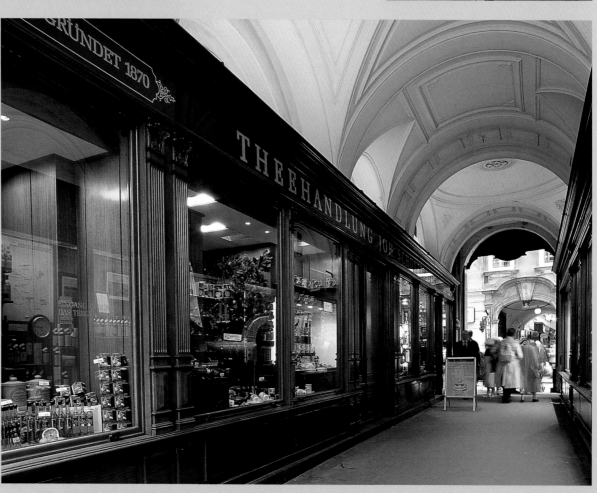

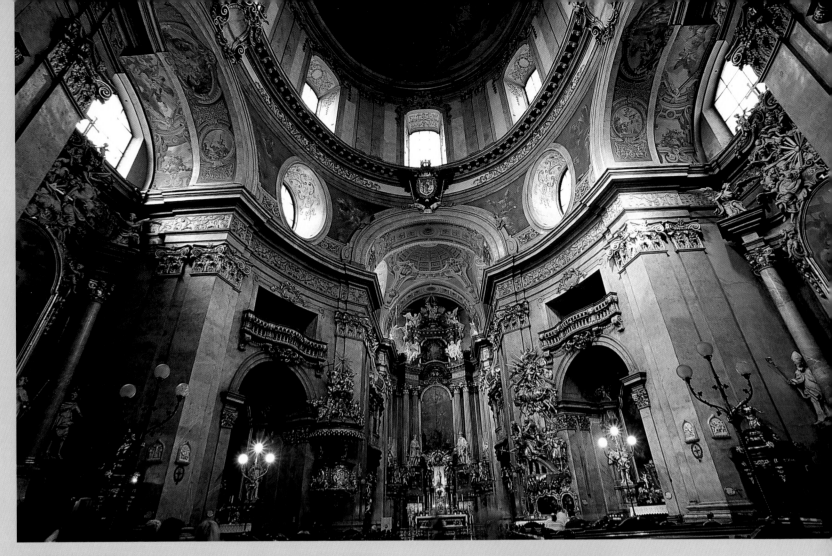

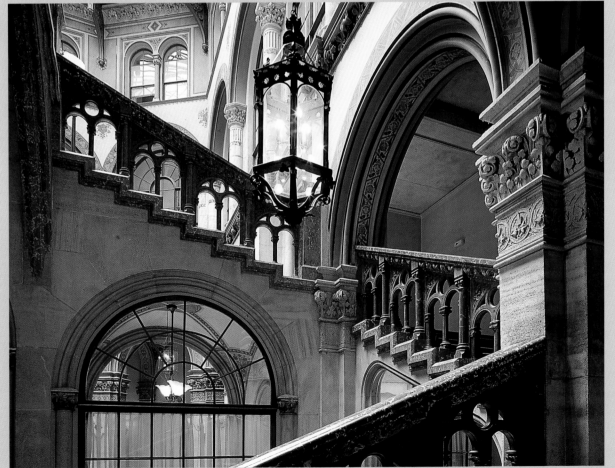

Above:
St Peter's in Vienna, north of the Graben, was built on the foundations of a late Romanesque church between 1702 and 1733 and modelled on St Peter's in Rome. The interior of its huge cupola is decorated with frescos by Michael Rottmayr from 1714.

Left:
Palais Ferstel on Freyung in the heart of Vienna was erected between 1856 and 1860 by architect Heinrich Ferstel for the National-bank. It houses an exclusive shopping centre and the infamous Café Central which was opened in 1860.

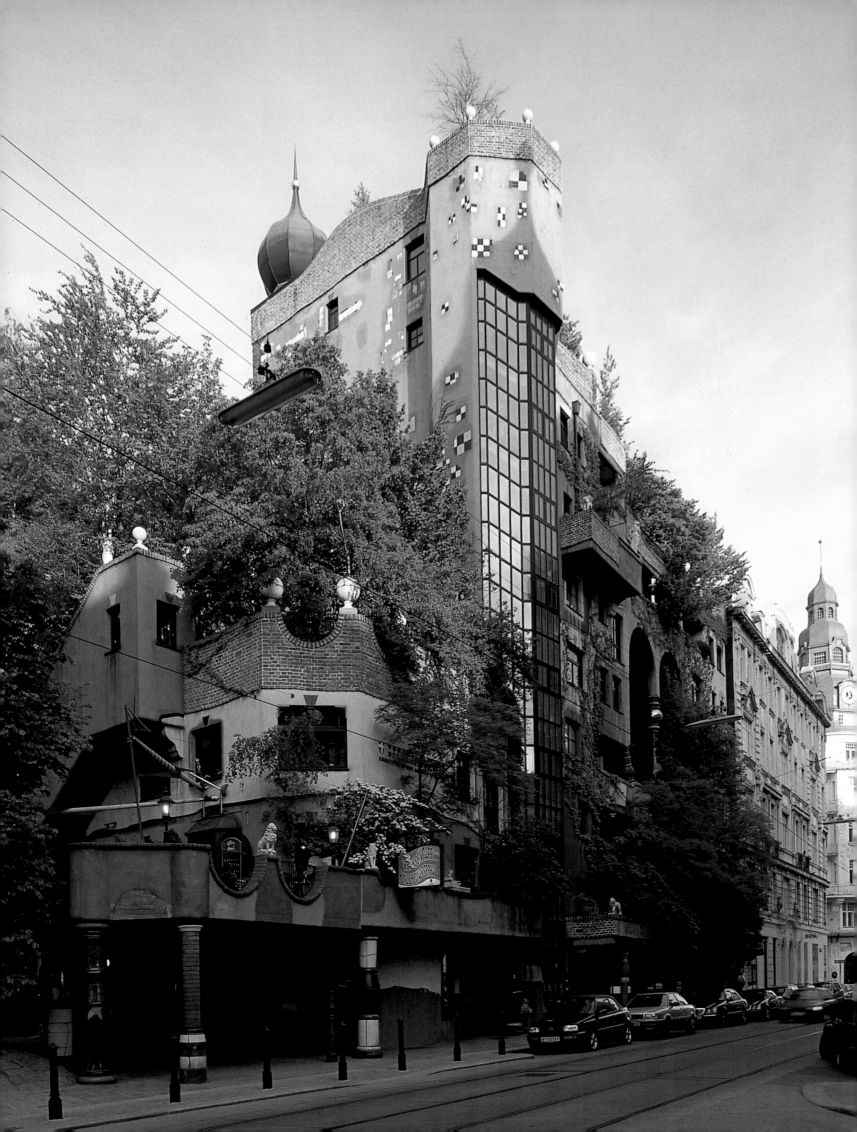

Left:
From 1983 to 1985 the Thonet complex on Vienna's Löwengasse was transformed into the colourful Hundertwasser House with its uneven walls and floors, onion domes, mirrors and abundance of plants. In 1991 a museum was integrated into the residential block.

A gilt iron dome of laurel leaves crowns the headquarters of the Vienna Secession, founded in 1897 and headed by Gustav Klimt. Josef Olbrich designed the Art Nouveau edifice south of Opernring in Vienna in 1898/1899.

Vienna's star architect of the late 19th and early 20th centuries was Otto Wagner (1841–1918). Karlsplatz has two of his pavilions in the style of the Secession from 1901, one of which is still an Underground station and the other now a café.

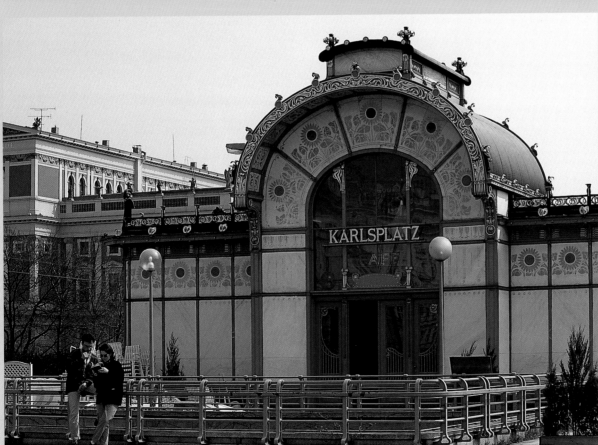

A VIENNESE INSTITUTION –
THE COFFEE HOUSE

Below:
The literati of Vienna, such as Alfred Polgar (1873–1955) and Peter Altenberg (1859–1919), treated Café Central on Herrengasse as their intellectual headquarters. The latter even gave his address to his publisher as that of the café; he still sits at a table near the door, large as life.

The legendary cult of the coffee house is inextricably linked to Vienna – and has also left its mark on several other cities briefly in the clutches of the Habsburg dynasty, such as Cracow and Prague. What better than to while away a lazy morning (and possibly also an afternoon) in Café Hawelka, Central, Herrenhof or one of those other revered Viennese establishments? But what makes the perfect "Kaffeehaus"? The large selection of current newspapers and magazines, the quality of the pastries and the coffee itself? The smell of tobacco and freshly brewed Java bean? The chess sets and packs of cards awaiting service in the corner? The absence of any form of musical backdrop? According to

Heimito von Doderer the epitome of the coffee house is the synthesis of the Oriental and the classic: "A Viennese café has ingested that meditative quiet and purposeless passing of time which anyone who has ever visited an Oriental, a Turkish café will know, [entering] not out of curiosity, but, like the others, as an insular, isolated guest who sits as far away from the other café-goers as possible. At the same time the café is our true public life, a forum diffused into hundreds of tiny pieces which is everywhere and accessible to all."

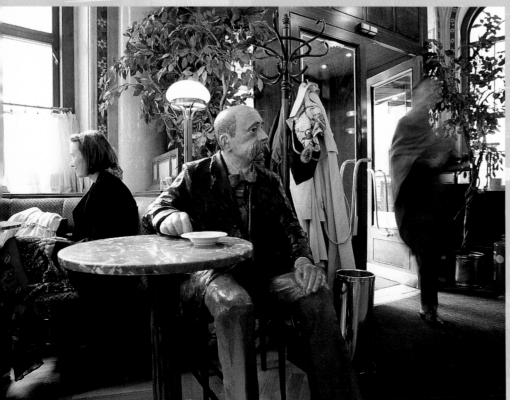

STUFFY BUT NOT SMELLY – COFFEE HOUSE CRITERIA

Wolfgang Hutter's criteria for a good coffee house include: "Not well aired but also not smelly. Pleasantly lit, but on no account sunny. Waiters who slightly overtax their guests but never hold them in contempt. To be able to have a conversation but not be obliged to. To have a good acquaintance sitting at the next table with whom no word need be exchanged for hours with no offence caused." And above all: "To the guest a

change in waiter at a coffee house can seem like the downfall of the monarchy; a new, unfamiliar face peering out over the nickel silver trays is pure anarchy."

THE TRIUMPHAL MARCH OF COFFEE

How did coffee come to Vienna? The stimulating beverage spread from Ethiopia via Arabia, Egypt and Turkey to almost all the other countries of Islam before establishing itself in Europe. Here it

was first introduced to Venice in 1615, then Marseilles (1644), Paris (1643) and London (c. 1651). When in 1683 the Turks unsuccessfully laid siege to Vienna, one of the things they left behind was their coffee ration. Franz Georg Kolschitzky from Poland scooped up the bags of the bean and soon afterwards began serving coffee at the Bischofshof, now number 6 on Domgasse.

On a purely physiological note the pleasures of the coffee house can be attributed to the following. Caffeine increases the concentration of neuro-

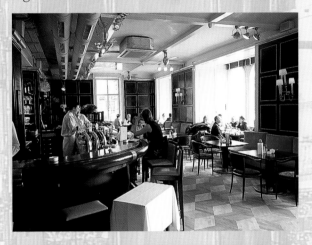

transmitter serotonin in the brain. This acts as an antidepressant and is formed in the body under the influence of light. In the darker regions of the world, such as Scandinavia, the yearly per capita consumption of coffee is thus about twice that of Mediterranean countries, where extremely strong coffee is drunk so that it has any effect at all under the glare of the hot sun. It's thus hardly surprising that coffee is a sociable beverage – and one which also stimulates the inspiration, concentration and powers of association.

Centre left:
Café Demel has a long tradition going back to 1786, when a pastry chef from Württemberg in Germany came to Vienna and opened a cake shop. Christoph Demel took over the business in 1857; since 1888 the Kaiserlich-königliche Hofzuckerbäckerei Ch. Demel's Söhne has been run from a palatial residence on Kohlmarkt, the interior an elaborate homage to the style of the day.

You can become acquainted with the culture of the Viennese coffee house at many of the city's establishments, such as here at Café Julius Meinl on Petersplatz.

A cosy atmosphere devoid of loud music and hustle and bustle is a rule of thumb in the coffee house, such as here at Café Vienna. How else could you spend hours here reading the paper or playing chess?

Below:
Coffee house culture wouldn't be complete without apple strudel and an "Einspänner", a double mocha in a glass mug served with whipped cream.

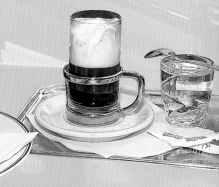

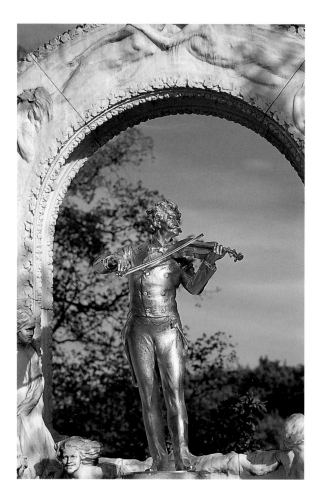

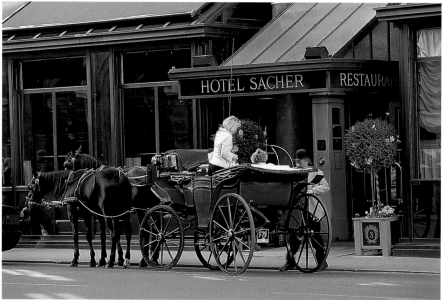

Left:
Johann Strauß (1825–1899), the composer of famous tunes such as the "Blue Danube" and "Roses from the South", has been immortalised in this gilt bronze statue north of the Kursalon in the Stadtpark.

Below:
An old-fashioned horse and carriage pulls up outside Hotel Sacher whose impressive history owes much to the commitment and personal drive of one Anna Sacher. She successfully managed the establishment for almost forty years.

Right:
In the park surrounding Schloss Schönbrunn a neoclassical columned hall was erected in 1775 to commemorate the victory over Frederick the Great in 1757. Today the building accommodates the Café Gloriette.

Above:
An avenue of trees on Parkring skirts the northwest edge of the Stadtpark, the first public park in Vienna. It was laid out on the left bank of the Wien as an English garden in 1862, with the more shady Kinderpark being opened a year later on the opposite bank of the river.

Right:
According to legend, in 1832 Count von Metternich requested a special dessert for his esteemed guests. As his head chef was ill, 16-year-old Franz Sacher set to work creating the prototype of the famous "Sachertorte", a chocolate gateau filled with apricot jam. Almost two centuries on several hundred of these Viennese specialities are sold and shipped off around the globe per day.

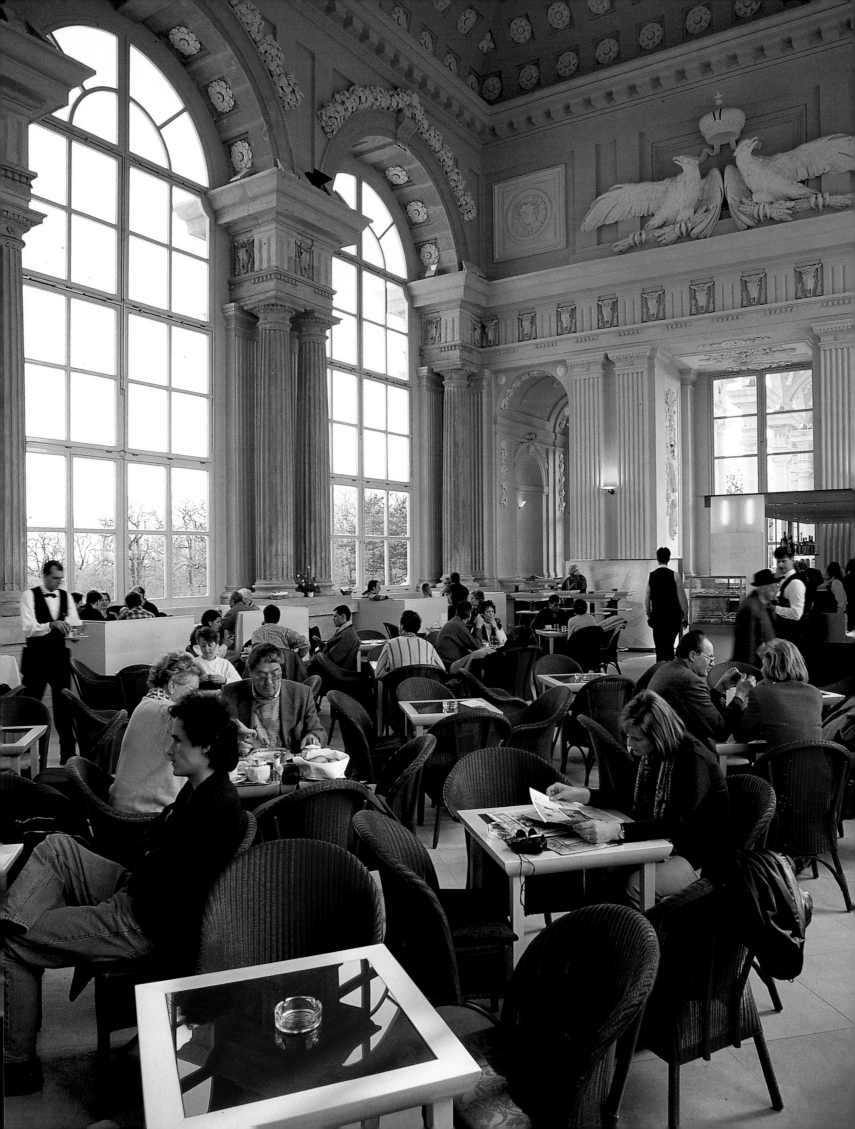

Ca. 20 km (12 miles) south of Vienna is the little wine village of Gumpoldskirchen, first mentioned in documents in 1140. The Gothic parish church of St Michael's is reached across a moated bridge guarded by a statue of St John of Nepomuk and a Gothic relief depicting Christ on the Mount of Olives.

In the Vienna Woods at the entrance to the Helene Valley lies the spa town of Baden bei Wien with plenty of places to relax, such as here at Café Damals.

The hot sulphur springs in Baden bei Wien were popular with Romans coming to take the waters here. On Grüner Markt with its colourful market stalls there are also plenty of remedies for a rumbling stomach.

The arcaded courtyard at Weingut Aigner in Gumpolds-kirchen is the perfect place to savour one of the new vintages harvested from the local vineyards. Popular varieties of grape grown here include Zierfandler, Rotgipfler and Neuburger, all of which produce excellent white wines.

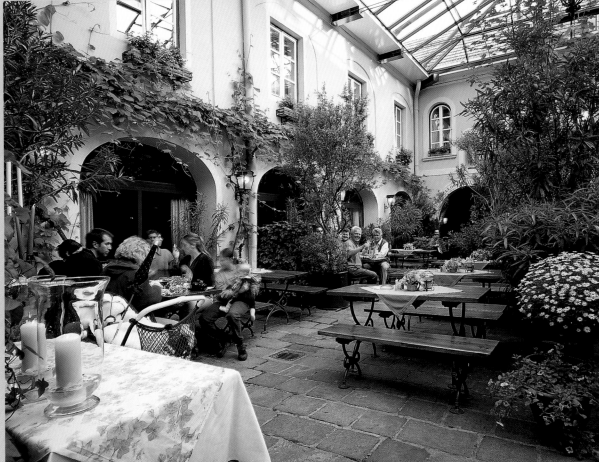

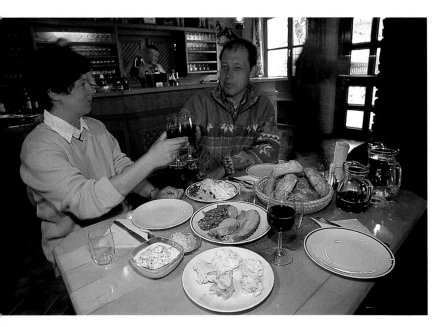

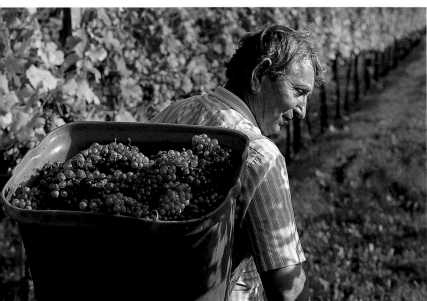

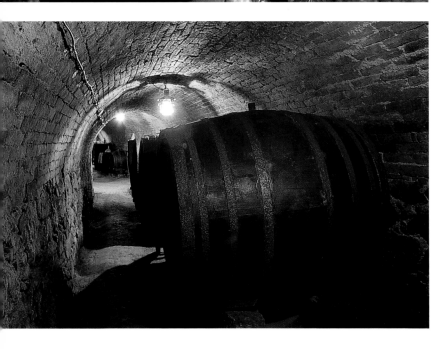

Top left:
In the Triesting Valley in the Vienna Woods the Herzog family from Berndorf-Ödlitz serves a hearty local platter with their new wine.

Centre left:
In the Wachau region between Melk and Krems the wine-making tradition goes back to the Celts. As here in Rührsdorf the vineyards are often steep, making harvesting hard work.

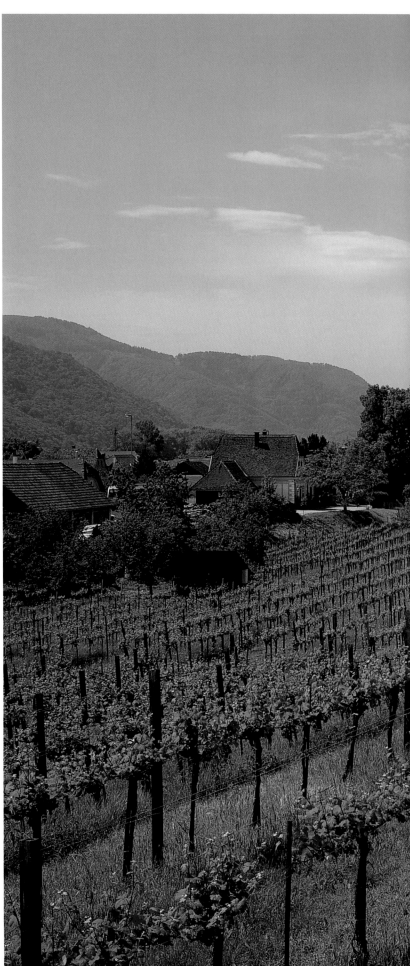

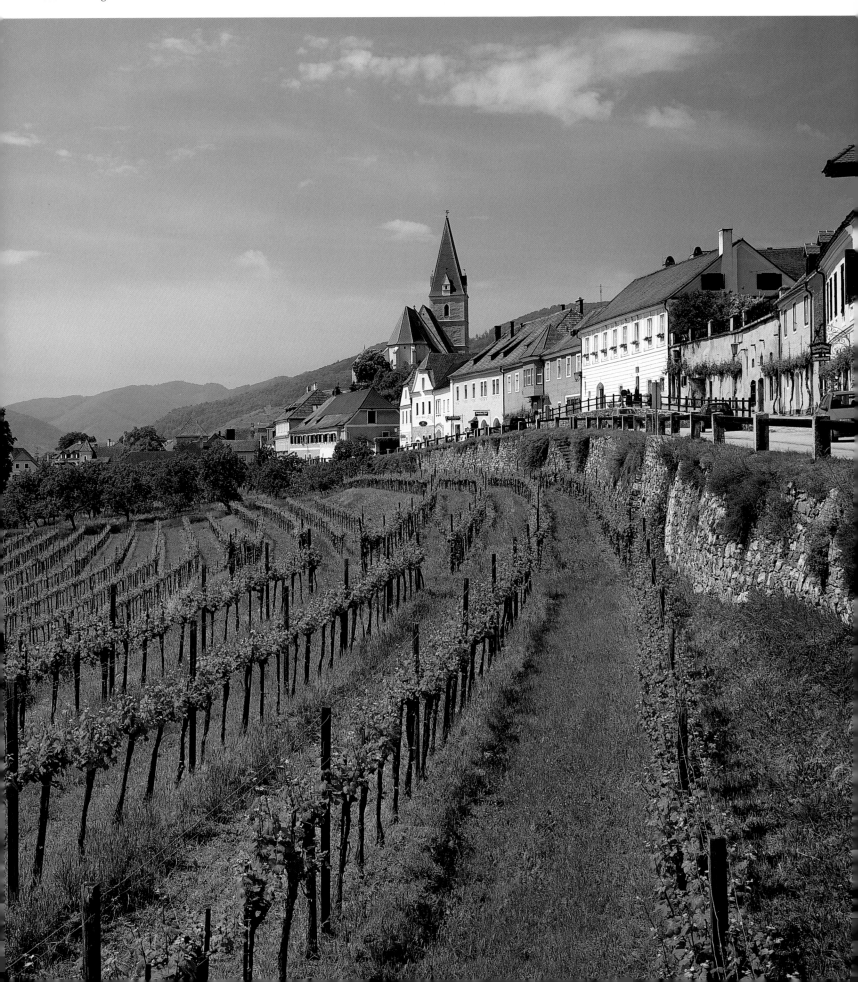

THE BENEDICTINE MONASTERY OF MELK

"We also reached the area around Melk, where the magnificent monastery, restored several times over the centuries, still stands proud above a bend in the river."

(Umberto Eco, The Name of the Rose)

These are the words of the fictitious scholar from Eco's novel "The Name of the Rose", searching in vain for a 14th-century manuscript in the monastic library. The lost work details the incredible events of the year 1327, written in Melk by Adson, a Benedictine monk. Eco chose well when he selected the Austrian monastery for his story which in the Middle Ages was home to a famous scriptorium.

SLAVONIC ROOTS AND ROMAN RUINS

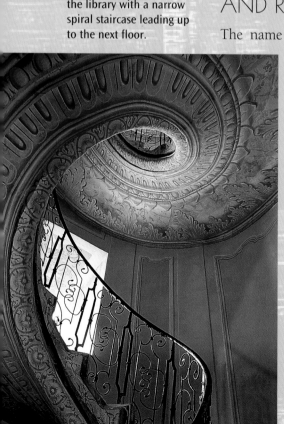

The name Melk was first documented in 831 and stems from the Slavonic word "medjilica" for "frontier river". Both Slavs and Bavarians populated the River Enns region. To fortify the Carolingian frontier zone against Avars and later Hungarians the first castle was built on a strategically positioned rocky outcrop, probably on the ruins of an earlier Roman fortress. The Babenberg margraves, who initially governed their country of Ostarrîchi from here, later moved their place of residence to Thunau, Tulln, Klosterneuburg and finally, in 1156, to Vienna. A monastery of canons was set up in Melk as early as c. 985; this was taken over by Benedictine monks from Lambach in 1089. In 1121 Abbot Erchenfried took command of the monastic community, causing Melk to blossom under his rule. Christine Glaßner, who has done a lot of work on the library archives, believes that the monks owned a minimum of 17 manuscripts when Erchenfried was made abbot, with this number rising to at least 68 by the end of the 12th century – clearly accentuating the significance of each individual volume and of the monastery as a seat of learning.

THE HEART OF THE MONASTERY – THE LIBRARY

At the beginning of the 12th century Melk was home to Ava, one of the first Austrian writers known by name, who recorded religious history in German. The second half of the 12th century produced another Middle High German poet who had close associations with the monastery: Heinrich von Melk. His legacy includes the poem "Erinnerungen an den Tod" (Remem-

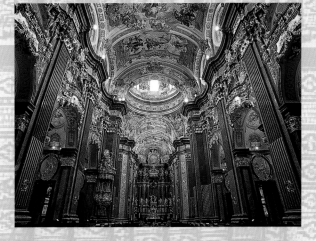

Sumptuously decorated, with marbled stucco adorning the walls, the monastery church is a kaleidoscope of gold, orange, ochre, grey and green. The ceiling of the nave is bedecked with a fresco painted by Michael Rottmayr in 1722.

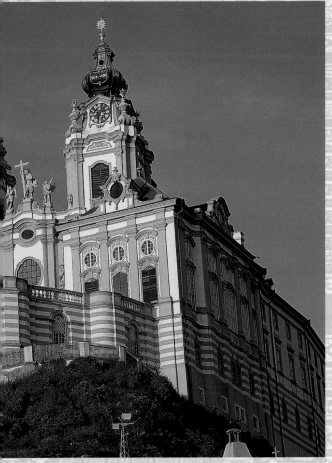

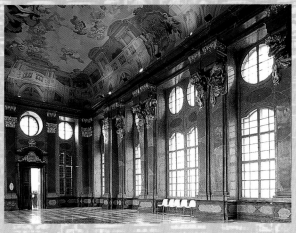

The marble hall is opposite the library to the southwest of the monastery complex. A ceiling fresco by Paul Troger from 1731 shows Pallas Athena on her journey from the world of evil to the world of good and light.

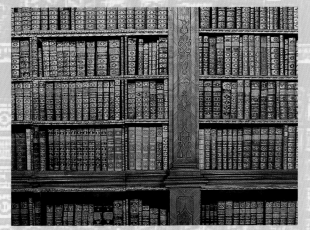

The walls of the monastic library at Melk are lined with lavishly inlaid shelves holding an extremely precious collection of books and manuscripts. Bound in leather with gilt lettering on their spines, these priceless volumes are the extraordinary sum of centuries of monastic study.

brance of Death), contained in a manuscript from the 14th century.

BAPTISM BY FIRE – A GRADUAL REBIRTH

In 1297 almost the entire monastery was destroyed by fire. Reconstruction was slow; the monastery did not experience a second boom until the 15th century. Further major structural changes were made during the 18th century when the complex took on its present form. The

library, whose ceiling frescos were created by Tyrolean artist Paul Troger in 1731/32, became the heart of the monastic community, together with the church and marble hall. There are ca. 90,000 volumes stored in the library, 1,858 of which are manuscripts, with 1,230 of these from the 9th to 16th centuries, and 798 incunabula. The walls are stacked with lavish, inlaid bookshelves on two levels, the contents of which would have caused Wiborada, the patron saint of bibliophiles from St Gallen in Switzerland, to reverently whoop with delight.

133

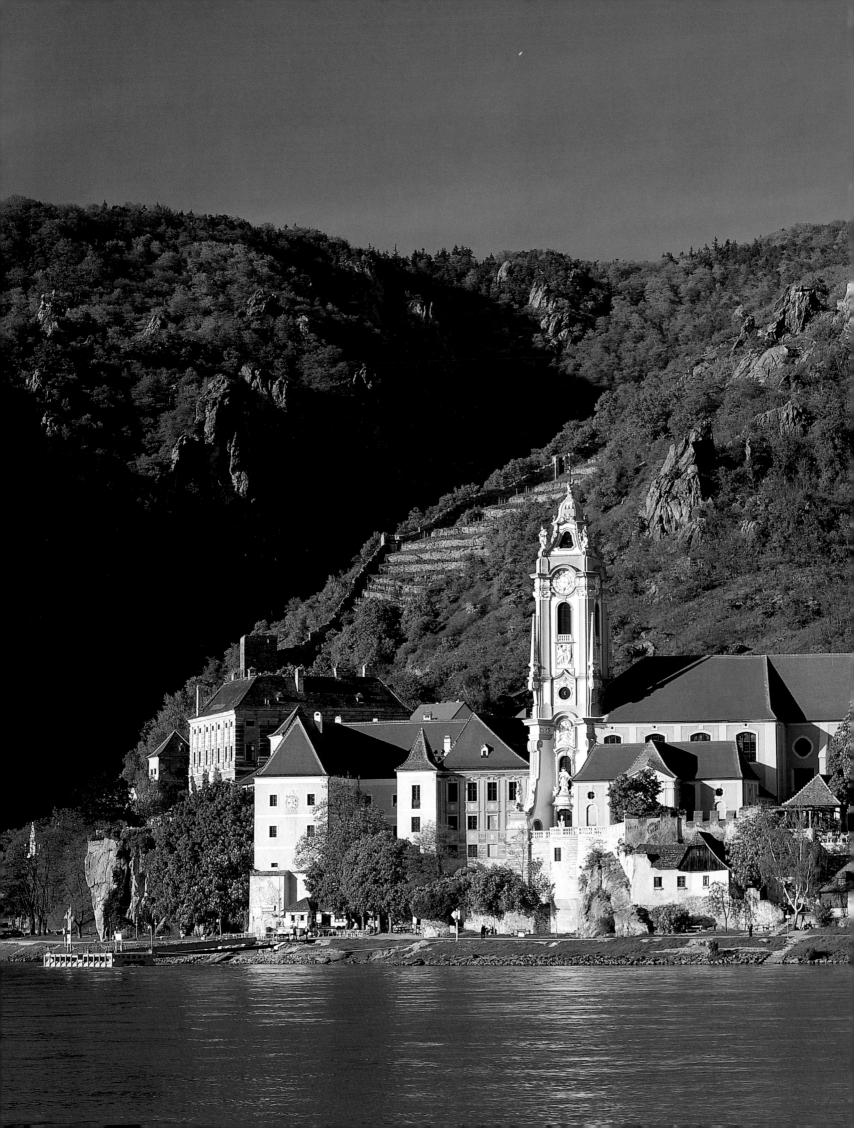

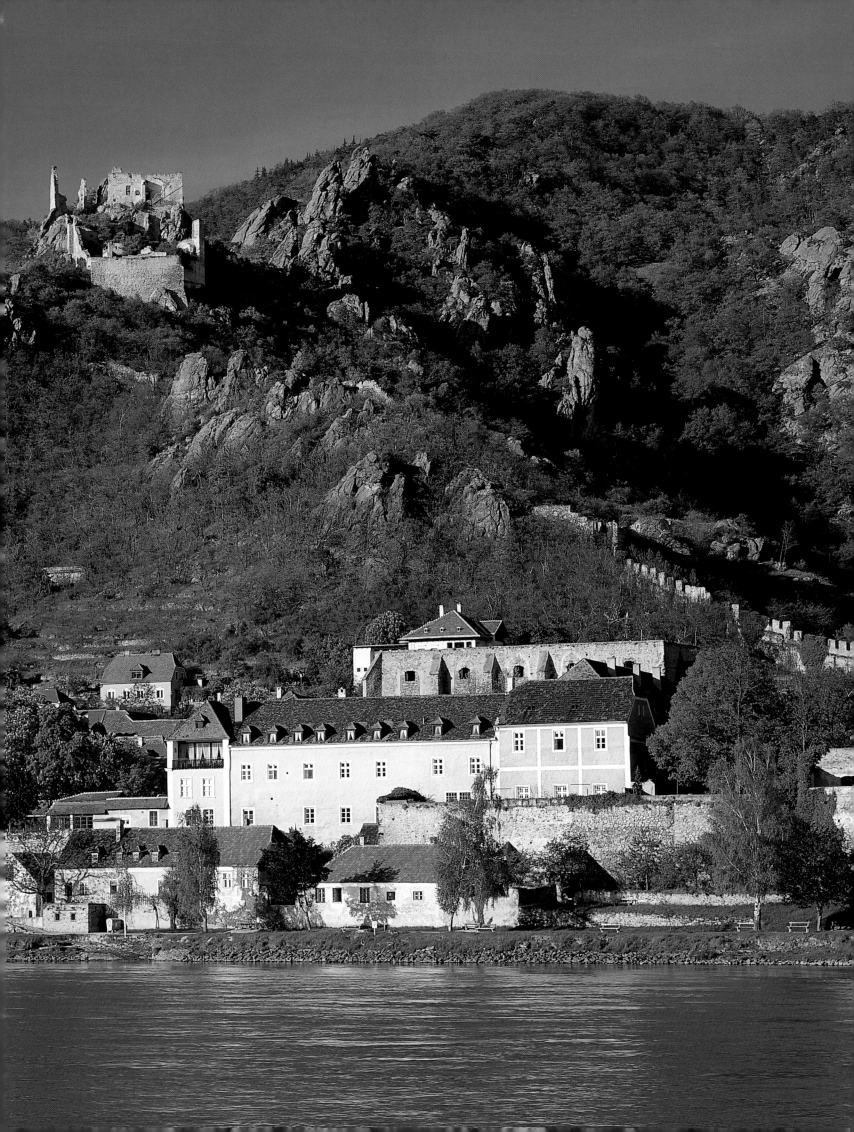

Page 134/135:
On the Danube near Weißen-kirchen is Dürnstein whose baroque church steeple can be seen for miles around. High up above the town are the ruins of a castle destroyed in 1645 where Duke Leopold V held England's King Richard the Lionheart captive in 1193.

Stein on the banks of the River Danube has been part of Krems since 1938. The two towns gradually merged in the Middle Ages, prospering through their trade in wine, grain, salt and iron. The towers of the old Minorite church of St Ulrich's and the parish church of St Nicholas dominate the landscape.

One popular Austrian tradition is the erecting of a May tree, a spruce or fir, decorated with flags and ribbons, shown here in Hofarnsdorf in the Wachau. The night of April 30 was originally a heathen festival marking the event of spring; in the wake of Christianity it became Walpurgis Night or the night of the witches.

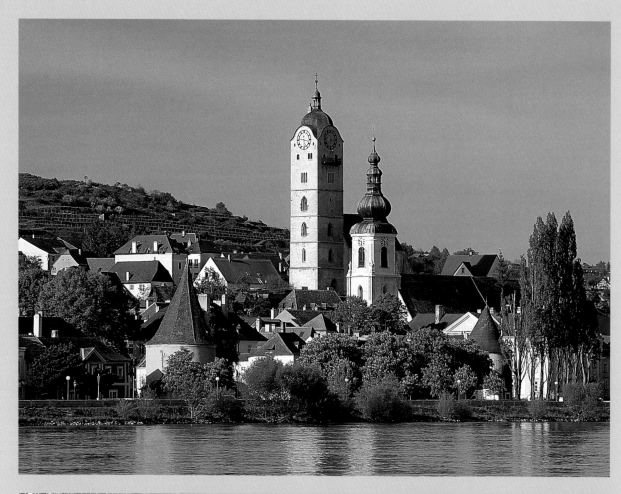

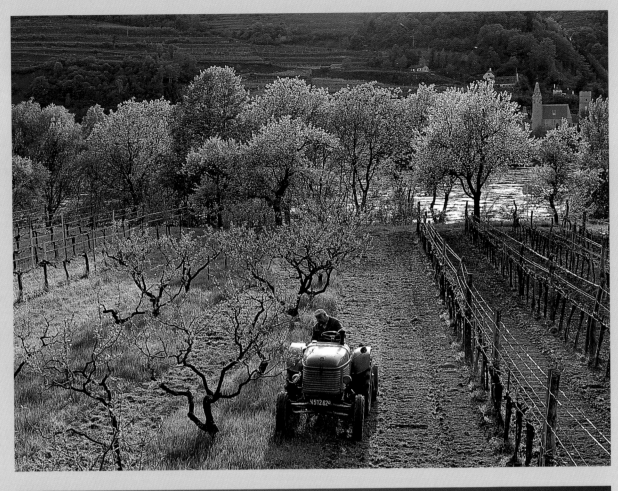

Near St Johann im Mauer-
thale the fruit plantations
run right down to the River
Danube. The mild climate of
the Wachau is perfect for the
cultivation of wine, apples
and pears.

South of the Danube, where
the Mostviertel stretches
between the Enns and the
Vienna Woods, pear trees in
blossom line the Moststraße
on its way to St Georgen.

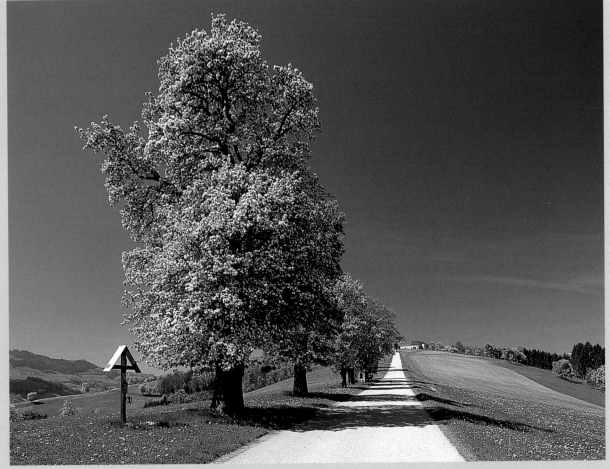

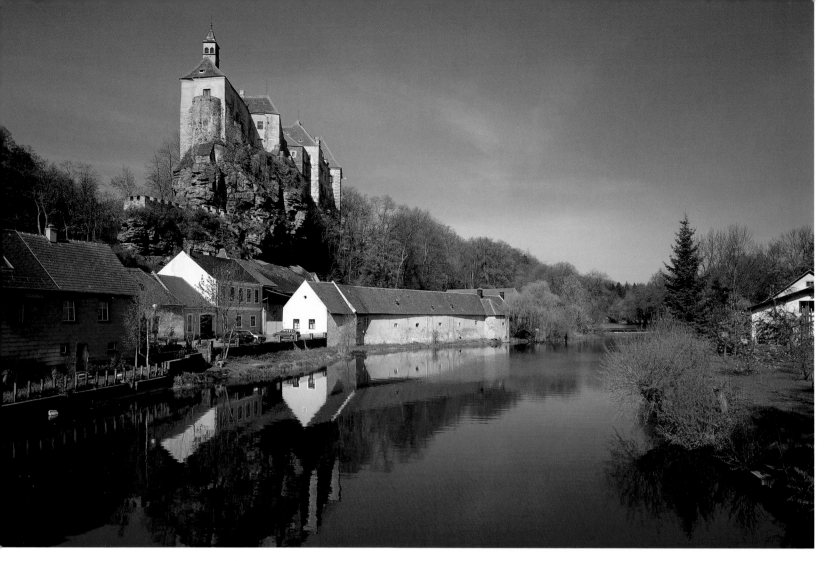

Above:

At the confluence of the German and Moravian Thaya stands Schloss Raabs, first mentioned in 1100. During this period the Raab dynasty, who were also the castle counts of Nuremberg until c. 1190, gradually colonised the northern Waldviertel. The Czech word for Austria is thus "Rakousko", the land beyond Raabs.

Right:

11th-century Burg Hardegg perches atop a spur of rock above the Thaya River close to the Czech border in the northwest Waldviertel. After changing hands many times, from the 17th century onwards the castle gradually fell into a state of decline until it was heavily restored by Count Khevenhüller-Metsch in c. 1900. A comrade-in-arms to Emperor Maximilian I of Mexico, the count turned part of the fortress into a museum devoted to his former officer.

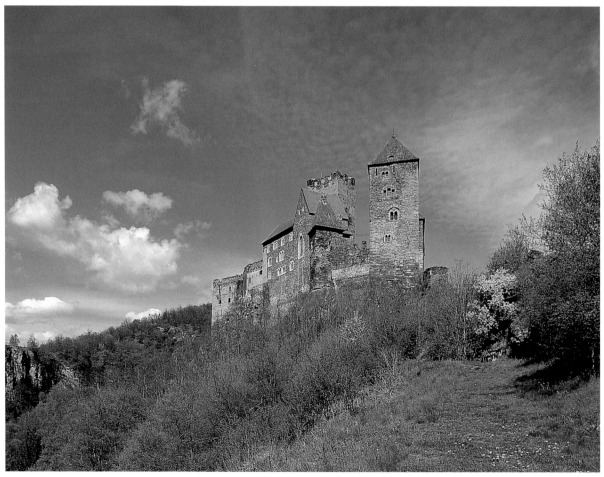

Left:
Near Münchreith in the Thaya, not far from Waidhofen, miles of hiking and cycling trails criss-cross the plateau of the Waldviertel, their users often protected by wayside crosses.

Below:
The town of Drosendorf, first mentioned in documents from 1188, is scenically set on a ridge surrounded by the River Thaya on three sides. A column from c. 1500 outside the colourful houses on the main square commemorates the granting of the town's market rights and right of jurisdiction. The figure on top of the column is a 1616 replica of the original which was destroyed by storms in the 17th century.

Below:
The Semmering (986 m / 3,235 ft) divides the Vienna Basin from the valley of the River Mürz which flows southwest towards the Mur. The pass also forms the boundary between Lower Austria and Styria. The mule track which cut across the mountain in the 12th century was turned into a more substantial road in 1728.

Top right:
Although the Alps gradually peter out in the northeast the Vienna Woods still have a few impressive peaks to offer, such as the Peilstein (716 m/2,349 ft) east of Baden bei Wien.

Centre right:
The highest mountain in Lower Austria, the Schneeberg southwest of Wiener Neustadt, is accessible by rack railway from the end of April to the end of October. From Puchberg to the final stop up the mountain at Hochschneeberg the train travels 9.7 km (6 miles) in 1 1/2 hours.

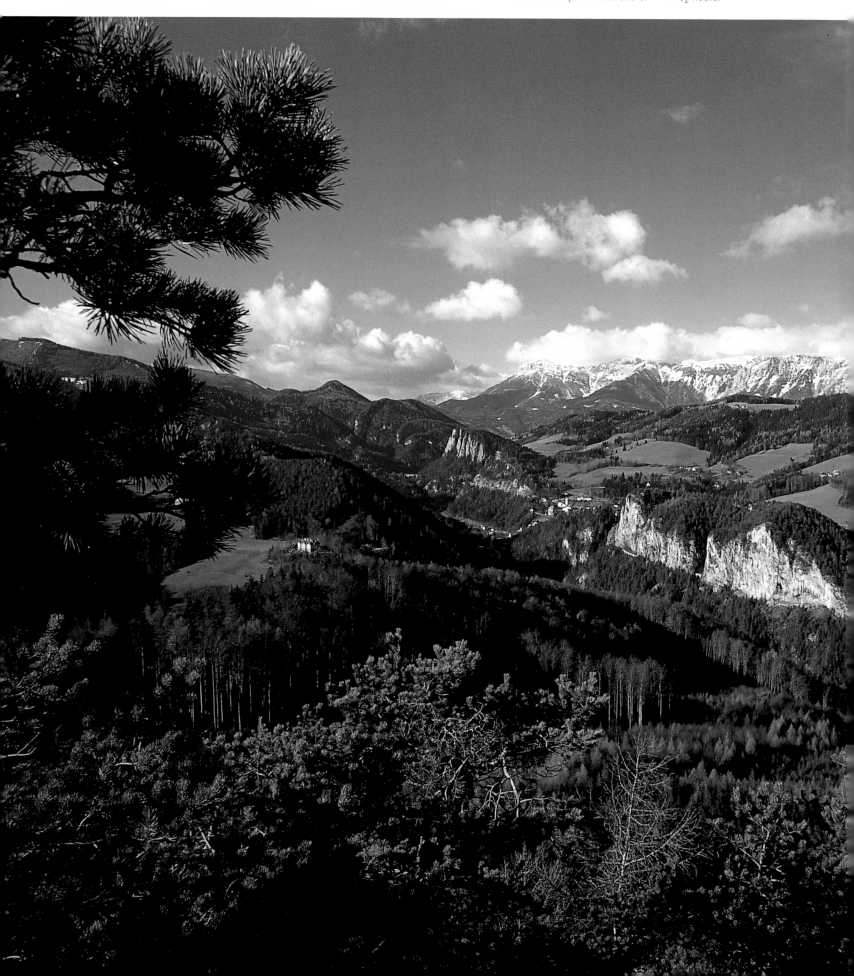

Bottom right:

The River Myra rises at the legendary Myralucke at the foot of Unterberg Mountain, fed by an underground lake. Its waters tumble down a rocky stream bed and through narrow gorges into the valley towards Pernitz and the mouth of the Piesting River northwest of Wiener Neustadt.

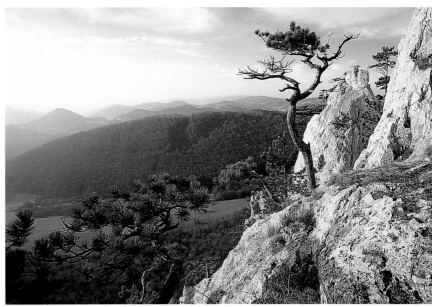

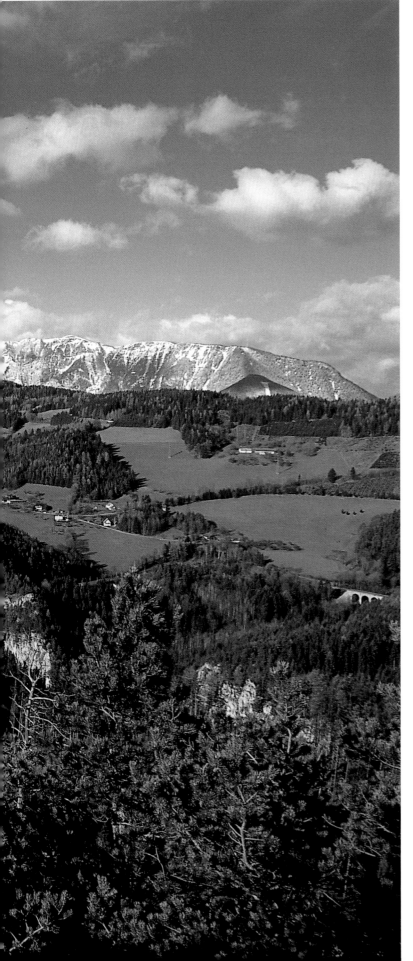

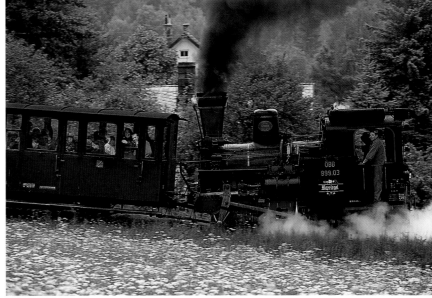

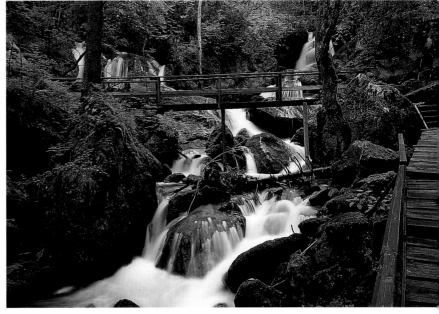

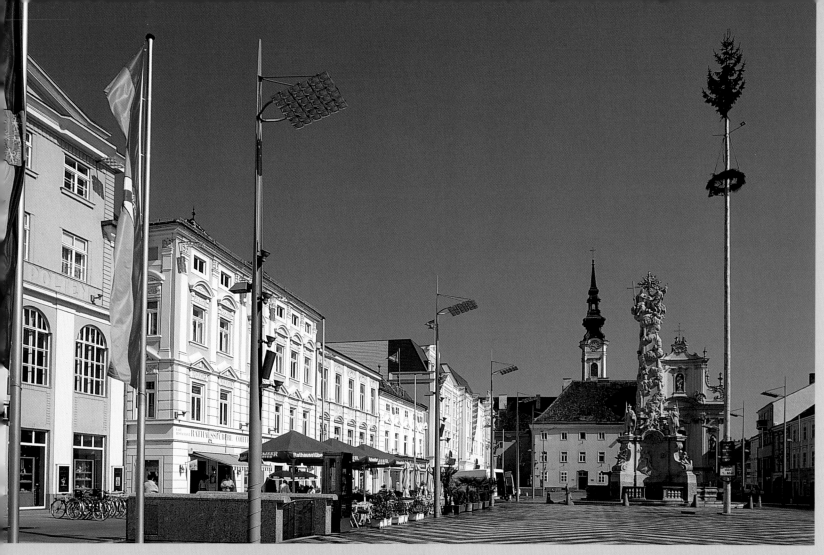

Above:
On the north side of the Rathausplatz in St Pölten stands a Rococo Franciscan church built between 1757 and 1779. The tall pillar dedicated to the Holy Trinity was erected in the middle of the square by Andreas Gruber in 1782.

Right:
East of Vienna on the right bank of the Danube lies the historic site of Petronell-Carnuntum. Once on the amber trade route, the Romans founded a military camp and a town here which existed until c. 400 AD and in its heyday numbered over 50,000 inhabitants. Emperor Constantine II had a triumphal arch constructed here in the 4th century whose ruins, now known as the Heidentor or heathen's gate, still measure a proud 12 m (39 ft) in height.

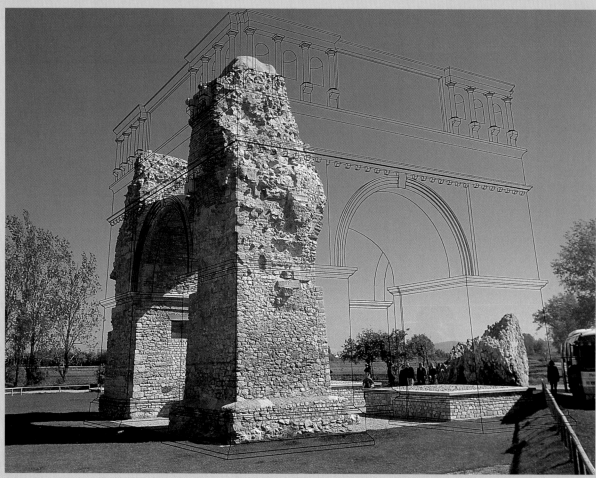

Left:
Tulln west of Klosterneuburg was once a Roman naval base and is mentioned in the "Song of the Nibelungs" as being the place where Attila met Kriemhild. The Baben-bergs resided here from 1042 to 1113. The basilica of St Stephen's was originally Romanesque; its 13th-century west portal still exists, with figures of the apostles worked into the niches of the round arches.

Below:
Waidhofen an der Ybbs southeast of Steyr was once a centre of the iron trade. The castle with its Gothic keep now houses a college of forestry. A permanent exhibition installed in the castle's various turrets informs visitors about the "city of towers".

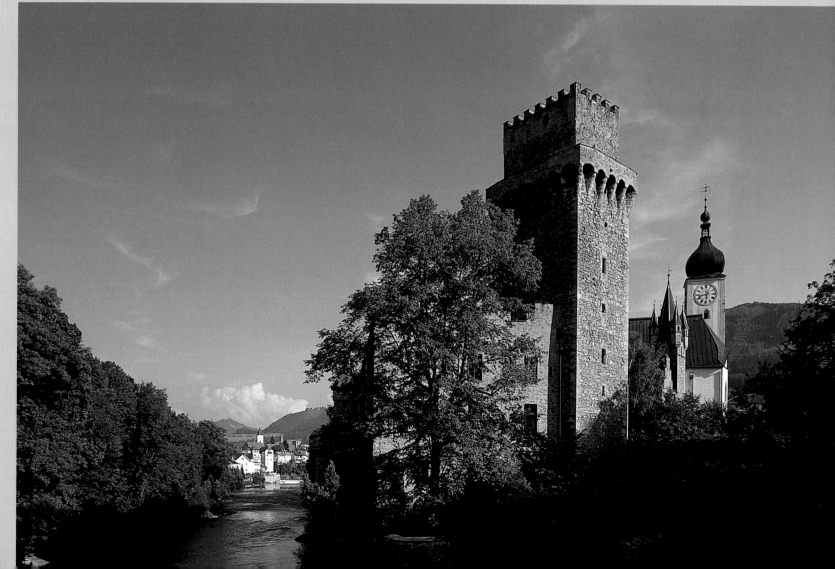

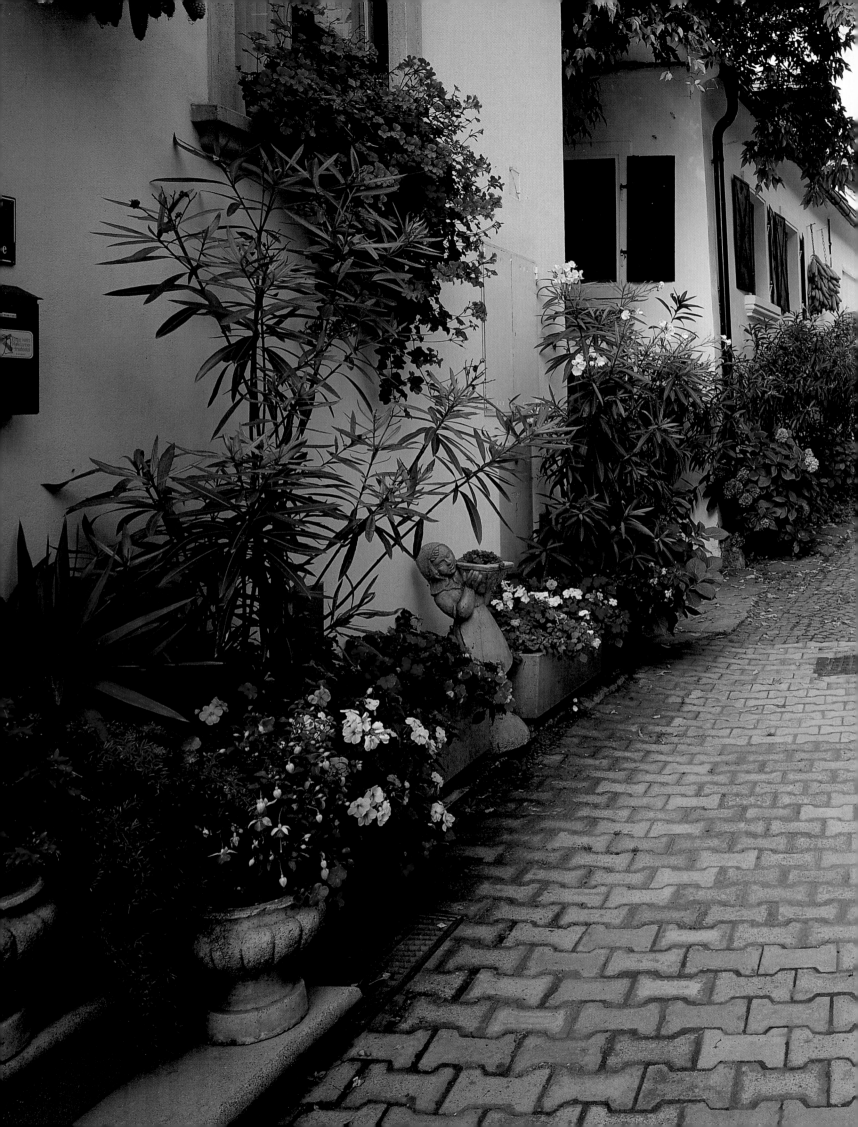

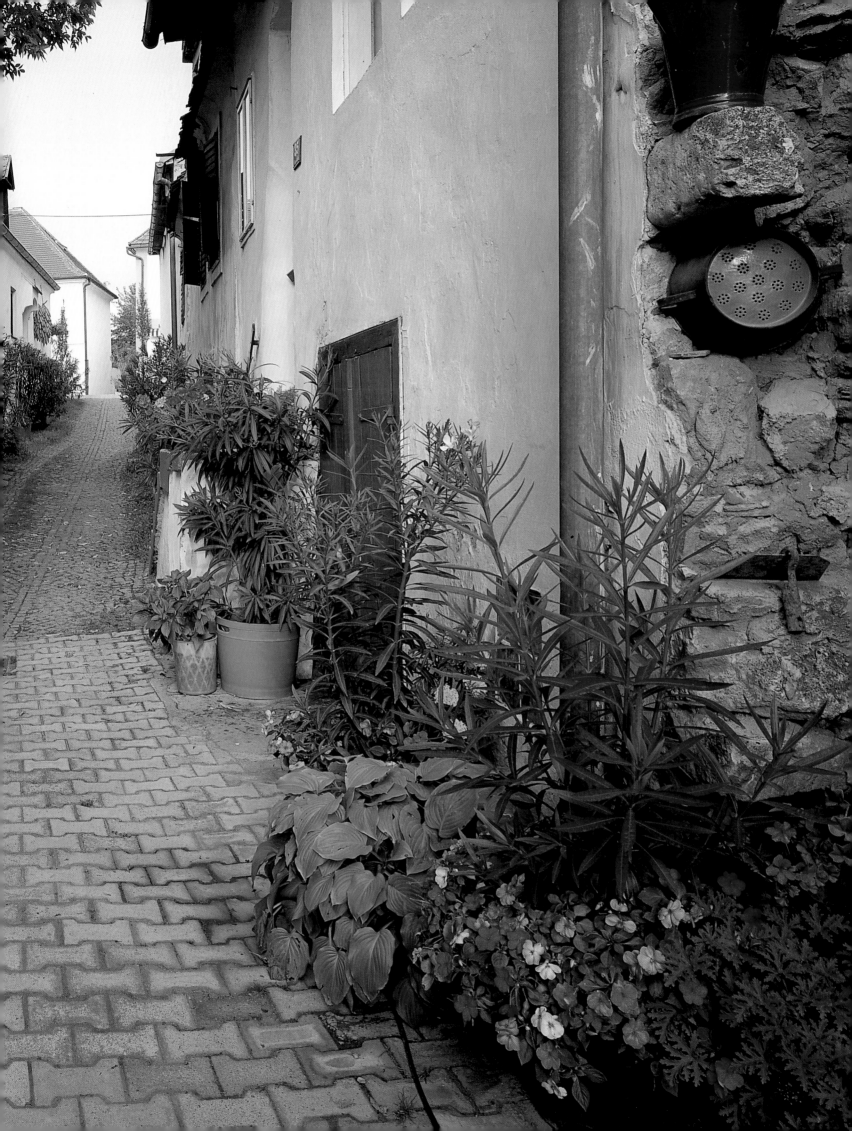

Page 144/145:
Mörbisch on Lake Neusiedler See is famous for its wines and long streets of ancient Burgenland houses and farms.

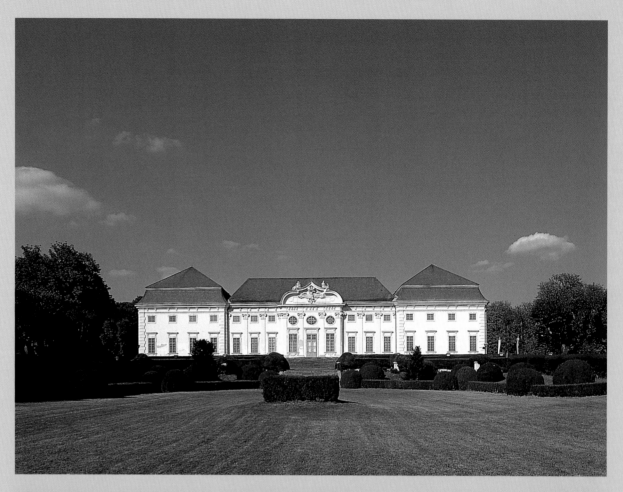

The baroque palace of Halbturn was built in 1711 as an imperial hunting lodge in the northern Burgenland not far from Lake Neusiedler. Its architect Lucas von Hildebrandt was one of Austria's chief proponents of the late baroque.

At the heart of the Burgenland at the entrance to the Güns and Zöbern valleys in Geschriebenstein National Park stands Schloss Lockenhaus from the 13th century. The knight's hall, depicted here with its Gothic rib vaulting and round pillars, is in the oldest part of the building. Styrian poet Paul Anton Keller bought the castle in 1968.

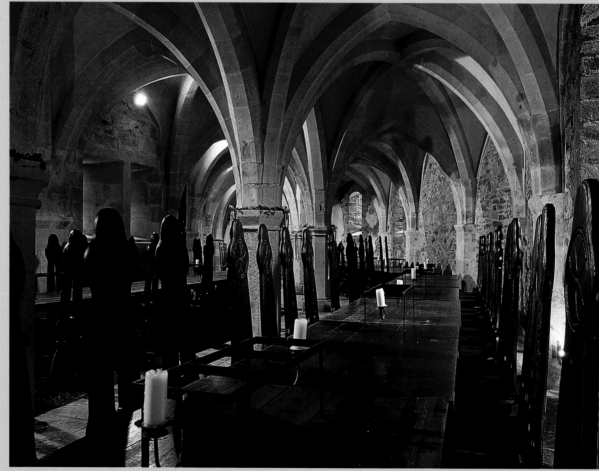

Right:
Schloss Esterházy in Eisenstadt was originally a medieval castle refurbished in the baroque style between 1663 and 1672. Joseph Haydn took up a post with the Esterházys here in 1761. The palace now accommodates the cultural and educational offices of the provincial Burgenland government.

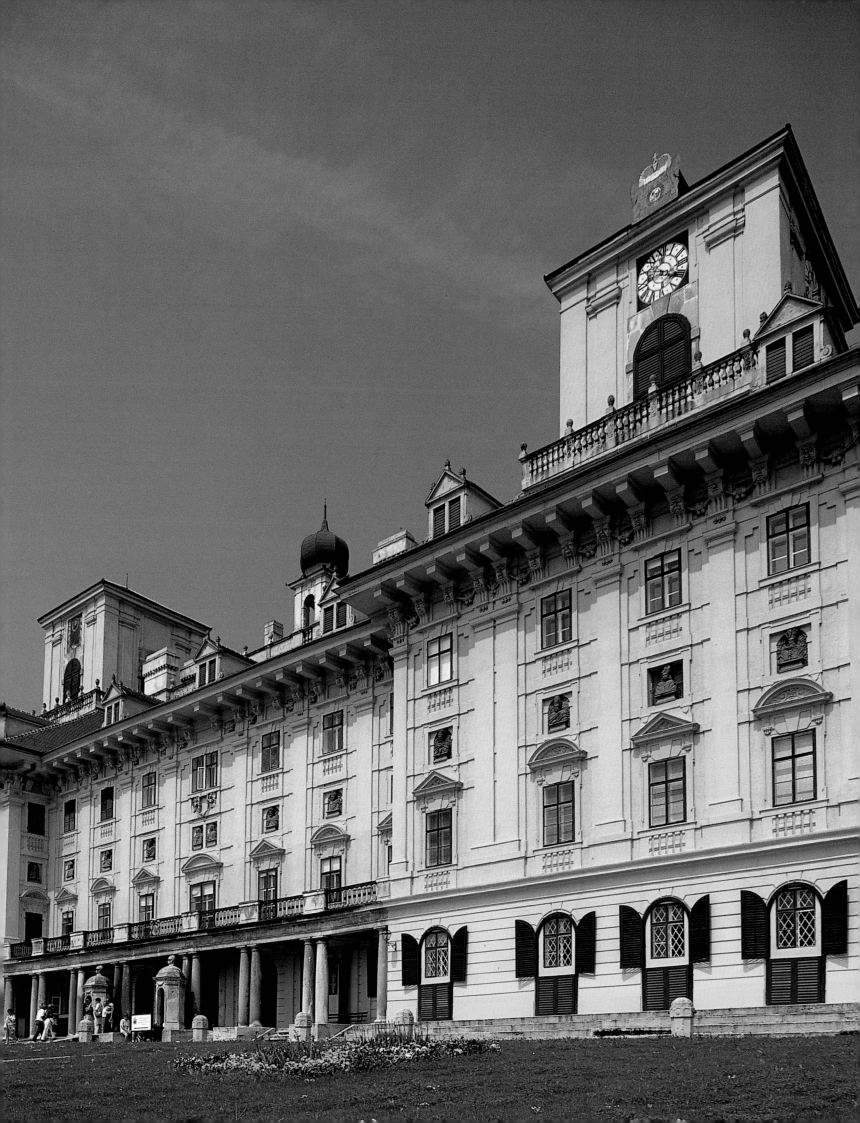

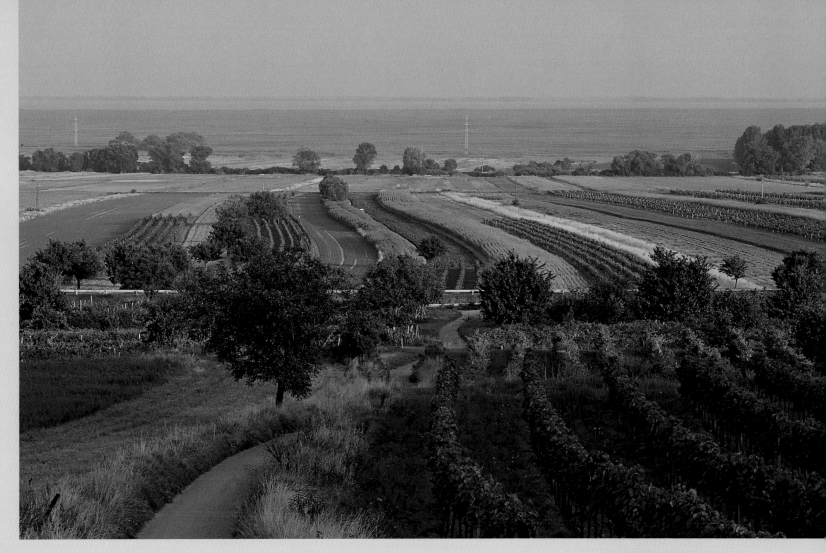

Above:
Wine is cultivated along the shores of Lake Neusiedler, such as here near Donner-skirchen, on a grand scale. With over 2,000 hours of sunshine a year the climate is particularly favourable; with its help over the past few years local vintners have gone from strength to strength to produce vintages of outstanding quality.

Left:
The Seewinkel on Lake Neusiedler is not far from the Hungarian puszta, with horses grazing the lush green meadows a common sight.

Left:
Rathausplatz in Rust on Lake Neusiedler is surrounded by town houses in the style of the Renaissance and baroque. The Zum Auge Gottes building from the first half of the 18th century has a lavishly decorated corner oriel. The steeple of the neoclassical church from 1784 was erected in 1896 and sports neo-baroque stucco.

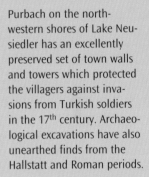

Purbach on the north-western shores of Lake Neusiedler has an excellently preserved set of town walls and towers which protected the villagers against invasions from Turkish soldiers in the 17th century. Archaeological excavations have also unearthed finds from the Hallstatt and Roman periods.

Heiligenbrunn in the southern Burgenland near Güssing was mentioned in documents as being a wine village as early as 1198. Uhudler, the local wine, is made from ancient varieties of grape, such as Ripatella, Othello, Isabella and Noah, and has a hint of wild strawberry. There are over 50 thatched wine cellars and taverns in the village, most of them listed buildings, where visitors and locals alike come to taste the year's Uhudler vintages.

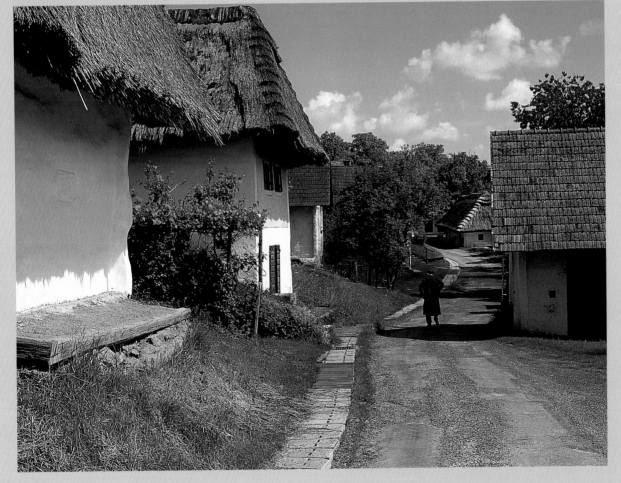

151

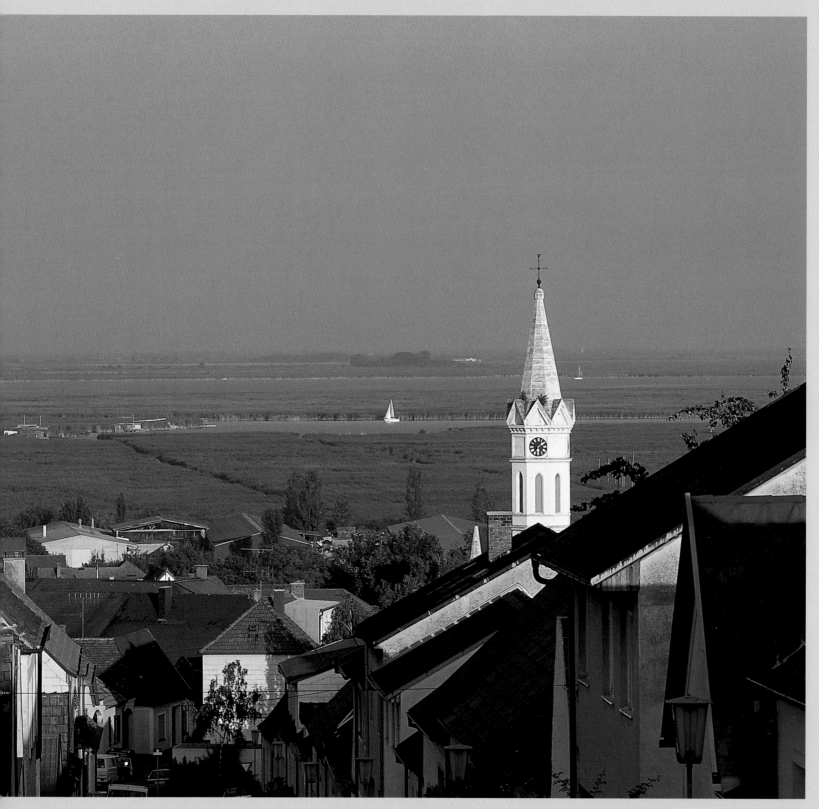

Conditions on much of
Lake Neusiedler are ideal
for sailing and windsurfing.
Mörbisch has its own yacht-
ing harbour and various
other sporting facilities,
including a beach which is
reached along a huge dyke.

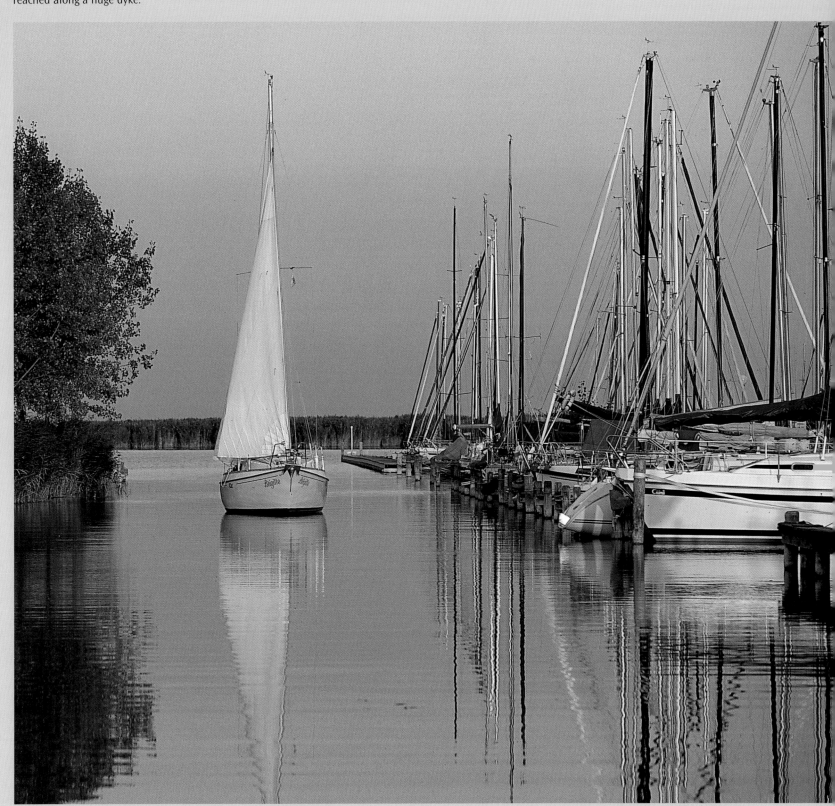

INDEX

Ulm ■

Lindau ●
Boden see
Bregen ●
Dornbir ●
● Hohenems
● Rankweil
Feldkirch ●
Le
● Blude
Schruns ●
VORARLBER

● Chur

SCHWEI

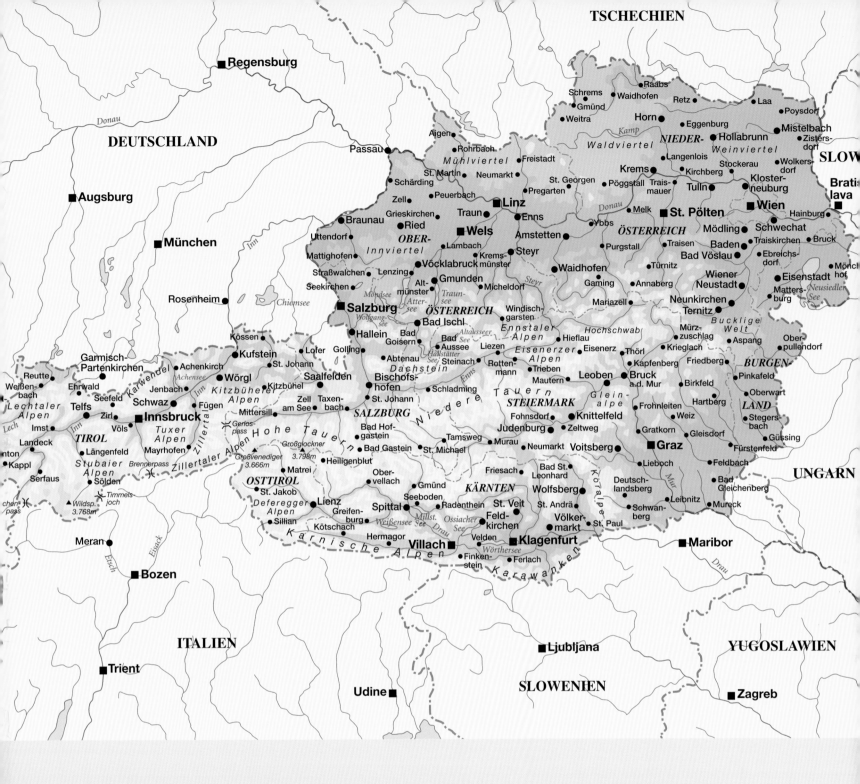

CREDITS

Design
Siberwald - Agentur für visuelle
Kommunikation
www.siberwald.biz

Map
Fischer Kartografie, Aichach

Translation
Ruth Chitty, Schweppenhausen

Printed in Germany
Repro by Artilitho, Trento, Italy
Printed and bound by Offizin Andersen Nexö,
Leipzig
Typesetting by Fotosatz Richard, Kitzingen

© 2006 Verlagshaus Würzburg GmbH & Co. KG
www.verlagshaus.com
© Fotos: Martin Siepmann

ISBN-13: 978-3-8003-1739-4
ISBN-10: 3-8003-1739-7

Not far from the Krimmler
Tauernhaus the high-lying
Windbach Valley slopes
down to the southwest
where Alpine cattle graze
the fertile slopes of the
Windbachalm in summer.

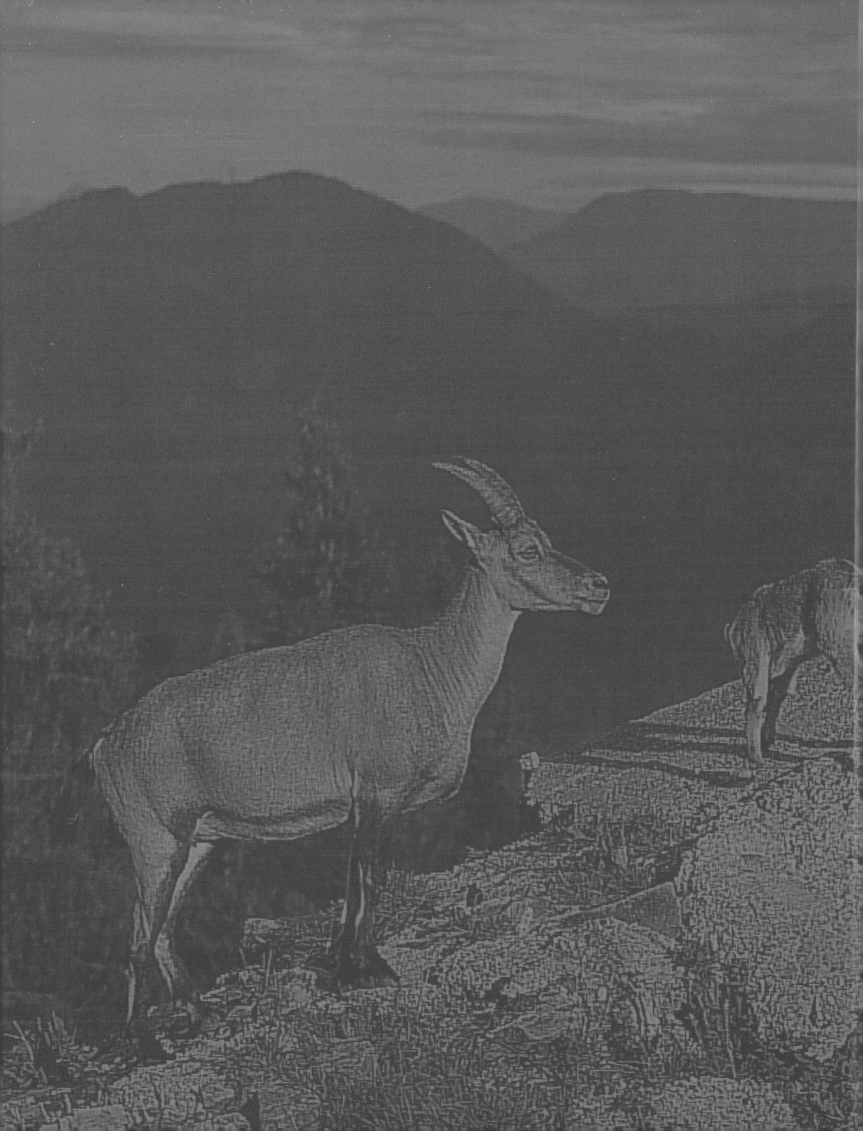